The dark side of the landscape

The dark side of the landscape

The rural poor in English painting 1730-1840

JOHN BARRELL

University Lecturer in English and
Fellow of King's College, Cambridge

CAMBRIDGE UNIVERSITY PRESS
Cambridge
London New York New Rochelle
Melbourne Sydney

Published by the Press Syndicate of the University of Cambridge
The Pitt Building, Trumpington Street, Cambridge CB2 1RP
32 East 57th Street, New York, NY 10022, USA
296 Beaconsfield Parade, Middle Park, Melbourne 3206, Australia

First published 1980

Printed in Great Britain at the
University Press, Cambridge

Library of Congress Cataloguing in Publication Data

Barrell, John.
The dark side of the landscape.

Includes bibliographical references and index.
1. Painting, English. 2. Painting, Modern—17th–18th
centuries—England. 3. Painting, Modern—19th century—
England. 4. Rural poor in art. 5. Gainsborough,
Thomas, 1727–1788. 6. Morland, George, 1763–1804.
7. Constable, John, 1776–1837. I. Title.
ND466.B28 759.2 78-72334

ISBN 0 521 22509 4

FOR
JOHN ELLIS BARRELL
AND
BEATRICE MARY BARRELL

No system can possibly be formed, even in imagination, without a subordination of parts. Every animal body must have different members subservient to each other; every picture must be composed of various colours, and of light and shade...It would have been no more an instance of God's wisdom to have created no beings but of the highest and most perfect order, than it would be of a painter's art to cover his whole piece with one single colour, the most beautiful he could compose. Had he confined himself to such, nothing could have existed but demi-gods, or arch-angels, and then all inferior orders must have been void and uninhabited: but as it is surely more agreeable to infinite Benevolence, that all these should be filled up with beings capable of enjoying happiness themselves, and contributing to that of others, they must necessarily be filled with inferior beings, that is, with such as are less perfect, but from whose existence, notwithstanding that less perfection, more felicity upon the whole accrues to the universe, than if no such had been created. It is moreover highly probable, that there is such a connection between all ranks and orders by subordinate degrees, that they mutually support each other's existence, and every one in its place is absolutely necessary towards sustaining the whole vast and magnificent fabrick.

(Soame Jenyns, quoted by Samuel Johnson, *Review of a Free Enquiry*, 1757.)

CONTENTS

ILLUSTRATIONS

Dates are given only when the artist painted more than one picture of the same name, and at different dates.

The author and publisher would like to thank the following for their permission to reproduce the paintings in this book: the Earl of Mansfield (Wilkie's *Village Politicians*); the Duke of Rutland (Gainsborough's *The Woodcutter's Return*); Lord Tavistock (Gainsborough's *Landscape with a Woodcutter Courting a Milkmaid* and *Peasant with Two Horses*); City of Bristol Museum and Art Gallery (Lambert's *Woody Landscape with a Woman and Child Crossing a Bridge*); Barber Institute of Fine Arts, University of Birmingham (Gainsborough's *The Harvest Wagon, 1767*); Trustees of the British Museum (Gainsborough's *Wooded Landscape with Boy Reclining in a Cart*, Orme's *Morning, Higglers Preparing for Market* [after Morland] and Syer's *The Alehouse Door* [after Morland]; Fitzwilliam Museum, Cambridge (Morland's *Midday Rest at the Bell Inn*, *The Benevolent Sportsman*, *A Gypsy Encampment* and Ward's *Sun-Set: a View in Leicestershire* [after Morland]); Ipswich Borough Council (Constable's *Golding Constable's Flower Garden*); The Trustees of the National Gallery, London (Constable's *The Haywain* and Claude's *Coast Scene with Aeneas at Delos*); The National Gallery of Scotland (Constable's *Dedham Vale*); Castle Museum and Art Gallery of Nottingham (Morland's *The Artist in his Studio* and Wheatley's *The Harvest Wagon*); Royal Holloway College, London (Gainsborough's *Peasants Going to the Market*); The Tate Gallery, London (Constable's *A Country Lane* and *The Valley Farm*, Gainsborough's *Mrs Graham as Housemaid*, Lambert's *Hilly Landscape with a Cornfield*, Lewis' *Hereford, Dynedor and Malvern Hills*, Linnell's *Wood-cutting in Windsor Forest*, Morland's *Morning Higglers Preparing for Market*, *The Gravel Diggers*, *The Alehouse Door* and *The Door of a Village Inn*; Stubbs's *Haymakers* and *Reapers*, and Turner's *Ploughing up Turnips near Slough* and *Frosty Morning*; Trianon Press (Blake's '*Oft did the harvest to their sickle yield*'); Victoria and Albert Museum, London (Constable's *Boat-building near Flatford Mill*, sketch for *Boat-building near Flatford Mill*, *Flatford Mill from the Lock*). The Museum of Fine Arts, Boston (Constable's *Stour Valley and Dedham Village*); The Cincinnati Art Museum (Gainsborough's *Cottage Door with Children Playing*); Henry E. Huntington Library, San Marino, California (Wheatley's *Palmerston Fair*); The Metropolitan Museum of Art, New York (Gainsborough's *Cottage Children*); The Art Gallery of Ontario (Gainsborough's *The Harvest Wagon 1784–5*); University of California at Los Angeles (Gainsborough's *Peasant Smoking at a Cottage Door*); Yale Center for British Art (Constable's *Dedham Vale with Ploughman*, Lambert's *Extensive Landscape with Four Gentlemen on a Hillside*, and Rowlandson's *The Hedger and Ditcher* and *Labourers at Rest*); The Faustus Gallery, London (Morland's *Tavern Interior with Sportsmen Refreshing*); Thos. Agnew and Sons Ltd (Gainsborough's *Peasant Girl Gathering Faggots*). All other paintings are located in private collections and are reproduced here by kind permission of their owners.

ACKNOWLEDGEMENTS

I would like to thank Tim Clark, Harriet Guest and Michael Rosenthal, who read through the whole manuscript of this book at various stages, and commented in detail upon it; I have adopted most of the alterations and improvements they suggested. I would like to record here a large additional debt to Dr Rosenthal, who over a number of years has been most generous in allowing me to read drafts of his own work in progress, and who has pointed out to me a number of pictures and texts which I would otherwise have missed. Thanks are also due to two in particular of my research students in Cambridge, Stephen Copley and Nigel Everett: I drew freely on their knowledge of writings about the poor in the eighteenth century when they were meant to be drawing on mine. Simon Wilson invited me to contribute to the Constable Bi-centenary lectures at the Tate Gallery in 1976, and so gave me the first opportunity to try out in public some of the ideas developed in this book, and Leonie Cohn, of BBC Radio Three, gave me the chance to clarify my view of Gainsborough in two radio talks. I should like to thank also Terry Moore, Maureen Leach and other members of the staff of Cambridge University Press, and a number of friends or correspondents who have offered information or opinions about various matters discussed in the book, often no doubt without realising they were doing so: Duncan Bull, David Coke, John Hayes, William Joll, Aram Raworth, David Simpson, Lindsay Stainton, and Tony Tanner. Anna Mendleson helped with the typing of the manuscript.

King's College, Cambridge John Barrell
April 1979

Introduction

It is indeed commonly affirmed, that truth well painted will certainly please the imagination; but it is sometimes convenient not to discover the whole truth, but that part which only is delightful. We must sometimes show only half an image to the fancy; which if we display in a lively manner, the mind is so dexterously deluded, that it doth not readily perceive that the other half is concealed. Thus in writing Pastorals, let the tranquillity of that life appear full and plain, but hide the meanness of it; represent its simplicity as clear as you please, but cover its misery. (*The Guardian*, no. 22, 6 April 1713)[1]

I

Since the publication of E. P. Thompson's *The Making of the English Working Class* in 1963, and with the appearance of more recent work by him and by others connected with him, we have come to know a good deal more about the social history of the eighteenth and early nineteenth centuries – about the emergence of a working-class-consciousness, and about the relations of rich and poor as they are revealed in legal, charitable, and other transactions.[2] The essays in this book are an attempt to study the image of rural life in the painting of the period 1730–1840, not exactly in the light of this new historiography, for this is not a social history of art, but taking advantage of the new freedom that Thompson's works have given us to compare ideology in the eighteenth century, as it finds expression in the arts of the period, with what we may now suspect to have been the actuality of eighteenth-century life. The essays examine how the rural poor are represented in the landscape and *genre* paintings of the period, and, more generally, how social relations are depicted in such paintings, and what place the poor are shown as occupying in the society of England seen as a whole. I shall argue that this vision of rural life can be understood only by understanding the constraints – often apparently aesthetic but in fact moral and social – that determined how the poor could, or rather how they could *not* be represented; and that we can understand these

constraints by attempting to understand the imagery of the paintings I discuss, and how it relates to their organisation as pictures. The scope of the book is fairly modest, in that although I shall suggest that the painters I discuss may be seen in terms of a tradition, I have not tried to study that tradition as a whole, and have been content to discuss what I shall argue are its most important moments, for the most part as they are represented in the work of the three painters who are the subjects of my separate essays.

That paragraph begs a number of questions, the answers to which are perhaps sufficiently apparent in the essays that follow, but it will help if I make a preliminary attempt to discuss them here. Who are the 'rich' and the 'poor'? What are the 'constraints' I speak of, and why, if these constraints were social and moral, should they have appeared often as aesthetic constraints? How can we 'understand' the imagery of the paintings I consider, and understand it in the light of their composition? What is the 'tradition', and why have the three painters I discuss – Gainsborough, Morland, and Constable, who differ so much in their aims and achievements – been chosen to represent it?

II

If we can be sure of anything about the eighteenth century, it is that English society at the time was minutely stratified and subdivided, and there is no level at which a line can be drawn around the social pyramid, marking off the 'rich' from the 'poor', or the consumers of Britain's wealth from its producers. Thus the tenant-farmer – an occupation in itself too capacious to be generalised about with any confidence – may well feel himself to be a producer in relation to his landlord, and poor in comparison with him, while to his labourers he will often appear as the rich consumer of the fruits of their labour; and similar conventions of authority and deference which govern the relations of landlord and tenant will govern those of tenant and labourer. There are difficulties, too, in thinking of the 'labourers' as composing a homogeneous and recognisable class – for, as we shall see, many of them earned their living in a variety of ways, of which working in the fields of other men was only one, and there must have been significant differences in income among those who did, or did sometimes, thus hire out their labour. There is not one line but many, drawn by those in every station immediately above or below the position they feel themselves to occupy.

That is likely to be true, or course, in any developed or developing society; but what has often been denied about English society in the eighteenth century is that its members exhibit any consciousness of class at all, and it is asserted instead that in a society so stratified the

lines are drawn not by classes but by individuals, aware of relations of difference between themselves and others above or below them on the pyramid, but not of relations of similarity with those at the same level – for the levels are too many, the occupations too mixed and various, to allow generalisations in terms of class to be made by those alive then, or by us now.[3] This is not the place to discuss the issue in detail; but an acquaintance with eighteenth-century writing, whether with the imaginative literature or with the literature concerned more directly with the discussion of social problems, will reveal that the 'poor' were indeed coming to be thought of as a class, as the distant generalised objects of fear and benevolence;[4] and the widespread and continued necessity of keeping the labouring poor alive by supplementing their wages with public or private charity made the line dividing the poor from the rest of society brilliantly if misleadingly clear. And not to the politely literate only, but to the poor themselves, whose resentment of the erosion of their customary rights, of their own need – which appears to them often as the consequence of that erosion – for charity even when they were in full employment, and of the postures of cheerfulness, submission and gratitude they had to take up to receive it, was an important factor in creating a consciousness of solidarity among those who did, or did not quite, qualify for relief, and of difference from those who provided it, which must be understood as class-consciousness: us the poor, them the rich. It is this consciousness, on the part of the polite and vulgar alike, that I am appealing to when I appear to ignore the complexities of the society of the period, and refer so insistently to the 'rich' and the 'poor'.

That in the context of my argument the term 'rich' needs no further differentiation, I hope to show later in this introduction. Why in the eighteenth century the poor came to take on the status of an undifferentiated class, whose need for charity was their most distinguishing characteristic, is a problem that will not be resolved in this book; for it is by no means clear whether the poorest members of rural society did become significantly worse off between 1700 and 1800, or whether the greater awareness of the poor as a class that we observe among the rich in the last quarter of the century is in fact an awareness of the greater threat they posed to the stability of England, by reason of their increasing literacy and their own developing class-consciousness. There are good reasons for believing that the condition of the rural poor did indeed get worse. The long process of transforming the 'paternalist', and what has been called the 'moral' economy of English agriculture, into a capitalist economy resulted, as it was partly intended to do, in the reduction of the poorer members of rural society to the condition of a landless proletariat.

At various times in different places, by different forces operating gradually or suddenly, the process enveloped many of the smallest freeholders and copyholders, and the miscellaneous individuals who had managed to put together a living by what they could earn as hired labourers and in some cases as the practitioners of crafts and trades, and by what they could make or find by exploiting the customary rights which, insignificant as they apparently often were, provided some sort of a cushion against the seasonal variability of agricultural employment, and some valuable sense of independence.

The enclosure of wastes and open fields, and the consequent extinction of common rights, was one method by which this proletariat was created, and we should not overlook the evidence that one motive for enclosure was, precisely, to make the labouring poor more dependent on their employers, and so more tractable to their discipline.[5] But in fact, whether or not the rural poor did generally become poorer in the course of the century, it seems likely that their material condition was as desperate in parishes where rights of common had not been extinguished as where they had. The steep rise in population, the decline of the outworker system in the face of the greater mechanisation of the textile trades, and the system of parochial settlement, meant that in many parishes there were more labourers than could be employed, who became wholly or partly dependent on public and private charity.

It remains, in any case, by no means clear that the material condition of the poor was appreciably worse by the end of the century – the evidence is neither adequate nor, drawn as it is from so many different regions, susceptible of generalisation. It does seem clear that many of them had lost much of whatever degree of independence thay had formerly enjoyed, and this contributed to the creation of that working-class-consciousness that, as we shall see in the essays that follow, was feared and resisted by the rich; but this loss of independence may not have led to an actual reduction in their material standard of living. That it was *evident* by the later decades of the century that rural labourers were in many regions unable to earn enough by their labour to support their families may equally plausibly be explained by what I have called a new awareness of the poor on the part of the rich, and I shall return to this point in my next section.[6]

Whichever explanation we prefer, the continuing transformation of the agricultural economy remains the context in which the condition of the poor, and the art of rural life, must be discussed. The customary rights of the 'moral' economy were not easily surrendered, nor the increasing emphasis on labour-discipline easily accepted, and in the works of Thompson there is much evidence of social conflict in the countryside in the period covered by this book.[7] This conflict

should not be interpreted as a matter of local and casual lapses from an overall stability, inasmuch as it almost invariably takes the form of resistance to specific changes in the economic and social order – of attempts, mainly on the part of the poorer members of society, joined sometimes by the better-off when their interests were threatened by the largest landowners, to preserve the customs of the old economy against the encroachments of the new. 'The Plebeian culture', as Thompson has written, 'is rebellious, but rebellious in the defence of custom'.[8] And yet this conflict is largely ignored by the poetry of rural life until the last decades of the century, and it never breaks the surface of the painting of rural life, except, as I shall argue, in a number of paintings by George Morland. For the most part the art of rural life offers us the image of a stable, unified, almost egalitarian society; so that my concern in this book is to suggest that it is possible to look beneath the surface of the painting, and to discover there evidence of the very conflict it seems to deny. The painting, then, offers us a mythical unity and – in its increasing concern to present an apparently more and more actualised image of rural life – attempts to pass itself off as an image of the actual unity of an English countryside innocent of division. But by examining the process by which that illusion is achieved – by studying the imagery of the paintings, the constraints upon it, and upon its organisation in the picture-space – we may come to see that unity as artifice, as something made out of the actuality of division.

It goes without saying that the paintings I discuss were produced for those who by this account, and at least from the perspective of the poor, were rich; and the 'constraints' I have referred to were the constraints which governed how the labouring, the vagrant, and the mendicant poor could be portrayed so as to be an acceptable part of the *décor* of the drawing rooms of the polite, when in their own persons they would have been unlikely to gain admission even to the kitchens. These constraints still operate in subtle ways today, as I shall try to show in a brief discussion of Stubbs later in this introduction; so that when in the essays that follow I refer to 'our' response to a picture, or to what 'we' demand to see in the image of the eighteenth-century poor, it is not to be thought that I am confusing the amateurs of art today with the connoisseurs of the period covered by this book, but rather that we should ask ourselves whether we do not still, in the ways we admire Gainsborough, Stubbs, and Constable, identify with the interests of their customers and against the poor they portray. I am not suggesting that we should do anything else, merely that we should ask what it is that we do; to identify with the exhausted and underfed labourers is impossible for us, and would be insulting if it were not.

III

The tradition of the art of rural life that I am concerned with can loosely be defined as one involved in the attempt to portray the social life of the rural poor of England; but that definition must be qualified as soon as it is uttered. To begin with, Gainsborough, who appears in this account as one of the initiators of the tradition, claimed as we shall see to take as little account as possible of the figures in his landscapes; while in the work of Constable, with which the tradition closes, the figures are often so small as almost to escape our notice. In the second place, this concentration on the social life of the poor might suggest that the painters are concerned to produce an actualised image of that life, and so in a limited sense they are; but often this seems to involve little more than that their figures are to be taken as representatives of humble life in England, and not that life in Italy or in an imagined classical or theatrical Arcadia. The treatment of the figures may still seem to us ideal, as it does in much of the work of Gainsborough and in almost all that of Francis Wheatley; but the disjunction between this ideal image of the rural life and its actuality was not one that preoccupied the artists themselves, for as I have argued the point of the enterprise was to suggest that no such disjunction existed, and in that way to offer a reassurance that the poor of England were, or were capable of being, as happy as the swains of Arcadia, their life as delightfully simple and enviable.

It remains, however, the unmistakable Englishness of the figures, and the discreet hints of actuality provided by tattered clothes, heavy boots and agricultural implements, which distinguish the paintings of this tradition – by Gainsborough, Wheatley, Morland, Constable and a few others – from the surviving Italianate tradition, represented in eighteenth-century England by the art of Zuccarelli, for example, still elaborately Arcadian in its frivolous recreation of the world of Claude and Poussin. It is equally distinct from the work of such a painter as Richard Wilson, whose landscapes are entirely free of the reek of the human, the figures in them simply objects of colour insufficiently particularised to contribute anything to our sense of the meaning of his pictures, and judged appropriate to their surroundings by the criteria of art, not of experience.

The demand for both poetry and painting to offer a more English image of rural life was understood to be the same thing as the demand for a more actualised image of that life. This demand is clearly heard in discussions of pastoral poetry at the beginning of the century; it takes some time for it to be taken up by writers on painting, for a greater realism was seen to involve a willingness to break with classical and European conventions of Pastoral, as established by

Virgil for poetry and by Claude and Poussin for painting; and for various reasons, perhaps more to do with the greater variety of traditions available to the poet of rural life, than with the wider social base of his public, the poets were more able to make such a break than the painters. Thus realism is an issue in the quarrel, on the proper nature of Pastoral, between Pope, Gay, and Ambrose Philips in the early 1710s; a decade later, Jonathan Richardson notes of landscape painting that it

> is like Pastoral in Poetry; and of all the Landskip-Painters *Claude Lorrain* has the most Beautiful, and Pleasing ideas; the most rural, and of our own Times. *Titian* has a Style more Noble. So has Nicolas Poussin, and the Landskips of the Latter are usually Antique, as is seen by the Buildings, and Figures

and he goes on to suggest that 'Poussin has sometimes Err'd in the Figures he has put into his landskips'.[9] There is a hint here of a desire for a more realistic portrayal of country life, more than undercut by the belief that Claude's figures are 'of our own Times', and hardly yet articulated into a demand. It does become articulate, later in the century, in this remark, for example, by Horace Walpole:

> As our poets warm their imaginations with sunny hills, or sigh after grottoes and cooling breezes, our painters draw rocks and precipices and castellated mountains, because Virgil gasped for breath at Naples, and Salvator wandered amidst Alps and Apennines. Our ever-verdant lawns, rich vales, fields of hay-cocks, and hop-grounds, are neglected as homely and familiar objects.[10]

But by this time, the 1760s, the poets he speaks of have vanished, and the issue is one to be faced by painters only.

In the history of literature we usually relate this demand for a greater realism to the rise of a middle-class readership, in the terms established by Ian Watt in his book *The Rise of the Novel*.[11] But it is not clear how far this holds good for the readership of poetry: the subscribers to the 1730 edition of James Thomson's *Seasons* – the most influential of the georgic poems of the eighteenth century – include the queen, ten dukes, thirty-one earls and countesses, and a larger number of the lesser peerage, of the sons and daughters of the nobility, of men shortly to be ennobled, of baronets, and of miscellaneous women entitled to style themselves 'lady'; while it may not have been until the second half of the century that there was any considerable interest on the part of the middle-classes in the poetry of rural life.[12] It is still less clear how far the demand of a middle-class public may help to explain the emergence of what was thought to

be a more actualised image of rural life in the visual arts. It is certainly the case that from the middle of the century at least the buying of pictures was not confined to the very highest classes, but it is not possible to attach the demand for actuality to any particular class of buyers. There may have been no great market for the rustic scenes that Gainsborough produced in Suffolk in the 1750s, and before he had access to the richer and more prestigious customers he met in Bath and London: some of these pictures may have been given away to friends,[13] some were probably bought by members of the local gentry, two were sold to the Duke of Bedford, who may also have been the original purchaser of the two distinctively English landscapes produced by George Lambert in the 1730s, and discussed later in this book. The English pastorals of Gainsborough's Bath period were, a number of them, bought by members of the peerage, who were also eager to buy the fancy pictures of mendicant children from his final, London period. In the same way Morland was solicited by the Earl of Derby,[14] one of the richest men in the country, to sell him some pictures, but prints of his work must also have been sold to the petty-bourgeoisie of London – and as we shall see the demand of the buyers of his prints was for a more idealised image of the English peasantry than his oil-paintings offered.

It is the taste of the aristocracy here that seems to stand most in need of explanation – why, while they were still interested in buying the Arcadian images of Zuccarelli, they also showed an interest in more workaday images of English rustic life, which we might well have expected to have been more attractive to the rural professional class[15] and to the urban middle-class. The explanation may be found, perhaps, in the nature of the aristocracy itself, and the changing image it wished to project of its own role in the economic and social life of England. These subjects have been amply studied elsewhere, and the briefest of summaries will be adequate – I am thinking particularly of the increasing *rapprochement* in the early eighteenth century between the court and the city; of the increasing interest on the part of the aristocracy in the efficient management of their estates, if less often in the details of husbandry itself; of the increasing exploitation of the mineral resources on their lands; of the increasing opportunities for them to engage in manufacturing projects;[16] in short, of all the activities by which the landed aristocracy maintained its political hegemony through the eighteenth century, as the economic basis of power shifted from agriculture to industry and commerce. The practical aspects of estate management were no doubt matters of concern to the aristocracy before 1700, but they certainly became more so later; and more to the point the greater respectability attaching to an interest in economic issues in the

eighteenth century – when the greatness of Britain came to be measured as much by its wealth as by its military power – evoked in them a greater willingness to demonstrate that concern in 1750 than in 1680.

If we were to judge by the art of the period, we would come to the conclusion that in the decades after the Restoration the chief characteristic of the truly aristocratic attitude was disregard for the productivity of one's estate, and an easy unconcern for what, in the necessary extravagence of daily life, one wasted. This is evident, for example, in the relentlessly contemptuous references to provincial life in Restoration comedy, and equally so in the nearest equivalent to an art of landscape produced in England around 1700, the likenesses taken by Kip, Knyffe, and Siberechts of the houses of English Lords and Gentlemen. These pictures may be sprinkled with figures, but those near to us are all wigged and mounted, and only occasionally in the distance do we find what we often see in the topographical art later in the century, the gardeners and other labourers who dressed and worked the landscape. The land in the Roman landscape paintings which in the first half of the eighteenth century were so assiduously collected in England is a golden age landscape, and so almost never cultivated – perhaps thinly grazed by sheep or cattle – and the figures are often the shepherds of Arcadian Pastoral, who were not, as I shall suggest, identified simply as rustics. The pastorals of Claude were especially valued for the classical, and more especially for the Virgilian, associations they evoked,[17] and so valued as identifying their owners as the Augustan patricians they aspired to be.

The absence in the early eighteenth century of an indigenous pastoral painting – at the time the English seem to have wanted portraits of themselves or their estates only – means that we must look to pastoral poetry to understand the connection, if any, in the minds of the aristocracy, between the landscape of Virgilian Pastoral and the English agricultural landscape; and we discover that poetry to have been characterised by an extreme reluctance to mention the practical aspects of rural life. The eclogue by Mrs Singer, for example, 'Love and Friendship', which is preserved among Prior's works,[18] is a pastoral inasmuch as its setting is rural and its form the eclogue; but the word 'shepherd', which occurs in the ninth line, is the only reference in a poem of over fifty lines to the pastoral life. Prior's reply to Mrs Singer contains also, one brief reference to the shepherd's life, in the prayer –

Pan guard thy Flock, and *Ceres* bless thy Board
('To the Author of the Foregoing Pastoral', line 20)[19]

– a reference that has as its function not only to remind us that this is a poem about shepherds, but also to allow us to forget it – if Pan does the guarding, and Ceres the reaping, then Sylvia, or Mrs Singer, can love and sing. Of Prior's other occasional pastorals, 'The Despairing Shepherd'[20] dramatises a shepherd who has lost his crook, and leaves his flock, to 'nourish endless woe', and the point is clear, that emotions worth writing about in poetry don't occur to the sheperd who joins in the rural life, and thus identifies himself with the other shepherds, but only to those who leave that life alone; and Alexis having once abandoned his pastoral responsibilities in the first stanza, neither he nor Prior refers to them again.

In Pope's eclogues, similarly, the shepherds, so far from pre-occupying themselves with rural business, show an easy disregard of it:

Let other Swains attend the Rural Care,
('Summer', line 35)

says Alexis, preferring a life of love and music to the acquisitive drudgery of shepherding. Aegon, in Pope's 'Autumn', with still more insouciance sees no point in saving his sheep from wolves if the price of pastoral vigilance will be to have insufficient time in which to bewail the faithlessness of his wayward lover. In this world, no moral value is ascribed to industry, or to a servile vigilance, for the shepherds live in a nature which is responsive, productive, and itself servile. The chorus in Handel's *Acis and Galatea*,[21] a pastoral opera for which Gay wrote the libretto, celebrate their liberation from the life of labour in these lines:

O the Pleasure of the Plains,
Happy Nymphs and happy Swains,
Harmless, Merry, Free, and Gay,
Dance and sport the Hours away.
For us the Zephyr blows,
 For us distils the Dew,
For us unfolds the Rose,
 And Flowers display their Hue,
For us the Winters rain,
 For us the Summers shine,
Spring swells for us the Grain,
 And Autumn bleeds the Vine.
(Act I, lines 1–12)

This sort of attitude is so much a commonplace that it may seem unnecessary to label it as aristocratic, but the appropriateness of the adjective becomes clear when we discover, in John Gay's *The*

Shepherd's Week (1714), how absurd it seems when distinctively English rustics claim the right to put their love before their work;[22] or when we consider the embarrassment which informs the eclogues of the thresher-poet Stephen Duck – for Duck is aware of being an anomaly in the world of courtly literature, a 'shepherd' who is 'meanly born',[23] and he rightly understands that the eclogue is not the most humble of poetic forms, as it pretends to be, but the form which is more than any other the exclusive preserve of the truly polite. In writing formal pastorals, he is aiming above, not below his station, and his attempts to assume the 'shepherd's weeds' cannot disguise his origins, but only make them more conspicious.

The attitude to work which Arcadian shepherds display, however little it may be the whole attitude of the aristocracy to the issue, does seem to be an attitude which only an aristocracy can afford to indulge. It is an attitude, of course, which intends to remind us that pastoral poetry is often thought of as occurring in the Golden Age, before the curse of labour was visited upon mankind; but to point to the origins of the attitude in literary history is not to dispose of the social point I am trying to make, for in England only when the pastoral life came to be identified as a life led by aristocrats were the idleness and insouciance of that life brought into especial prominence. If in Elizabethan Pastoral, the ease of the shepherd's life is mentioned, it is usually in relation to the courtiers of romance, as they contemplate disguising themselves as shepherds, and who in that disguise have little expectation of being taken for the real thing; but in Elizabethan eclogue, and as part of the continuation of the tradition of *bergerie*[24] in which the humble shepherd had been seen as a model of dutiful watchfulness and sagacity, an account of the simplicity of the shepherd's life will usually involve an admiration of his punctual performance of his duties to his flock.

But a wasteful magnanimity is only one aspect of an aristocratic attitude to land and wealth. It seems to be a characteristic of aristocracies to be caught within the contradiction – or if that puts it too dramatically, to live comfortably with the contradiction – that on the one hand they must acknowledge by their display no limits to their income, but that on the other hand it is of pressing importance to them to preserve and pass on their wealth with their title from generation to generation, by a ruthlessly prudent management of their estates, by (in England) careful entailment, and by a ruthless parsimony towards all but the heir himself.[25] These two attitudes no doubt always co-exist in an unresolved tension, but at different times during the history of the English aristocracy one or other has seemed to predominate in the art which tries to reflect the aristocracy's image of itself. In 1700 the second element in this

tension, the need to preserve rather than to squander, can find no expression in poetry or the visual arts; and one aim of this study is to show how the art of rural life was adapted over the century so that it became able to express that other more prudent attitude, and could satisfy the rich and the leisured in their capacity also as the largeminded and benevolent patrons of England's agricultural, mercantile, and industrial progress. To do this, it was necessary to find a way of admitting into the Pastoral exactly those everyday concerns of work, organisation and management, that are hidden in the landscapes imported from Italy and in Virgilian eclogue.

But forms and *genres* cannot simply be invented as the need for them is felt to arise; and especially at the start of the eighteenth century, when social and literary proprieties were so inextricably interlinked, for poets to go against the authority of Virgil and to misuse the pastoral eclogue by contaminating it with the everyday image of the English countryside, was to go also against the powerful authority of Pope, the guardian of literary propriety, and of that view of English letters as the production, properly, of an élite, centred (in theory if not in fact) at court, and contributing to a supra-national, a European tradition of literature. Whatever progress could be made towards the production of a more homely poetry of rural life could be made only within the established conventions of that literature. There was, however, a *genre* at hand to minister to the need for such a poetry, and sanctioned by the example of Virgil – the Georgic, which in its peculiarly English manifestation, not so much a vision of the rural life alternative to the Pastoral, as (the point will be made clear in the essay on Gainsborough) complementary to it, became the dominant mode of poetry in the mid-eighteenth century. It was a mode that celebrated the comforts as well as the rigours of rural life, and one in which the harshness of actuality was carefully mitigated by an ornate diction. The poet Joseph Warton apologises for such vulgarity as his own translation of the *Georgics* unavoidably exhibits, which will, he fears, 'unconquerably disgust many a delicate reader'. His examples include not only such palpable barbarisms as *dung*, *ashes*, *horse*, and *cow*, but also *plough*, *sow*, and *wheat*, which have probably lost forever their power to shock.[26] It is the delicacy as well as the practicality of English Georgic that was responsible for its success, and made it well able to reflect that double image of the aristocracy, as the leisured consumers of Britain's wealth, and as the interested patrons of her agricultural and mercantile expansion.

A similarly complementary tradition was to become available to the painters of rural life. The mixed imagery of Gainsborough's Ipswich pastorals is usually discussed in terms of a combination of

the influence of French rococo painting, and of the pastorals of Watteau, on the one hand, and, on the other, of Ruysdael, of Hobbema, of Wijnants, painters of the actuality of Dutch rural life – and this combination Gainsborough may have been well-placed to effect, for there is evidence of the direct importation in the eighteenth century of Dutch landscapes into East Anglia by merchants trading with the Netherlands.[27] We should not make the mistake, though, of assuming that in managing to reconcile the atmosphere of Watteau's *fêtes galantes* with the naturalism of the Dutch, Gainsborough was unifying an aristocratic and a specifically bourgeois taste. As John Hayes has pointed out, in the 1740s in London the landscapes of Ruysdael and Hobbema commanded high prices, and 'the purchasers of these pictures were not only middle-class patrons, but connoisseurs of the highest distinction',[28] so that the taste for a more practical image of the rural life than had been offered by the French painters was as much an aristocratic as a bourgeois one. It is a taste which underlines the point that in relation to the poetry and painting of rural life, we need to assume not a conflict but a consensus between the concerns of an aristocratic and a bourgeois public; the artistic interests of the aristocracy – except in so far as they preserved through to the last quarter of the century an interest in Arcadian and rococo pastoral painting – were probably shared by all those with an interest in reading poems or buying pictures.

I shall discuss this demand for realism in the following essays, and trace out its development and transformation from the mid-century through the rest of the period covered by this book. I want now to raise a few suspicions about it. Firstly, it's worth pausing briefly over a point that we will encounter again and again in the essays, that realism, actuality, involves, reasonably enough, a need to portray the figures in landscape at work, and not idle as the shepherds of Arcadia were known to have been; so that in his ironic 'Proeme' to *The Shepherd's Week*, Gay proudly asserts:

> Thou wilt not find my shepherdesses idly piping on oaten reeds, but milking the kine, tying up the sheaves, or if the hogs are astray driving them to their styes.

This insistence on a workaday actuality becomes indistinguishable from a demand that rustics *must* be shown as industrious, so that we have no way of telling a 'straightforward' image of the poor at work from a prescriptive image of them as they should be, working. In the essay on Gainsborough we shall find enough evidence to suggest that in the middle of the eighteenth century an image of men at work was more than a neutrally 'descriptive' one, but there is no clear evidence that at this time the demand for such images was a consciously *moral*

demand. There was, indeed, little pressure on writers and artists to acknowledge the prescriptive aspect of a descriptive representation of work until, in the last decades of the century, the threat which the workers themselves might represent as an undisciplined, collective force was also recognised, as writers and artists in whom we may detect an overt or implicit radicalism appropriated the pastoral ideal, of a life of light labour, as a radical ideology, in the face of an increasing demand on the part of employers and moralists that the poor submit to labour as to a moral discipline (see below, p. 81). Thus in *The Village* (1783) Crabbe attacks Goldsmith's image, in *The Deserted Village* (1770), of the leisured poor primarily as an idealising falsification; in *The Parish Register* (1807), he attacks it mainly as a dangerously radical one.

I shall discuss this issue further in relation to the painting of rural life in my next section; in the meantime there is a second suspicion it seems worth raising here about the demand for realism, that it must sometimes be seen as an attempt not to kill off the superannuated shepherds of Pastoral, but to inoculate them with a dose of the new critical rationalism that would otherwise have wiped them out. Thus the author, perhaps Thomas Tickell, of a series of essays on pastoral poetry in *The Guardian* of 1713,[29] argues that English writers of Pastoral should introduce 'certain changes from the ancients' in the interests of probability. That 'Cornucopia of foreign fruits' which decorates so much English Pastoral, must give way to native delicacies; the hyacinths and 'Paestan' roses must be replaced by king-cups, endives and daisies; the classical gods must give place to English fays; and the superstitions, proverbial sayings, names, customs, sports, language, must all be those of the English peasantry; for poetry

> being imitation, and that imitation being the best which deceives the most easily, it follows that we must take up the customs which are the most familiar or universally known, since no man can be deceived or delighted with the imitation of what he is ignorant of.[30]

This introduction of the theory of imitation should not blind us to the fact that Tickell introduces it for rather special reasons. All poetry is fiction, and all poets attempt to suspend our disbelief by one means or another. But, since the Renaissance, their licence to do so has usually been granted on the grounds that the work they thus produce is true on another, a higher level, than that of mere factual accuracy. It is a repository of moral or imaginative truth, which we would not be able to apprehend as freely, were we not to some degree persuaded of the local and concrete truth of the

characters and incidents in a poem. Tickell's position is rather different: Pastoral for him is entirely unreal, untrue, as he cheerfully admits on every possible occasion – and the function of the concrete is to persuade us to believe more willingly in a poetry which is a fiction at every level. And it follows that the problem of actuality must pose itself more sharply for him, in that he sees a degree of realism to be more necessary with Pastoral than with other poetry, for a poetry with no higher truth in view will be more dependent on the air of truth in its local colour to deceive us. But at the same time, the Pastoral, having no other function than to deceive us into believing in an entirely imaginary world, cannot tolerate an actuality considerable enough to drag the illusion into the light of day. The small misfortunes that Tickell recommends the shepherd of Pastoral should suffer, if his life is not to be a flat continuum of incredible peace – a thorn in the foot, a stolen lamb[31] – are the ballast which allows the pastoral balloon to manoeuvre; any more weighty problems and it would never get off the ground.

The point is that we can read the history of the poetry and painting of rural life just as well as a process of continually substituting one version of Pastoral for another, as if we read it in terms of the classical Pastoral of Virgil and Claude being slowly replaced by an image of greater actuality, and it seems to make surprisingly little difference, as we study the work of specific poets and painters, which account we prefer. The convenience and the limitation of Arcadian Pastoral was that it enabled the ideal life to be described in terms so remote from the details of contemporary actuality as to make it appear that the ideal had changed hardly at all since Virgil: it was a harmonious life in nature, its stability guaranteed by its longevity. But it has become clear that around 1710 this ideal of stability was being used, however obliquely, to describe an ideal of aristocratic life, and that as such it was being felt to be threatened by an intrusive awareness of the world beyond the circles of the court; exactly as the primacy of 'natural' property in land was being challenged by the more mobile power of money, the hierarchical coherence of 'paternalist' society by what is perceived as a 'new' economic individualism. The disappearance of Arcadian Pastoral, and the emergence of a more actualised poetry and painting of rural life, makes it clear that an account of the ideal life which entirely ignored this awareness could no longer be plausible, and to cease to ignore it meant, inevitably, to admit some degree of concern for work, for the industriousness which was from now on to be regarded as chief among the virtues. From the point of view of this study it is this concern that is, after the first decades of the eighteenth century, the crucial characteristic of the poetry and painting of rural life, and not whether individual

poets or painters welcomed or regretted its intrusion; for in either
case, as we have seen, it inevitably involved exchanging the shepherds
of Arcadia for the ploughmen of England, and their appearance in
the art of rural life was bound to raise issues about their relation to
the classes for whom that art was produced, and so to help engender
that new awareness of the poor I referred to in my first section. It
committed the poets and painters to a continual struggle, at once to
reveal more and more of the actuality of the life of the poor, and to
find more effective ways of concealing that actuality – to present, in
the words of the epigraph to this introduction, only 'half an image'
of rural life. It is in this contradiction above all that the tradition
I have been trying to define will be seen to operate.

As the rustic figures become less and less the shepherds of French
or Italian Pastoral, they become more and more ragged, but remain
inexplicably cheerful. The effort is always to claim that the rural
poor are as contented, the rural society as harmonious, as it is possible
to claim them to be, in the face of an increasing awareness that all
was not as well as it must have been in Arcadia. The jolly imagery
of Merry England, which replaced the frankly artificial imagery of
classical Pastoral, was in turn replaced when it had to be by the image
of a cheerful, sober, domestic peasantry, more industrious than
before; this gave way in turn to a picturesque image of the poor,
whereby their raggedness became of aesthetic interest, and they
became the objects of our pity; and when that image would serve
no longer, it was in turn replaced by a romantic image of harmony
with nature whereby the labourers were merged as far as possible
with their surroundings, too far away from us for the questions about
how contented or how ragged they were to arise. The detail of these
changes, and the reasons why they occur, may be left to the essays
that follow; but they were not of course as clear-cut and as neatly
consecutive as all this suggests, which is why I have preferred to
present this book as three linked but separate essays, and not as a
continuous narrative.

IV

It will probably be objected, and not without justification, that in
concentrating as much as I do on the figures in the landscapes I
discuss, I am attributing to them an importance, and a power to
influence the meaning of those landscapes, far greater than the
painters themselves would have acknowledged as reasonable. The
remark by Gainsborough which opens my first essay certainly lends
authority to the objection: he conceived, he says, of his figures
simply as 'a little business for the Eye to be drawn from the Trees
in order to return to them with more glee'; they simply 'fill a place'.

Uvedale Price, in his *Essays on the Picturesque,* tells an anecdote of Richard Wilson that makes a similar point:

> Sir Joshua Reynolds told me, that when he and Wilson the landscape painter were looking at the view from Richmond Terrace, Wilson was pointing out some particular part; and in order to direct his eye to it, 'There,' said he, 'near those houses – there! where the *figures* are.' – Though a painter, said Sir Joshua, I was puzzled: I thought he meant statues, and was looking upon the tops of the houses; for I did not at first conceive that the men and women we plainly saw walking about, were by him thought of as figures in the landscape.[32]

For all Reynolds's surprise, we should not perhaps see that either as attributing any importance to the sort of figures I shall be discussing: the 'men and women' walking about were probably ladies and gentlemen, with many of whom he would have been acquainted; and they could reasonably expect to be the main subjects of the paintings that Reynolds produced, and not merely stop-gaps in the landscape compositions he hardly ever attempted.

Perhaps the first thing to make clear is that in the eighteenth and well into the nineteenth centuries, it was an almost invariable feature of landscapes in oils that they were peopled landscapes, and so to a greater or lesser extent subject pictures. The landscapes of Claude and Poussin were for a long time regarded by collectors and painters alike as historical or mythological subjects, and this had no doubt much to do with the persistence of figures in English landscapes, even of painters such as Wilson with evidently little interest in painting people. The crucial point concerns the price of pictures: according to Joseph Farington, Wilson could get forty guineas for a full-length landscape without figures, but twice that amount for a peopled landscape of similar size.[33] His customers, clearly, looked *at* the subjects in eighteenth-century landscapes, as it has now become the custom to look *through* them.

I am not about to argue, then, that eighteenth-century landscape paintings are merely the settings in which labourers or gypsies are the main subjects; but I do hope to show that the figures have a crucial importance in determining the subject, and so the 'meaning' of such landscapes, and the value they had for those who looked at them. There were a number of unwritten but binding rules which governed the terms on which the poor could appear in landscapes at all, which for the most part were recognised only when they were broken. If these rules were not consciously obeyed by the painters, that is because, although they existed to protect the sensibilities of the polite, for a long time they operated in the paintings as

aesthetic, not social constraints: what sort of figures of the poor look right in a landscape, and where do they look right, in relation to the organisation of the picture as a unity? In their responses to these questions, George Lambert, for example, and Gainsborough, and Constable, all reveal attitudes not to the poor alone but to the society as a whole, which may be their own, or their customers', or both; and in this way their paintings come to express what they or their customers wish to believe was true about the rural poor and their relations with nature and with the rest of society. It is not often intended or explicit meanings that I shall be pointing to in the essays that follow, but meanings that emerge as we study what can *not* be represented in the landscape art of the period; and though I have often used the language of intention in my essays – 'Gainsborough is attempting to show', and so forth – this must be taken as a metaphor only, used to call attention to what the polite wished to believe about the society of the countryside and the condition of the poor, whether that wish was conscious or not. And sometimes – in the case of Constable especially – the language of intention can be used to distinguish between what Constable wished to portray in the image of the labourer, and what his paintings cannot help admitting about the actuality of their condition, by the very means he must use to express his wishes.

We can get an idea of the terms on which an image of the poor would 'look right' in landscape from this comment by James Barry, made in a lecture delivered probably in the 1780s:

> There is no department of art which might not become interesting in the hands of a man of sensibility. Who does not feel this in the landscapes of N. Poussin, sometimes verging to sublimity, and always engaging from their characteristic unity, graceful simplicity, or ethical associations. Allowing for a little unnecessary rags and vulgarity; who is not also delighted with the serenity and innocent simplicity of many of the scenes of Berghem, Both, Claude, Swanefeld, and Wilson? the simple, laborious, honest, hinds; the lowing herds, smooth lakes, and cool extended shades; the snug, warm cot, sufficient and independent; the distant hamlet; and the free, unconfined association between all the parts of nature, must ever afford a grateful prospect to the mind[34]

Before I discuss this, I should point out that the lecture was delivered at the Royal Academy, an institution which had no high regard for landscape-painting in general, and still less for the tradition of anglicised landscape that we are examining, as its awkward relations with Gainsborough, and especially with Constable, will

Uvedale Price, in his *Essays on the Picturesque*, tells an anecdote of Richard Wilson that makes a similar point:

> Sir Joshua Reynolds told me, that when he and Wilson the landscape painter were looking at the view from Richmond Terrace, Wilson was pointing out some particular part; and in order to direct his eye to it, 'There,' said he, 'near those houses – there! where the *figures* are.' – Though a painter, said Sir Joshua, I was puzzled: I thought he meant statues, and was looking upon the tops of the houses; for I did not at first conceive that the men and women we plainly saw walking about, were by him thought of as figures in the landscape.[32]

For all Reynolds's surprise, we should not perhaps see that either as attributing any importance to the sort of figures I shall be discussing: the 'men and women' walking about were probably ladies and gentlemen, with many of whom he would have been acquainted; and they could reasonably expect to be the main subjects of the paintings that Reynolds produced, and not merely stop-gaps in the landscape compositions he hardly ever attempted.

Perhaps the first thing to make clear is that in the eighteenth and well into the nineteenth centuries, it was an almost invariable feature of landscapes in oils that they were peopled landscapes, and so to a greater or lesser extent subject pictures. The landscapes of Claude and Poussin were for a long time regarded by collectors and painters alike as historical or mythological subjects, and this had no doubt much to do with the persistence of figures in English landscapes, even of painters such as Wilson with evidently little interest in painting people. The crucial point concerns the price of pictures: according to Joseph Farington, Wilson could get forty guineas for a full-length landscape without figures, but twice that amount for a peopled landscape of similar size.[33] His customers, clearly, looked *at* the subjects in eighteenth-century landscapes, as it has now become the custom to look *through* them.

I am not about to argue, then, that eighteenth-century landscape paintings are merely the settings in which labourers or gypsies are the main subjects; but I do hope to show that the figures have a crucial importance in determining the subject, and so the 'meaning' of such landscapes, and the value they had for those who looked at them. There were a number of unwritten but binding rules which governed the terms on which the poor could appear in landscapes at all, which for the most part were recognised only when they were broken. If these rules were not consciously obeyed by the painters, that is because, although they existed to protect the sensibilities of the polite, for a long time they operated in the paintings as

aesthetic, not social constraints: what sort of figures of the poor look right in a landscape, and where do they look right, in relation to the organisation of the picture as a unity? In their responses to these questions, George Lambert, for example, and Gainsborough, and Constable, all reveal attitudes not to the poor alone but to the society as a whole, which may be their own, or their customers', or both; and in this way their paintings come to express what they or their customers wish to believe was true about the rural poor and their relations with nature and with the rest of society. It is not often intended or explicit meanings that I shall be pointing to in the essays that follow, but meanings that emerge as we study what can *not* be represented in the landscape art of the period; and though I have often used the language of intention in my essays – 'Gainsborough is attempting to show', and so forth – this must be taken as a metaphor only, used to call attention to what the polite wished to believe about the society of the countryside and the condition of the poor, whether that wish was conscious or not. And sometimes – in the case of Constable especially – the language of intention can be used to distinguish between what Constable wished to portray in the image of the labourer, and what his paintings cannot help admitting about the actuality of their condition, by the very means he must use to express his wishes.

We can get an idea of the terms on which an image of the poor would 'look right' in landscape from this comment by James Barry, made in a lecture delivered probably in the 1780s:

> There is no department of art which might not become
> interesting in the hands of a man of sensibility. Who does not
> feel this in the landscapes of N. Poussin, sometimes verging to
> sublimity, and always engaging from their characteristic unity,
> graceful simplicity, or ethical associations. Allowing for a little
> unnecessary rags and vulgarity; who is not also delighted with
> the serenity and innocent simplicity of many of the scenes of
> Berghem, Both, Claude, Swanefeld, and Wilson? the simple,
> laborious, honest, hinds; the lowing herds, smooth lakes, and
> cool extended shades; the snug, warm cot, sufficient and
> independent; the distant hamlet; and the free, unconfined
> association between all the parts of nature, must ever afford a
> grateful prospect to the mind[34]

Before I discuss this, I should point out that the lecture was delivered at the Royal Academy, an institution which had no high regard for landscape-painting in general, and still less for the tradition of anglicised landscape that we are examining, as its awkward relations with Gainsborough, and especially with Constable, will

testify. Barry is concerned here with the higher styles of landscape, whether produced by Claude and Poussin, or, more recently, by Richard Wilson, and which I shall glance at in some later remarks on George Lambert; and the fact that his views can be used to illustrate practices in a tradition which (as we shall see in the next essay) he regarded as irredeemably vulgar, tells us much about why the higher style of landscape was moribund by the time this lecture was delivered. For Barry has clearly been obliged, whether he knows it or not, in some degree to accommodate his idea of landscape painting to the demand for a more actualised image of rural life. Thus it is entirely appropriate to the higher style to question whether the rustic figures it represents should appear in rags; but it had by no means been a characteristic of that style that they should appear 'laborious', though that they were 'simple' and 'honest' was given by their pastoral context.

For a landscape to be 'interesting', then, in the hands of a 'man of sensibility', the 'hinds' – the word calls attention to the degree of pastoral artifice which will be necessary if the image is not to offend us – must be 'simple, laborious, honest', their cottages 'sufficient and independent' – which is to say that the cottages must not attract attention to the distresses of the actual poor. But the point is not exactly that the picture must tell a moral story, though the right 'ethical associations' may add to its charm. It is rather that Barry's demand that the 'hinds' be properly laborious and honest occurs unselfconsciously in a list of other demands that are not felt to be moral at all – for 'unity' of composition, and so for a 'free, unconfined association between all the parts of nature'; for 'grace'; for 'serenity'; for, in short, a pastoral mood which would be threatened if the hinds chose to be idle, not industrious, but which is itself a mood of calm, peace, repose. The painter of sensibility, in selecting the images that will conjure up this mood, must no more choose to portray the hinds as idle, than to show the surface of the lake whipped up by a violent storm; but as long as he does not make the wrong choice, he will probably be no more conscious of choosing to show them at work, than he would of choosing to show the lake as smooth and placid – his 'sensibility' will choose for him; so that even Wilson, for whom figures are just figures, is approved by Barry for having done the right thing, when the moral issue probably did not occur to him at all – and when it certainly makes no great impression on us.

The situation is different, of course, in some *genre* pieces of the 1780s and 1790s: titles such as Wheatley's *Industrious Cottager* – and there is a painting by Morland of the same name – are not those of pictures which hide their moral light under a bushel.[35] It seems legitimate to me, however, to see the tradition I am defining in terms of

landscape and *genre* painting alike, for the crucial figure in the tradition is Gainsborough, of whom Morland and Constable are continually aware. Of most of the paintings by Gainsborough that are relevant to this study, we cannot say with confidence that they are landscape or *genre* pieces, so that his influence may be discovered equally in painters concerned to offer an image of the poor with a wealth of moral and anecdotal detail, and in others for whom the figures in the landscape may well have been put there to 'stop a gap', and to whom the restraints governing how and where they appear are less evident.

Even in subject-painting, however, we cannot be sure, even at the end of the century, when as we shall see 'industry' was the chief virtue a poor man could display, that the demand that the poor be shown as industrious was recognised *as* a demand, except when it was overtly acknowledged by the title of a picture, or when it was not fulfilled. The point can be made most conveniently by considering the reasons for what was a remarkable increase in rural subject-painting in the 1790s. In the nine years from 1792 to 1800, pictures depicting a wide variety of rural crafts and occupations were exhibited at the Royal Academy. In addition to the tasks which had long been common in landscape-art – ploughing, haymaking, reaping, shepherding, and so on – there were pictures of sheep-shearing, feeding pigs, lime-burning, harrowing, threshing, and sowing; of carting sand, dung, and timber; of wheelwrights, hoppers, and 'wheat-setters'; of a furze-cutter and a chaff-cutter. This interest in the detail and diversity of rural occupations suggests that in this period at least there was among subject-painters a disinterested concern with how the poor lived: painting, almost, as reportage.

But this interest was not as unambiguous as it might seem. To begin with, it is a fact that in 1792 the number of rural *genre*-pictures exhibited at the Academy suddenly went up sharply, to about three times the average for the previous five years. The two likeliest explanations for this are, firstly, the death of Sir Joshua Reynolds, a President less friendly to the 'familiar' style of painting we are considering than was his successor Benjamin West, who occasionally dabbled in it; and, secondly, the visible threat of war with France – the increase may be a phenomenon similar to the suddenly enormous output, in the Second World War, of books about English rural and traditional life, printed on economy paper. This latter may be the more important reason: for the average number of rural subjects exhibited at the Academy remained fairly high right through the French Wars, dipping only once – and perhaps significantly – during the cessation of hostilities in the first years of the new century; and it continued high until 1818, by which time post-war euphoria

had given way to post-war depression, but when West's presidency
still had two or three years to run. That rural subjects were seen in
a strongly nationalistic light at this time is confirmed, for example,
by some sales-promotion literature about George Morland, which
dates probably from 1793: 'His sailors are British, and have braved
many a storm...His fishermen, post-boys, and ostlers are...*English
– English Sirs, from top to toe!'*[36] It is clear that if the chaff-cutters and
furze-cutters in the Academy catalogues were painted to provide this
sort of reassurance, then the interest of painter and public in the
manner in which they performed their tasks cannot have been as
disinterested as we might have imagined, though there is little
evidence in the titles at least of these pictures (which is in many cases
all that seems to be left of them) that there was any need to be always
pointing to their moral function, and thus to acknowledge it overtly.
We do not find *The Industrious Furze-Cutter* or *The Honest Chaff-Cutter*
in the Academy Catalogues, but simply *Furze-Cutter* (1797) and
Chaff-Cutter (1796). But that such images were more than what I have
called 'neutrally descriptive' is certainly suggested by the anxiety
created in Morland's critics by some of his images from the 1790s of
men *not* working – an anxiety which is caused not by the fact that
these images are unrealistic, but by the fact that they are unpatriotic,
and unsafe.[37]

That labourers in agriculture be presented as honest and laborious
is a constraint which operates in our tradition throughout the period
I shall be discussing, in landscape and *genre* painting, though it comes
to be more urgent in the 1770s. It does not of course always mean
that they must never be shown at rest, though it comes to mean
something very near that, but it does prescribe the terms on which
they may relax – in the evening, after a hard day's work; after the
harvest, on their way to the ritual feast; during the harvest, at
meal-breaks, but never far from the hooks and scythes which indicate
that they are resting only for a moment; never in the alehouse, if they
are not to attract the disapprobation that Morland's labourers
attracted, who change from 'hinds' to 'boors' as soon as they reach
for a drink.[38] The social constraints which influence *how* the poor are
represented at work do change, however: in the mid-eighteenth
century they work blithely, for work is then a pleasantly social
activity; at the end of the century, cheerfully, to reassure us that they
do not resent their condition, or blame us for it; in the work of
Constable, automatically, and in the distance, for the resentments of
the poor are now known to us all, and those resentments could not
be concealed in any credible image of the poor except by hiding the
poor in the middle ground, where we can see their labour but not
their expressions. Gainsborough, on the other hand, can place his

figures more in the foreground, because the pastoral conventions still available to him, but not to Constable, mitigate the harshness of actuality; when Morland places them there in the 1790s, they can seem uncomfortably close.

There are constraints too on what sort of image of the poor may be portrayed in the full light of day, and what in darkness. A basic rule of landscape composition in the eighteenth century – exemplified well enough by George Lambert's *Woody Landscape* of 1757[39] – is that the rich and their habitations must be illuminated, and the poor and theirs be left in the shadows of the 'dark side of the landscape';[40] or, as Crabbe puts it, when satirising the complaints of the radical poor, the 'proud mansion...keeps the sunshine from the cottage-gate'.[41] This division has the advantage of marking the differences in status and fortune between rich and poor, while showing that the unity of the landscape and of the society it can be seen to represent is dependent on the existence of both, which combine in a harmonious whole. As the landscape could not be structured without the natural contrasts of light and shade, so the society could not survive without social and economic distinctions which are thus also apparently natural. But in landscapes such as those by Lambert himself which are discussed in the first essay, the rule may be bent if not wholly broken, and the peopled landscape

George Lambert, *Woody Landscape with a Woman and Child Crossing a Bridge*, 1757

can be made to embody a social ideal more comforting for the poor, and so more reassuring for the rich, by allowing the 'good' poor at least – 'simple, laborious, honest' – a place in the sun.

We cannot understand the constraints that I have been describing from the pictures alone; if we are to be able to distinguish between what we find in them now, and what might have been found in them when they were produced, we must look at them also in the light of contemporary literary sources. There are dangers in doing this, but far more in not doing it, as nothing shows more clearly than the current evaluation of Morland's work, put into circulation by critics who have not, apparently, come across the judgements of his contemporaries, with their confused pattern of enthusiasm and disgust. Morland's biographers will help us with his work, and Constable's correspondence with his, but there is much less contemporary writing by or about Gainsborough. To try and grasp the significance of his imagery, I have read it in the light of the tradition of eighteenth-century poetry, and I have also made what I hope are helpful comparisons between the paintings of Constable and the poetry of Gray, Wordsworth, and Clare. There are, as I have said, dangers in thus invoking the aid of poetry to help us translate images into the more explicit medium of language, one of which I have referred to already – that in the middle eighteenth century, painting lags behind poetry in its ability to adopt an apparently 'realistic' imagery of rural life – and it is up to the reader to judge how far my approach is successful. But there is one clear advantage in turning to the works of poets and of critics of poetry rather than to those of writers on the problem of the poor, or on political economy: that the poets, like the painters, were involved in the continued effort to adapt a conventional pastoral imagery to make it reflect more of what they wished to believe was the actuality of rural life. I have not treated the content of the poetry as given – I do not find, for example, Gay and Thomson as empty, Goldsmith as sentimental, or Crabbe as humane, as do most of my fellow literary critics, and I shall be disappointed if my readings of the poetry are not found to be as tendentious as those of the painting.

V

In the three essays I discuss in passing works by Lambert, Wheatley, Rowlandson, Wilkie, G. R. Lewis, and Turner, but make little or no mention of a number of artists who can certainly be seen in terms of the tradition, or as occasionally touching on it – Wootton, for example, or Hogarth, or Ibbetson, or Bigg, or Ward, or De Wint, or Mulready; and my hope is that what I say about the painters I do discuss in detail will illuminate the works of those I do not. Thus

it seems to me that Francis Wheatley, by reputation one of the most considerable artists, apart from those that I have studied, to produce a large number of paintings of rural life, contributed little to the tradition that is not already implicit in the work of Morland or late Gainsborough, except insofar as his images are rather more sentimental than Morland's, or than any of Gainsborough's apart from the pictures of rustic children. An apparent exception are the watercolours he began to produce in the 1780s of Irish low life,[42] which are quite unrepresentative of the rest of his work, and apart from the insistent prettiness of the décolleté colleens, are remarkably exact recreations of the unsentimental spirit of seventeenth-century Dutch realism. It is indeed precisely this aspect of their success which seems to remove them from the tradition I have been examining; for they remain superb pastiches of Wouvermans, insistently directing our attention to the success of their manner, and away from their matter; and the fact that Wheatley seems to have been unable to assimilate that manner to his sentimental *genre*-pieces of the English peasantry, or was unwilling to do so, only emphasises the gap

Francis Wheatley,
Palmerston Fair, 1782

between these Irish watercolours and the paintings of rural life that I am concerned with.

A more awkward case is that of George Stubbs, whose superb and puzzling series of farming scenes, painted between 1783 and 1795, are similarly at a remove from the tradition I have defined, except in so far as they may help us to define that tradition more closely, by an implied criticism of it. There are six of these scenes: the *Reapers* and *Haymakers* of 1783; two more of the same subjects, dated 1784 and 1785; and two in enamel on Wedgewood stoneware of 1794 and 1795.[43] There is a great similarity among all six: in all of them the groups are arranged more or less in a frieze; the figures have a dignity of posture and expression that we do not find even in Gainsborough's last paintings, and they are strikingly tidy: the men wear what could possibly be the clothes of labourers, but without a trace of dirt or patches; and women seem dressed well above their station. The groups stretch across the foreground of landscapes which are beautiful and deceptively simple, rarely of more than three planes, and set off by a *coulisse* of stately trees to left or right, placed, as it characteristically is in Stubbs's paintings, behind the main figures. But for all their simplicity they seem to me the most refined and artificial images of the rural labourer that the century produced; and in the light of

George Stubbs,
Haymakers, 1785

my discussion of the painting of rural life as involving a continual search for a more and more apparently realistic image, they clearly demand discussion at some length.

For these pictures, so universally admired, have never been adequately discussed, and their clear, harmonious surface seems quite impenetrable. A brief paragraph by Ronald Paulson in *Emblem and Expression* is illuminating in relation to the general argument of his chapter on Stubbs, but less so in relation to the paintings themselves.[44] When in 1977 an appeal was launched to buy the paintings of 1784 and 1785 for the Tate, the gallery issued a press-release, to me as puzzling as the pictures themselves. 'Stubbs', it said, regards his labourers 'seriously, even tenderly, but seeks neither to romanticise them nor to ennoble them'. It went on

> Deceptively commonplace ingredients – men and women at work, swathes of hay and sheaves of corn, billhooks and scythes – are lifted high above the level of matters of fact by Stubbs's miraculously assured sense of design.

The pictures, finally, 'treat the everyday activities of the ordinary working man with a dispassionate objectivity that is unique in English Art'.[45] It seems they do everything at once: the men and women are not ennobled, but still somehow elevated, yet in this process of elevation they are still seen with 'a dispassionate object-

George Stubbs,
Reapers, 1784

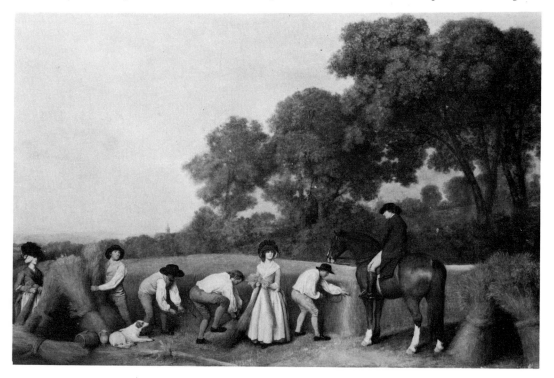

ivity'. Denys Sutton, in an article published in *The Financial Times*[46] during the same campaign, appears at first sight to agree with the 'Tate Gallery authorities', or with one of their opinions at least, and argues that the paintings, 'far from being...masterpieces of realism, are pictures of fancy – the equivalent of the pastoralism of Marie Antoinette'; but then goes on to assert that 'the figures...look as they do in life'; but then again, 'here is captured the idyllic life dreamt about by the city dweller'.

It was right that the pictures should have stayed in England, if only to give us the opportunity to sort out our confusions – confusions here only too clearly caused by the collision of what we see and what we wish to believe. It surely must be apparent – if it is not, the evidence of Morland may make it so – that these reapers and haymakers do not look at all as they did in 'life', that they are indeed 'lifted high above the level of matters of fact'; and if the Tate Gallery and Denys Sutton feel bound to assert that the pictures are realistic in almost the same breath as they deny it, it may be because the price of simply denying it is one they are not willing to pay or even to contemplate. For at the back of this confusion is there not a nostalgia for the eighteenth century as a period of imagined social and artistic stability? – a nostalgia which finds its loudest expression in the long lament for the passing of the English country house, and which could be more easily justified if only we could be sure that the poor who paid for the construction and maintenance of those houses were as well-rewarded as Stubbs's image of them suggests. For if they were, they can be forgotten, along with all the social issues they would otherwise raise and which so many art historians find tendentious, boring, or reductive.

The best piece of art journalism which appeared during the campaign to 'save the Stubbs' was by Richard Cork in *The Guardian*,[47] but it achieved the coherence so lacking in the Tate Gallery's and in Sutton's pieces at the price of boldly denying that the pictures were idealised in any way at all; that denial is to me incomprehensible, but on its own terms the article makes sense. Cork's argument is, briefly, that Stubbs's paintings are 'radical', in that they acknowledge an 'individuality' in the labourers which looks 'forward to a time when art would be about the many rather than the few'. 'There is nothing very fancy', he writes, about Stubbs's interpretation of his theme:

> The most remarkable feature of both the *Haymakers* and the *Reapers* is their willingness to deal seriously, carefully, and clearly with people so bucolic that their mundane character had to be dressed up by all other artists who depicted them in eighteenth-century England.

It is an odd implication that 'all other' painters of rural life obliged their subjects to exchange their impeccably neat costumes which, by this account, they habitually wore, for the ill-fitting and ragged garments, hand-torn no doubt in the studio, by which they solicit our pity in the paintings of Morland and even the late Gainsborough. Like the late Basil Taylor,[48] Cork is struck by the individuality of the portraits of the labourers:

> In *Haymakers*...even the two women on the left...are distinct in themselves, their differences as sharply observed as their similarities...The third woman...is not so much resting from her labours as challenging her eighteenth-century audience to brush away their prejudices and acknowledge her individuality.

William Blake, 'Oft did the harvest to their sickle yield'

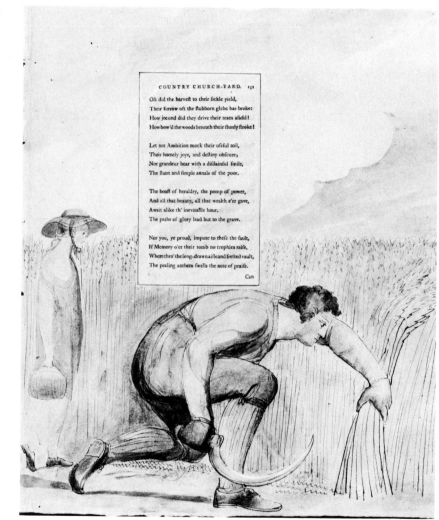

This sort of argument is meat and drink to a leftist like me, and I would willingly ignore the evidence of my eyes and endorse it, but can't. It is not that Stubbs's labourers seem to me so much ennobled, dignified, or whatever – they seem anaesthetised, working in their sleep. Their academy-poses are so studied, their actions so deliberate, that they seem frozen – there is not a trace of the vigour we find in Gainsborough, or in the swirling spiral made by the body and the sickle of the reaper in Blake's water-colour illustration to Gray's 'Elegy',[49] or in the grotesquely exaggerated arms and torso, the expression of effort and perhaps of resentment, of Rowlandson's *Hedger and Ditcher*,[50] whose work is being inspected, as is that of

Thomas Rowlandson, *The Hedger and Ditcher*

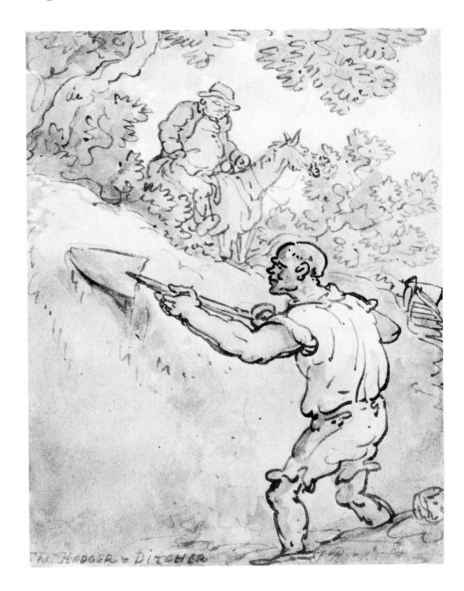

Stubbs's reapers, by a mounted overseer. Though there is a reasonable variety in the features of Stubbs's men, at least, I find in them a serenity, certainly, but no more animation than I do in a still-life – I intend no adverse criticism. Taylor argues that the paintings do not imply 'emotional encounters', but in one of them at least, the *Reapers* of 1784, we may suspect an intention to suggest some sort of emotional relationship between the mounted figure and one or both of the women, which is causing some anxiety in the man furthest to the left. Or the tension may be social rather than romantic: there is an anonymous ballad-opera of 1770, *The Reapers*,[51] in which some discontented harvesters complain of unfair treatment to their master, who soothes their worries so persuasively that they break into a jolly harvest song. Stubbs's image may possibly be reminiscent of this, or of similar confrontations in meadows and cornfields in the poetry of Duck and Chatterton.[52] But any sense of conflict seems virtually negated by the way in which Stubbs seems to keep the past and future entirely suspended; and we feel as Keats did of his Grecian Urn, that the lovers will never meet, and that the labourer's resentment, whatever its cause, will never find expression or mitigation.

If there is no conflict, there is no unity either. The most likely literary source for these pictures, if there is one, is the pair of haymaking and reaping scenes in Thomson's 'Summer' and 'Autumn',[53] so well known in the eighteenth century that it is more than likely that Stubbs knew them too. In 'Autumn', the rural community is unified by its delight in the harvest – the thought of future riches swells the master's heart with joy, while the reapers lose all sense of the arduousness of their task in their enjoyment of its pleasantly social nature; yet Stubbs's harvest scene seems as far removed from delight as it is from any less manageable emotion. The aesthetic unity of the picture could hardly have been established more geometrically than it is; but the frozen quality of the figures – the coldness, the 'want', in Hazlitt's phrase, 'of flexibility, and transient expression '[54] – seems to prevent us from translating this into an image of social unity or of social control. The authority of the master is certainly confirmed by the diagonal formed by the high cliff of elms, but there is nothing active in that authority – it seems to be in a purely formal relation to its objects.

The demand for a greater credibility in the image of rural life, however spurious, however easily satisfied by substituting one version of Pastoral for another, is a demand entirely ignored by these paintings. And it is hard to see how Stubbs could have satisfied it: in his paintings of humans, if not of horses, he seems to aspire always to the formal, the monumental – for an image of life as contained and shaped by form, and not appearing to create that form itself. The

dynamic lines of Gainsborough's first *Harvest Wagon* (discussed on pp. 59f. below), the sentimentality of his images of rural children, the picturesque raggedness of Morland's rustics, must have been all equally uncongenial to him. To relate these pictures to other images of rural life, we must look back, as Stubbs surely does, to the landscapes of Poussin – to his *Summer*, especially, in the Louvre[55] – for like Poussin's these are images of activities that are timeless, and can be represented as frozen, as immobile, because their essential nature never changes. For that reason Stubbs has no interest in the transient and contingent details of rural life that can be invoked to make a version of Pastoral more credible; and without that particularity of detail, which might detach these solemn labourers from their universal tasks and identities, it seems they must become automata, somnambulists. In the context of our tradition, they must seem absolutely artificial and unnatural, quite impossible to believe in as labourers; for though in the contemporary theory of portrait-painting, as announced in particular by Reynolds,[56] a proper fidelity to general nature could be achieved only by abstraction from particulars, in our tradition a fidelity to nature could be recognised only in terms of a faithful selection of the details of contemporary rural life. In their determination to exclude them, and to lift the labourers 'high above the level of matters of fact', Stubbs's farming pictures exclude themselves from the tradition we are examining.

VI

It remains for me to indicate – the individual essays will make the point more clearly – why it is that I regard Gainsborough, Morland and Constable as the painters from whom we can learn most about the demand for a more actualised image of rural life than could be offered by the tradition of Virgilian Pastoral. The career of Gainsborough is remarkable in that it spans a period from the middle to the end of the eighteenth century in which the attitudes of the rich to the rural poor, not no doubt as they were expressed in the relations of real life, but as they could find expression in poetry and painting, changed utterly; rural labourers cease to be 'happy husbandmen', and become 'the labouring poor'; and in the changing imagery of Gainsborough we can trace out this transformation as we can in the work of no other painter or poet. I concentrate on the art of Morland because in his imagery and in the reactions to it of his contemporary critics we can understand more clearly than from any other source what could not be represented in the image of the poor; for the best work of Morland should, I argue, be seen as an attempt to discover the limits of what his public could tolerate in the painting of rural life. My interest in Constable is not so much in the fact that he is

almost exclusively a landscape painter, as in *why* he is – why a painter apparently so anxious to paint a landscape rich in human associations should have placed his figures so often in the middle ground, until they become almost invisible in the landscapes they have made; and until, in his later work, they cease to have any of the power to determine the 'meaning' of the landscape that they had in the eighteenth century, or in his own earlier work.

What is true of Constable's later painting is true also of much of the landscape-painting of the mid-nineteenth century, though for different reasons, and probably because, by then, the labourer in agriculture is no longer, and is no longer regarded as, the prototypical English worker. The concern of the rich has shifted to the worker in industry; and it is he who seems to carry the burden of England's economic progress, and he who seems capable of threatening it by indiscipline, idleness, or revolt. And though, for reasons which need not detain us here, the value of the rural community as it had traditionally been defined, and as it had been reaffirmed in the poetry of Wordsworth, is strengthened and emphasised in the Victorian novel as a better alternative to the anonymity of industrial civilization, in poetry and painting the countryside comes to take on the simply negative virtue of not being the city. It is no longer a place of tension, as we will find it to be in the work of Gainsborough, Morland, and Constable, but one defined as empty of tension; a place of refreshment and recreation, where we may recover the sense of our potential as

John Linnell,
*Wood-cutting in
Windsor Forest*

sensitive individuals which is lost in the urban life of affairs – a sentence full of *clichés*, but so is the sense it describes. The inhabitants of the countryside can now be presented as unproblematically at one with their surroundings, as the painters we shall study, for all their efforts, could not show them to be.

As an early indication of this, we may take a painting by John Linnell, *Wood-cutting in Windsor Forest* (1834–5).[57] The woodcutters, neither large enough to become a *genre*-subject, nor relegated to the distance, are happily at rest among the trees; there is no pressure on us to wonder if they have earned their leisure, for in thus relaxing they seem to be doing just what it is appropriate even for labourers to do in such a scene. It is a change we can neither applaud nor regret; for though it may suggest a less demanding and a less oppressive attitude to the labourer in agriculture, it may be taken also as a symbol of the complete omission of the interests of the rural labourer – even of agriculture itself – from the economic considerations of successive nineteenth-century governments. Once again, one version of Pastoral has simply replaced another, and the rural poor were no worse off when at the end of the eighteenth century they were continually obliged to express their gratitude and obedience, than when in the middle of the nineteenth their chief virtue was to be seen but not heard.[58]

I Thomas Gainsborough

Do you consider my dear maggotty Sir, what a deal of work history Pic-
tures require to what little dirty subjects of coal horses & jackasses and
such figures as I full up with...But to be serious (as I know you love to
be) do you really think that a regular Composition in the landskip way
should ever by filled with History, or any figures but such as fill a place
(I won't say stop a Gap) or to create a little business for the Eye to be
drawn from the Trees in order to return to them with more glee...
(Thomas Gainsborough to William Jackson, 23 August 176?)[1]

I

In 1755 Thomas Gainsborough delivered to the Duke of Bedford two
landscape paintings which still hang at Woburn. In the smaller of
these, *Peasant with Two Horses*, a boy slouches lazily on a white horse,
which has moved into the shade of an overhanging tree, to escape
the intense heat of midsummer. The second horse, made stupid by
the heat, is indolently resting its head on the rump of the other; while
in the distance some less fortunate labourers are at work, loading a
hay-cart. In the larger painting, *Landscape with a Woodcutter Courting
a Milkmaid*, there is a similar combination of images of the rural life
as relaxed, as idle even, and of that life as industrious, laborious. The
milkmaid sits beside her cow and turns her face shyly away from the
woodcutter who stands nearby; and both seem to have time on their
hands compared with the figure, in the left middle distance, of a more
ragged ploughman – so often the representative countryman, when
the rural life is to be understood as arduous, and when bread is to
be earned in the sweat of one's brow. These are the figures that
Gainsborough 'fulls up with', and, as I have indicated in my
introduction, I shall be taking them rather more seriously than
Gainsborough himself would encourage us to do.

It is especially the contrast between these idle and industrious
figures, that I will be concentrating on in this essay. The contrast tells
us much about what was an important issue in moral and religious
debate in the eighteenth century: whether the good life was one of

unremitting toil in expiation of the curse of Adam, or a life of intellectual, and so moral, self-improvement, such as can be undertaken only by those with leisure for the task. And though the paintings by Gainsborough I have described seem to show us only images of one class of the rural society, the labourers, the contrast between the laborious ploughman and the idle milkmaid can throw some light too on how Gainsborough and his admirers understood the relations between the labouring poor, and those whom (by way of contrast) we may describe as the idle rich.

In the *Landscape with a Woodcutter Courting a Milkmaid*, these images of industry and of idleness are not discordant, but combine to present the harmonious view of a countryside which must be cultivated, of course, if it is to be productive, but which does not impose its sentence of hard labour without continual remissions. It's productive enough to allow its inhabitants a life of work and play together. One of the chief pleasures which for two hundred years English people have found in English eighteenth-century and early nineteenth-century painting of rural life is that it offers an image of that life neither too artificial, as French pastoral painting has often seemed to be, nor tediously minute, as Dutch painting is often accused of being; it evades the extremes at once of pastoral idleness in a perpetual and

Thomas
Gainsborough,
*Peasant with Two
Horses*

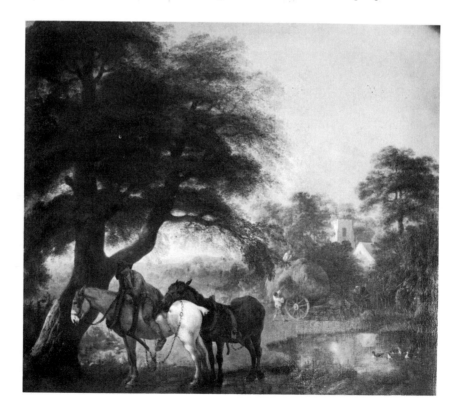

a hopeless present tense, and of a hard georgic life whose rewards and pleasures are always in the future, and which offers us in the meantime – and it's always the meantime – a life of assiduous self-discipline and of a continued effort to maintain civilisation by cultivation. By qualifying each of these extremes by the other, Gainsborough offers us an ideal of the rural life as one of varied but harmonious satisfactions.

The poetry which more clearly than any other satisfies these opposed needs – for an image of a relaxed, insouciant life, which can also somehow be responsible and active – is the tradition of English Georgic; a poetry concerned as much to soften as to recommend the hard moral lessons of Virgil's original *Georgics* to a polite English readership. English georgic poetry is written from the first decade of the eighteenth century through to 1770 or so; its most famous specimens include John Gay's *Rural Sports*, James Thomson's *The Seasons*, and John Dyer's *The Fleece*.[2] A first and casual reading of these poems will give the impression that their main concern is to present an image of English social life as in all important respects

Thomas
Gainsborough,
*Landscape with a
Woodcutter Courting a
Milkmaid*

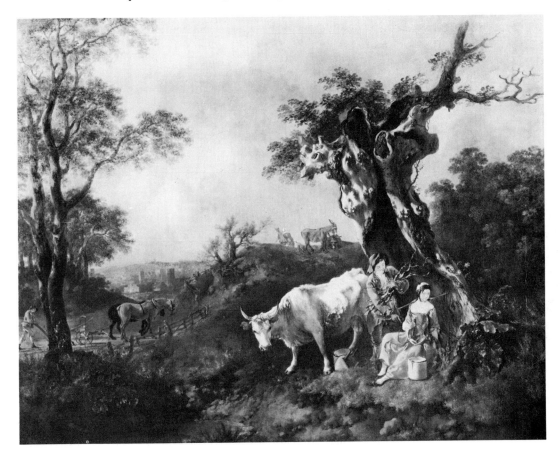

egalitarian and without conflict – of a society, that is, which may well permit inequalities of wealth, but in which the labels 'rich' and 'poor' cannot be translated into the more divisive distinctions of 'consumer' and 'producer'. The poetry makes it unambiguously clear that in England the means of life may be amply secured, but only by those who work for them: there is no room in 'Happy Britannia' – the phrase is James Thomson's[3] – for the indolent of whatever station in life. John Gay ends his *Rural Sports* with an apostrophe to the 'happy fields' of England, 'unknown', he says, 'to Noise and Strife, / The kind Rewarders of industrious Life'.[4] The peace of the English countryside is the reward of all who work, whether the responsible gentleman, shooting and fishing for relaxation, the busy citizen, visiting the country for recreation, or the industrious swain, whose health is guaranteed by his outdoor life.

In *The Seasons*, Thomson gives a brief history of man's progress in terms of the intervention of the personified 'Power' of 'Industry' in the life of the brutish and lazy savage: Industry, says Thomson, roused Man from his miserable sloth, and taught him to use tools, to mine ore, and to build; Industry

> Tore from his limbs the blood-polluted fur,
> And wrapt them in the woolly vestment warm,
> Or bright in glossy silk, and flowing lawn;
> With wholesome viands fill'd his table, pour'd
> The generous glass around, inspir'd, to wake
> The life-refining soul of decent wit.
> Nor stopp'd at barren, bare necessity;
> But, still advancing bolder, led him on,
> To pomp, to pleasure, elegance, and grace...
> ('Autumn', lines 84–92)

By our labour we are civilised; man must first work, and then he may repose – the georgic poetry of early and mid-eighteenth-century England is full of such assurances and reassurances. It is also full, though, of particular applications of those general statements which appear to contradict them utterly, and to grasp this we must peer under the classical draperies of this personified Industry, and ask who she is imagined to be, at the start of the passage and then again at the end. At the start, she appears to be an instructive, Promethean deity, who rouses man and teaches him various pieces of useful knowledge; and then, not content with teaching him merely, she tears from man's back the furs and skins that had served him for clothing, and wraps him in wool – and not wool only, but 'glossy silk' and 'flowing lawn'. Next, she loads Man's table with meat, pours out his wine...and it is clear by now that Industry is no longer the teacher of all men,

but the servant of some of them. 'Industry' means to Thomson now
what 'Labour' means to the manager of a factory; and the argument
which appeared to be saying 'by our work we are civilised' ends up
by saying 'we are civilised by the work of others'. If the contradiction
remains unclear, it's worth pointing out that Industry, having
wrapped man in silk or lawn, fed him with 'wholesome viands', filled
his 'generous glass', and left him to his civil and witty conversation,
is still thought, having done all this, to have satisfied only 'barren,
bare necessity'. These rewards are no more than all industrious men
enjoy, if they are more than brutes – that is what Thomson is forced
into suggesting; and the fragility of the suggestion is made
embarrassingly clear when he finds himself, 250 lines later, asking
the landlords of England to be flexible in their demands for rent after
a bad harvest:

> Ye masters, then
> Be mindful of the rough laborious hand
> That sinks you soft in elegance and ease;
> Be mindful of those limbs in russet clad
> Whose toil to yours is warmth and graceful pride;
> And oh, be mindful of that sparing board
> Which covers yours with luxury profuse,
> Makes your glass sparkle, and your sense rejoice:
> Nor cruelly demand what the deep rains
> And all-involving winds have swept away!
> ('Autumn', lines 350–9)

This passage admits everything that the lines on Industry have just
denied; it is the laborious efforts of the producer that procure the
ease of his landlord; the food which might by rights – the suggestion
is – be on his own 'sparing board' is carried away to provide the
superfluity on the tables of the rich; the 'viands', and whatever fills
the sparkling glass, are produced by one man and consumed by
another. A huge gap has now opened between rich and poor, which
only the benevolence of the rich can conceal – but that benevolence,
as the urgency of Thomson's tone suggests, is by no means universally
forthcoming.

The implausibility of Thomson's egalitarianism is matched by
Gay's, in his poem *Rural Sports*, where he considers the rewards which
the happy fields offer to the industrious, though to no-one else. If we
do not examine the notion too hard, we are likely to agree that the
countryside does offer a comparable sort of peace to labourer and
gentleman, and this seems to justify Gay's notion that the 'happy
fields' are 'unknown to strife', the rural society is without conflict.
But the rewards are different, of course, according to who you are.

To those who can afford the rural sports of the gentry, the fields offer distraction, peace, repose. To the industrious swain, the rewards are less obvious, but they include no doubt that simplicity of life guaranteed by the obligation to perform laborious tasks, and the 'blooming health' (line 221) which makes their performance such a pleasure. To the industrious rich, then, the reward is repose, to the industrious swain – as the poem shows quite clearly – it is more toil, the satisfaction of a job, not just well done, but evermore still to do.

But though the official ideology of these poets, as it appears in their statements of the unity of Happy Britannia, is fraught with contradiction whenever we try to apply it to the specific classes in rural society, this is not to be thought of as an unintentional lapse, an embarrassing discord in the swelling hymn to England. It's essential to the success of that hymn that it should make these contradictory statements – it matters only that the contradiction should be as far as possible concealed. So that while the georgic poets are keen to assure their public that English society is without conflict, its economy, a moral economy, at the same time they find ways of reassuring them that this egalitarian ideal does not do away with the necessary divisions between 'the labouring many and the resting few'[5] – which however give no cause for anyone's concern; for the gates of the Palace of British Liberty, as Thomson explains, are thrown open impartially to king and peasant, and 'equal spreads / The sheltering roof o'er all' – though still 'to different ranks / Responsive place belongs'.[6] In their explicit ideology the poems proclaim that the poor are as happy as we are; but in their presentation of the actuality of eighteenth-century life, they are obliged to remind us of the crucial role of benevolence in concealing the very social divisions they can then deny to exist, and at the same time they can reassure us that we are, in all sorts of unimportant but gratifying ways, much happier than the poor.

The contradiction is equally well concealed, and yet somehow equally apparent, in eighteenth-century writings on wealth and its creation, which are committed at once to a defence of the 'luxury' of the rich as the chief cause of social and economic progress, and to an egalitarian denial of the distinction between producer and consumer. Thus the taste for luxury in the rich will cause them to stimulate the husbandmen on their estates to produce more and more wealth, which will then be spent on luxuries, and so maintain a larger and larger class of artisans; so that the 'private vices' of the rich, in Mandeville's phrase, become of 'public benefit' to the state as a whole:[7] rich consumers are necessary to the well-being of poor producers. On the other hand Hume, for example, argues that

A too great disproportion among the citizens weakens any state. Every person, if possible, ought to enjoy the fruits of his labour, in a full possession of all the necessaries, and many of the conveniences of life. No one can doubt but such an equality is most suitable to human nature, and diminishes much less from the *happiness* of the rich, than it adds to that of the poor.[8]

But this argument cannot be taken too far: for it is quite clear to eighteenth-century writers on wealth that entirely to abolish the distinction between producers and consumers, in a complete equalisation of purchasing power, which they regard in any case as impossible, would serve to reduce the spirit of avarice and industry to the detriment of economic progress. Hume therefore chooses to consider that wealth is already distributed in England in a manner which may be described as egalitarian;[9] and instead directs attention away from such economic inequality as still palpably exists, as it is the custom of writers on wealth to do, and as James Thomson does, towards the alleged equality of all Englishmen before the law, and to insist that all are 'free' to rise by their own industry. But the eighteenth-century attempt to argue the equality of rich and poor in legal, rather than in economic terms, has recently been made to look rather fragile by the research of Douglas Hay;[10] and in any case it goes without saying that 'equality before the law' did not extend to an equality in making it.

II

I want to suggest, then, that it may help us to understand these Woburn landscapes if we read them in the light of English georgic poetry. For when, no doubt under the influence of lessons Gainsborough learned as an apprentice from Gravelot and Hayman,[11] he brought together in his landscapes of the 1750s the tradition of French rococo pastoral painting, and the more sternly georgic tradition of the Netherlands painters, this may not have been simply a happy eclecticism, but a combination that enabled him to compose an image of Happy Britannia as reassuring in its harmonies, and in its contradictions, as that which the English georgic poets had conveyed. That is to say, that these influences can be understood as complementary, as together prompting us to make a general statement about the nature of the ideal rural life, as a blend of work and play; but that seen in another way, the *Landscape with a Woodcutter Courting a Milkmaid* offers us also the image of a society divided between those who must, and those who need not work, and secures the pastoral present for the consumer, while deferring the happiness of the laborious producer to the distant georgic future.

I will try to make good this summary in my next section, but before we go on to examine Gainsborough's painting in more detail I want to look briefly at a pair of landscapes by George Lambert which he completed in 1733, more than twenty years before Gainsborough painted the picture that mainly concerns us. These earlier landscapes are of great interest to us, in that they offer an image of eighteenth-century society as ambiguous and yet as reassuring as that offered by Gainsborough, and they seem to be the first paintings produced in the century which portray the rural life of England with the same interests and in the same spirit as it is represented in English georgic poetry. They are quite unlike the imaginary classical landscapes and topographical paintings that make up most of the rest of Lambert's output; his later, Poussinesque landscapes may be thought of, as Poussin's themselves were, as pastoral, as may the figures in them also, whether dressed in classical drapery or an indeterminate uniform between the antique and the theatrically rustic – the *Woody Landscape*, reproduced on p. 22, will serve as an example. These figures are the equivalent in painting of the shepherds in Pope's *Pastorals*, who though they haunt the banks of the English Thames would scorn to be known by names other than those sanctified in the eclogues of Virgil; and there is no attempt in such paintings or in such poems to insist on a very direct connection between the inhabitants of these classical landscapes and, in Pope's phrase, shepherds or rustics 'as [they] at this day really are'.[12] The pleasure taken by eighteenth-century connoisseurs in Lambert's pastoral landscapes was entirely to do with the success with which he could imitate Poussin, and thus minister to their desire to be thought men of classical taste rather than to their wish to be seen as taking a dignified interest in the management of their estates; and so such pictures were valued the more for being idealised and 'poetic' in the more limited sense of that word. In this pastoral *genre* there is no praise to be earned by bringing Arcadia closer to the actuality of the English countryside, and although as I have said this does not imply that there was no interest in the first half of the century in a painting of rural life with more obvious affinities to the contemporary rural life, it does point to a separation and a hierarchy of *genres* in landscape painting: the pleasure we take in the higher, Claudian kind may not profitably be confused with the pleasure we may also legitimately take in the portrayal of English landscapes peopled by English figures.

The pair of landscapes we are about to examine – images of Summer and Autumn which anticipate the paired subjects of Stubbs's farming pictures – are of this lower kind – Lambert's 'low familiar style' which in 1765 James Barry found not so much 'natural' as 'familiar': 'there are other things in the world beside

the barns, hogs and haystacks, which Mr Lambert was so very fond of'.[13] The remark is reminiscent of a number of embarrassed discussions of the subject-matter of georgic poetry in the eighteenth century– Addison's, for example, who claims that the georgic poet will only 'toss the dung about with an air of gracefulness' if he takes care to express himself in '*Metaphors, Grecisms, and Circumlocutions*', and so never sinks into a '*Plebeian* Stile'.[14] Appropriately, then, the structure of these landscapes is remarkably informal, and cannot easily be read in the language of Claude and Poussin, of wings, masks, and a luminous distance. Of one, *Hilly Landscape with a Cornfield*,[15] Elizabeth Einberg has written that it has

> a breadth and fundamental calmness that is difficult to reconcile with some of Lambert's more claustrophobic compositions. This scene is dominated by the great chalky lump of the hill in the centre, reducing the remnants of the classical wings of trees into insignificance.[16]

George Lambert, *Hilly Landscape with a Cornfield*. (Detail below)

And of the other, *Extensive Landscape with Four Gentlemen on a Hillside*,[17] she says, 'the "wing" principle is abandoned here entirely',[18] though the composition is less original than this suggests.

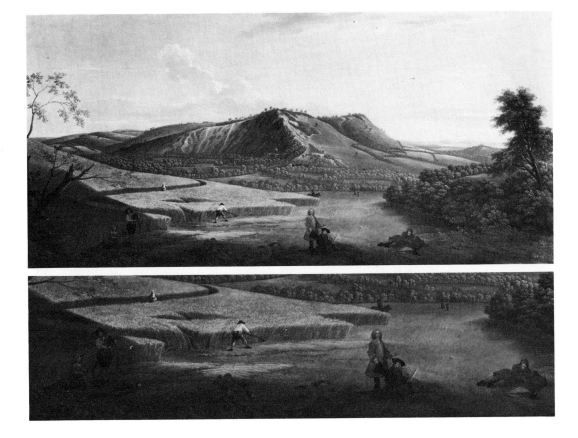

and seems to have been copied faithfully from Knyff's *View from Richmond Hill*.[19] Related to this abandonment of the conventional classical structure, which in his more formal pastoral compositions Lambert reproduces most faithfully, are the nature, the dress, the attitudes of the figures, who are English gentlemen and quite recognisably contemporary agricultural labourers, whose relation to the Arcadian shepherds of Pastoral is analogous to that of the mowers or reapers we find in the georgic poems of Gay and Thomson to the shepherds of Pope's and Prior's eclogues. It is on these figures, their attitudes and their disposition in the landscape, that I want to concentrate.[20]

In the *Hilly Landscape*, the most prominent group is of the three figures I have described as 'gentlemen': one stands and faces us in a confident and elegant attitude; one appears to be sketching, with a drawing-board on his knees; a third, slightly to the right of the others, is reclining, his body turned towards us, and seems to be reading. These gentlemen occupy the centre foreground of the picture, but no-one quite knows what they are doing there. Miss Einberg writes:

> Rather than representing just a country picnic idyll, as has been generally thought, they might also be engaged in a land survey. This would go some way towards explaining the reason for painting a specific English landscape without so much as a country house or hunt in sight, at a time when these were considered the only valid reasons for reproducing native scenery.[21]

It may be so, though Miss Einberg does not really explain why it should have been at this time any more acceptable to paint gentlemen or professional men engaged in a land survey than the same men enjoying a picnic; but in either case not only the dress of the gentlemen but their fairly leisurely attitudes are in sharp contrast with those of the other most salient figure in the landscape, the bending reaper, who, apparently abandoned by his fellow-labourers, has been left to tackle the wide cornfield on his own.

This figure, full in the sunlight which is reflected brightly by his white shirt, is in fact quite as prominent in his way as the group we have just examined; for although Lambert has almost dispensed with the classical technique of framing the landscape, as it were on a stage, by *coulisses*, or wings, he has no other way of rendering distances than by organising the landscape into a series of alternating dark and light bands one behind the other from foreground to horizon; and while the leisured gentlemen emerging from the first dark band are seen partly against the lighter tone of the second, they are still invested with some of the obscurity of the first, while the reaper in the second

plane is the brightest object in the entire picture. The darkest, on the other hand, is another group of reapers, apparently relaxing, in the first plane of the landscape, but entirely overshadowed by the broad patch of shade which serves a vestigial *coulisse* in the left foreground. One of these figures is standing, scythe upturned as if he may have been sharpening it; the other, a woman, sits on the ground beside him: the attitudes and positioning of the figures are a mirror image of those of the two gentlemen in the centre of the painting.

In the second picture, the *Extensive Landscape*, are similarly portrayed the figures of rustics and gentlemen, at work or idle. In the dark foreground is a figure whom Luke Herrmann believes to be a miner, kneeling by a hole in the ground where he may have been excavating fuller's earth.[22] Behind him to the left, again rising out of the shadow into the brighter day of the second plane, is a group of gentlemen with, once again, one standing and one sketching, and this time with two reclining near what may be either a map or a picnic cloth. In the centre of the second plane is a figure chasing a dog downhill, a figure who cannot easily be located on the social map of rural England – his clothing seems to make him an unusually energetic refugee from a landscape by one of the Poussins, though he may be wearing a labourer's smock. On the right, and more or less in shadow, is a hay-cart on which is seated a pair of rustic lovers, their labours ended for the day; behind it a meadow with haycocks.

George Lambert,
*Extensive Landscape
with Four Gentlemen on
a Hillside*

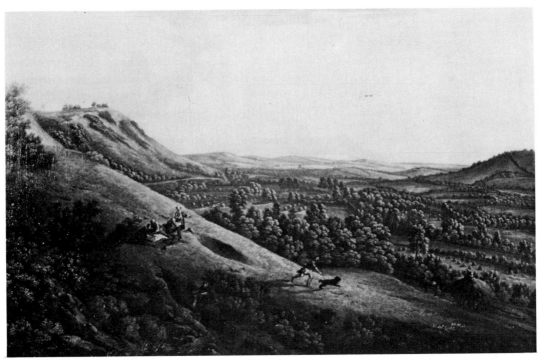

In the distance the rolling wooded fields give way to an urban settlement, at once indicated and concealed by the smoke by which it is blended into the countryside around.

What do these contrasted groups of figures tell us about the relation of gentleman and labourer, industry and idleness? To begin with, of course, there is a clear contrast between the more leisured positions of the gentlemen, and the industrious attitudes of the reaper and miner, and we are likely to feel in relation to these paintings, as we do when reading Gay's *Rural Sports*, that because the two sorts of opposed relationship with nature, a gentle pastoral idleness or a rustic georgic industry, can each be represented as a mode of peaceful harmony with nature, each must be in harmony also with the other, and the apparent division between those who bend and work, and those who lie and rest, is unimportant. The sense of unity that can be created in poetry by the ambivalent use of language – 'rewards', 'man', 'industry' are examples we have come across – can be created in paintings such as these by the resources of composition, in which each figure or group of figures has an appropriate place within an area which can only be articulated, can only become a painting, a 'landscape' at all, by being translated into a structure by which that area is automatically and necessarily perceived as unified, orderly, harmonious.

The presence of the idle labourers, however, means that we cannot see these landscapes simply as an expression of the unity of those who work and those who can afford merely to watch others work, and again a comparison and contrast with *Rural Sports* will help us understand the significance of the pictures. Among the pleasures of rural life, as Gay describes them, is that of watching the mower at work, and observing how, as the sun mounts the sky, he scatters the grass loosely on the ground to dry, but how, when a shower threatens,

> He strait in haste the scatt'ring Fork forsakes,
> And cleanly Damsels ply the saving Rakes.
> (lines 239–40)

The pleasure of thus observing the details of husbandry and the labours of the poor is curtailed, however, at high noon:

> But when th'Ascent of Heav'n bright *Phoebus* gains
> And scorches with fierce Rays the thirsty Plains;
> When sleeping Snakes bask in the sultry Sky,
> And Swains with fainting Hand their Labours ply,
> With naked Breast they court each welcome Breeze,
> Nor know the Shelter of the shady Trees:
> Then to some secret Covert I retreat,

To shun the Pressure of th'uneasie Heat;
Where the tall Oak his spreading Arms entwines,
And with the Beech a mutual Shade combines;
Here on the Mossy Couch my Limbs I lay,
And taste an Ev'ning at the Noon of Day.
(lines 269–80)

Thus protected and at ease as the swains cannot be, the poet at once diverts and employs his mind by studying Virgil's *Georgics*, or rather by 'wandering over' the 'various rural toil', and also the 'native Charms' and 'various Landschapes' that poem describes (lines 290–316). For Gay, then, the *Georgics* of Vigil, and his own poem can be an emblem of that resolution of duty and inclination, industry and idleness, by which Pope is described at the opening of the poem as 'employing' his 'easie hours' (line 3), and which is hinted at by the poem's title – *Rural Sports: A Georgic*.[23] It is a resolution assumed to be directly related to the harmonious nature of the rural life, in which rural sports and diversions, and rural labour, are but various aspects of one unified life in nature.

In the same way, these pictures by Lambert seem to offer us images of industry and idleness resolved or balanced. If those who looked at them in the eighteenth century knew that the gentlemen were engaged in the pleasant task of surveying a rich landscape on two summer's days, then all those gentlemen must have appeared in the role of the active overseers of agricultural production; and even if they are not surveying, one gentleman at least in each picture remains an image of that gentlemanly blend of leisure and activity that Gay enjoys and attributes also to Pope. And of course among the rustics themselves there are as many idle as there are industrious figures: the group in the *Hilly Landscape* which includes the active artist or surveyor is balanced by the group of relaxing reapers; and the *Extensive Landscape* depicts the end of the hay-harvest, and so of the labours of the mowers who sit at ease on the load of hay. These images, then, go rather further than did *Rural Sports*, towards proposing an image of harmony in the countryside understood as a resolution of industry and idleness, as aspects of the life of both classes in the countryside; for in Gay's poem, the rich may be mildly industrious, but the poor are never allowed to be idle, and the harmony of life in nature may not be equally evident to those who at high noon must keep on working if sportsmen and poets are to relax. We may make the same point about the *Hilly Landscape*, and note that the gentlemen and the reaper have exchanged their usual positions, the former now in the shade, the latter now working in full sunlight, at a time of day at which the gentlemen are unlikely to count

themselves losers by the exchange; but the point is qualified by the other tonal (and social) relations in the picture, and the life of rural England is now to Lambert, it seems, as it is intended to be understood in *The Seasons*, one in which all work and all relax, by turns. Pastoral and Georgic are intertwined in a way that is of distinct benefit to all classes, so that the swain may well smile as he works, and the gentleman will feel his leisure justified by his practical concern for rural affairs.

III

We may return now to Gainsborough's *Landscape with a Woodcutter Courting a Milkmaid*, and note that it too invites us to endorse the statement that the rural life is a blend of Pastoral and Georgic; it does not oblige us to adjudicate between them, for each seems necessary to the other, and the two co-exist quite harmoniously within the same mixed image. To start with the woodcutter, it's worth asking why he is, after all, a woodcutter and not a shepherd – a shepherd is traditionally idle, but in the figure of this woodcutter, who courts a milkmaid with a bundle of sticks in one hand, and a bill-hook in the other, the sense of idleness is already combined with industry, Pastoral with Georgic, and the Pastoral perhaps only predominates because the figure of the woodcutter is to be contrasted with that of the ploughman. The milkmaid, too, has been interrupted in the very act of milking by the woodcutter who has interposed himself between her and her cow. The ploughman, on the other hand, though we cannot see much of his expression, manages to express in his attitude a surprising sense of ease, less a symbol of arduous

Thomas
Gainsborough,
*Landscape with a
Woodcutter Courting a
Milkmaid* (detail)

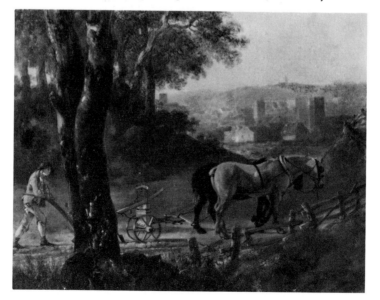

toil than of what the georgic poets like to call 'happy labour',
or 'grateful toil': these are the phrases whereby the producers of
Britain's agricultural wealth are seen to work as hard as they are
required to do by the moral imperatives of the georgic tradition, but
to be as happy as the idle shepherd is in the tradition of Pastoral.
This ploughman trundles his plough through the light soil like an
empty wheelbarrow along a concrete path; and it seems there's no
work without recreation, and no repose without the memory of
labour.

Whatever general statements, then, this picture seems to provoke,
it's certain that they will always be generated in complementary
pairs. The success of this picture on an ideological level, as of the other
Woburn picture or of other landscapes from this period of
Gainsborough's work, where the notion of industry may be expressed
by nothing more insistent than a plough prominently placed in the
foreground, depends on exactly this ambivalence in their imagery;
it allows us to see in them a justification of the social and economic
organisation of England which is equal to whatever demands we
make of them, whether we wish to believe that labour is a happy and
leisurely affair, or that leisure is a brief interlude, only, in a serious
life of labour. These mixed images permit whichever statement you
wish, and hold them in an unresolved but peaceful tension; so that
we must say simply that work and play, in whatever proportions, are
both parts of the ideal rural life of Merry England; and insofar as
we read the images as they would very likely have been read at the
time, ploughman and woodcutter as representatives of the classical
topoi of *labor* and *otium*,[24] they seem to permit no differentiation
between the separate classes of rural society, but to speak of the lot
of everyone, of the rural life, or indeed of life itself, in general.

Human happiness, according to Hume writing in the early 1740s,

> seems to consist in three ingredients: action, pleasure, and
> indolence: and though these ingredients ought to be mixed in
> different proportions, according to the particular disposition of
> the person; yet no one ingredient can be entirely wanting,
> without destroying, in some measure, the relish of the whole
> composition.[25]

Of the three ingredients Hume specifies, pleasure is common to the
other two, so that happiness consists in pleasurable action and
pleasurable indolence; and the 'whole composition' of a life – the
phrase may invite us to consider life, once again, as a picture –
depends on a due proportion of the two. What is a due proportion
depends in turn on 'the particular disposition of the person', a phrase
as conveniently ambiguous as Gainsborough's picture is. Its primary

meaning is to be understood in relation to Hume's apparent liberalism in economic matters, as referring to the particular 'inclination' of individuals, who may (he suggests) find pleasure in being now more, now less active. This primary meaning, however, conceals but does not quite obliterate a secondary one, the particular disposition of each individual in *society* – whether he is so situated as to be predominantly a producer or a consumer; and this meaning reinforces an apparent naturalism in Hume's writings, by which the present social and economic formations are accepted as the only ones which a scientific social philosopher is properly concerned with. In the same way, James Thomson could partly conceal the gap between producer and consumer, by describing the influence of Industry on one single, undifferentiated, representative 'Man' – who first produced, and then consumed the fruits of labour; and in the same way – one final instance will perhaps establish that the strategy is a common one – Pope conflates the two identities by a vision of 'Rich Industry' who 'sits smiling on the Plains', in *Windsor Forest* (1713, line 41). Pope's deity – whom we should imagine, perhaps, wreathed in ripe corn, carrying a sickle – must first of all have been conceived as a representation of those who produce the richness of the harvest. By describing 'Industry', however, as 'rich' Pope manages to suggest that those who work are rich, and equally that the rich work. All producers will consume and all consumers have produced what are anyway – in case we are disposed to make too much of the inequalities he is labouring to conceal – the 'gifts' of 'Ceres'; and when all have finished producing, all sit back and smile at the prospect of what they are about to receive.

But, as one nearly contemporary economist was moved to admit, 'it is not the same man that first works, and then reposes; but it is because the one works that the other rests'.[26] This is the reassuring actuality that Thomson and Hume are hinting at; and this Woburn landscape, too, offers the same reassuring reminder that ideology is only ideas, but that in the real world comforts are distributed with a more gratifying inequality. For there is still something more to be said about the figures in this landscape. Of all the human figures in the poetry and painting of rural life, the ploughman is the original of the working countryman; we never see him portrayed at rest, as we do the shepherd or even the hay-maker – he ploughs a straight furrow towards an ever-receding horizon. We can never mistake him for anything but an image of what he is, a rural labourer. The figures of the shepherd and shepherdess, on the other hand, particularly in the late seventeenth and early eighteenth centuries, cannot be identified too easily as countryfolk, but are images of the courtier's ideal of rural life, that combine his aspiration for a simpler life than

that lived in courts, and his actual freedom from the need to make any effort to survive.

In the art of the later eighteenth century, though, the figure of the shepherdess is often replaced by that of the milkmaid; her appearance in the imagery of Pastoral is part of the process by which that imagery was adapted during that century to be able to depict more of what was thought to be the actuality of rural life. A milkmaid is more of a country girl, and less a courtier, than is the silken shepherdess – we can imagine her working a little, even if she cannot often be portrayed actually squeezing the cow's udders.[27] In England, indeed, the milkmaid had figured in pastoral poetry before the shepherdess appeared, and had survived in pastoral-related folk-song and rhyme through to the eighteenth century; so that her reappearance in more formal versions of Pastoral seems to indicate a desire to return to what would have been thought of as a more realistic, because folk-based, imagery of rural life.[28] The point is well made by Matthew Prior, in his 'Satyr on the Modern Translators':

When from their Flocks we force *Sicilian* Swains,
To ravish *Milk-maids* in our *English* Plains...
I'd bid th'importing Club their Pains forbear,
And traffick in our own, tho' homely Ware.[29]

But the emergence of the milkmaid has also to do with the feeling so often expressed by eighteenth-century writers on Pastoral, for example by the author of the *Guardian* essays, whom we have already encountered, that if the ideal of a simple and idle rural life is to survive, it must accept a little contamination by the language and imagery of the practical world. Such an attitude accepts that the pastoral vision is somehow unreal, artificial; and the function of this practical imagery is to conceal this from us, though we know it to be true. The milkmaid, then, in the pastoral art of the eighteenth century, can be seen just as well as a shepherdess, but one who has exchanged her silken gown for a woollen frock, her crook wreathed with flowers for a stool and pail. She may still be a courtly lady, but one who has been threatened into assuming a more effective disguise – didn't Marie Antoinette dress as a milkmaid in her own *fêtes galantes* at the *petit hameau*? Or the milkmaid may hover between a courtly and a rustic identity, as the art of rural life hovers between idyll and actuality.

The polite viewers of this landscape, then, had the possibility of identifying with the milkmaid, and so with the cleanly and delicate-featured woodcutter, who is, precisely, 'courting' her, which they did not have, and certainly would not have wanted, with the ploughman. And once again, the general statement, that the rural life is a blend

of work and play, turns out to be contradicted, or qualified, by some more specific suggestion about who it is, precisely, that plays, and who it is that works. The resting few are maintained in ease by the labouring many, though the labouring many are unaware or quite content that this is so. We can say the same of the landscapes by Lambert, the happy egalitarianism of which cannot conceal the inequalities those pictures must also reveal. For though Lambert hints at a certain industriousness in the activities of his gentlemen, their attitudes are almost all of them relaxed, indolent; and though if we search the dark corners of the landscape we can glimpse the figures of labourers at rest, the central rustic characters are still shown hard at work, reaping or digging, so that it is the industrious aspect of the life of the poor that receives all the emphasis of the composition. All these pictures, then, confirm the boasted equality of Merry England, and deny it too. They proclaim the liberal ideology of a rich, happy, harmonious land, in which all men work together and all consume the fruits of that common industry; while they portray the repressive actuality, that the sweets of life are reserved for the rich, the sweat for the poor; and their success is to conceal this contradiction, by a careful handling of iconography and structure.

Ideology and actuality, falsehood and truth, remain in the picture on the most harmonious, the most peaceful terms – and that sense of peace, too, in the *Landscape with a Woodcutter Courting a Milkmaid*, is worth analysing a little further. For it is not so much a harmony between the pastoral and georgic figures together, who in fact ignore each other, as they balance each other, within the composition. It's rather that there is an easy harmony between each group or figure and the landscape itself. Thus the ploughman is bathed in a light which compares his clothing directly with the soil he works, with the plane of the landscape in which he moves and has his being; so that instead of standing out from his surroundings, as the small but often brightly coloured figures do in landscapes by Claude, he is part of them. The woodcutter recapitulates in his attitude, and in the bundle of twigs that he carries, the form of the hollow tree which forms a sympathetic and protective bower or canopy over him and over the milkmaid – and we may wish to make something of the point that this tree is the only image of unproductive nature in the landscape. These relations invite us to feel that if everyone individually is in harmony with nature, everyone must collectively be in harmony with each other too, and the rural society is a peaceful and a unified one.

The fluid and elusive imagery of Gay, Thomson, Lambert and Gainsborough was essential to the attempt made in the art of the mid-century to present England as Happy Britannia, as Merry England, an ideal which by the 1780s has become, a mere thirty years

later, so inconvenient a memory to the rich, so attractive a one to the poor. When later writers of the poetry of rural complaint looked back on these images of work and play that blend so invitingly in the art of Merry England, they were looking back, possibly, to a period when the labourer's day was more in his own hands, to organise and dispose as he wished; but they were certainly mistaking an image of an idle pastoral life reserved for the gentle milkmaid, for an image of how life had once been even for the base ploughman.

IV

Thomas
Gainsborough,
*Peasants Going to
Market: Early
Morning*

In 1759, Gainsborough moved from Ipswich to Bath, and the character of the figures in his landscapes changed considerably. They remain, however, as hard to locate on the social map of eighteenth-century England, as far as we can reconstruct it, as are the woodcutter and milkmaid of the Woburn picture. In the *Peasants Returning from Market*,[30] of c. 1767–8, *Going to Market*,[31] of about the same date, or *Peasants Going to Market: Early Morning*,[32] of 1773, the same puzzling groups reappear: attractive women, better-dressed

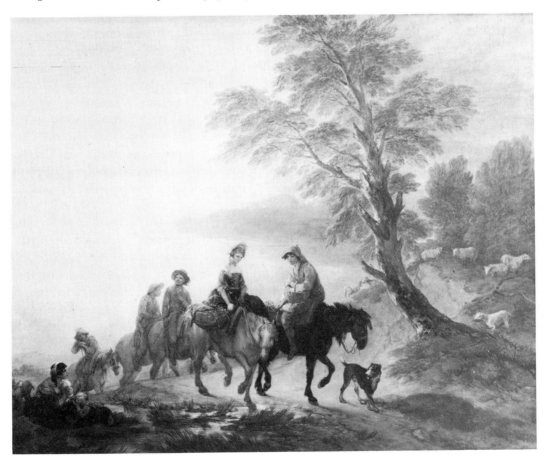

than was the Woburn milkmaid, accompanied by rough-looking men, apparently their husbands or lovers, yet worse-dressed than the Woburn woodcutter. But the men and women alike must be seen, in terms of the rural life of the period, as unusually prosperous: they are almost invariably mounted, though not on especially well-bred horses; they are going to market or returning from it, and so they must have something to sell, or a reason to travel as well as the means of travelling, which the contemporary labourer did not have. When their agricultural produce is painted, it is plentiful and varied. How can we identify these figures, and how explain the puzzling contrast between the men and women?

It will help us to understand these pictures too if we see them in the light of a literary tradition, and here specifically in the light of the comic Pastoral we associate with the work of John Gay. Gay's *The Shepherd's Week* was published in 1714, in the wake of a fairly public quarrel about the nature of Pastoral which involved Pope and Ambrose Philips, each of whom had published a sequence of eclogues in Tonson's *Miscellany* of 1709. The shepherds of Pope's pastorals were not intended to be mistaken for shepherds 'as they really are', but had the delicacy as well as the simplicity of shepherds as we may presume them to have been in the Golden Age, when aristocrats, when 'the best of men follow'd the employment'.[33] Philips on the other hand attempted rather diffidently to recall Pastoral to the native tradition of Spenser: his shepherds spoke what he thought of as a mildly provincial dialect, and kept their sheep in a landscape adorned with English vegetation, and not by the Flora of the Mediterranean. In 1713, the series of essays on Pastoral appeared in *The Guardian*, probably by Thomas Tickell, in which the allegedly greater realism of Philips's pastorals was highly praised, while Pope's eclogues were hardly mentioned; and piqued by this oversight Pope contributed a final essay to the periodical, anonymously, and as if by the author of the others, in which he further commended Philips's work at the expense of his own, and recommended writers of Pastoral to employ a still broader, earthier language and subject-matter than Philips had done, citing as a model of perfection in the *genre* a Somersetshire ballad he claimed recently to have discovered, in which 'Rager' and 'Cicely' discussed the infidelity of rustic lovers and the mating of cattle.[34] Incredibly, not everyone who read this final essay understood its ironic intention, and the same incomprehension greeted the publication of *The Shepherd's Week*, in which Gay, taking over the characters of Pope's ballad and adding more of his own, seems to have attempted to show once and for all the impropriety of writing formal eclogues in the comic language of the farmyard. It was an incomprehension that grew as

the century proceeded, and as Gay's poem became more popular. Pope's first editor, Warburton, noted that those who were 'strangers to the quarrel' mistook the point of the ridicule,[35] and took the poems for a burlesque of Virgil's eclogues; in his life of Gay, Johnson reported that soon after the poems appeared, readers who knew nothing of the circumstances of the quarrel were enjoying them, not as a parody but as a 'just representation of rural manners and occupations';[36] and John Aikin, at the end of the century, admitted that he could not decide whether *The Shepherd's Week* was written 'in jest or earnest'.[37]

The puzzlement of Gay's readers is not at all hard to sympathise with, and may indeed point to a confusion in Gay's own intentions which he could not afford to recognise. Neo-classical Pastoral is based on certain aristocratic assumptions which Gay as a poet may well have needed to believe in, but which as the son of a good but decayed family he was in no position to endorse without reservation. I mean for example that the life of rustics 'as they really are' is no subject for serious verse; that a concern with the processes of agricultural production is a mean concern; that the purpose of Pastoral is to present an ideal world which as we have seen is not so far however from the life of the early eighteenth-century aristocracy, insofar as it is a world from which all industry has been abolished, and food appears as it were magically, without the intervention of human effort. That the poems were burlesques, and broadly comic, was not in itself a clear guide to their intention, for it was a convention of neo-classical literature that the life of all but the aristocracy was the proper subject of the comic *genre* only, so that a writer who wished to portray the actuality of rural life had no alternative but to write in the comic mode; and in so doing it would have been understood that he was not simply trying to be amusing about that life, but using the only *genre* which permitted its description in any detail. What we perceive as an opposition between the conventions of comedy and the attempt at realistic description was not felt to be an opposition at all by readers of the early and middle eighteenth century.

But Gay's pastorals were not merely comic; they were also sentimental – and though the sentimentality may have been intended to reinforce the comic effect by bathetic juxtaposition, this was not invariably its effect in 1714, and it is not now. In 'Tuesday', for example, Marian – significantly, a milkmaid, not a shepherdess – is described like this:

> *Marian*, that soft could stroke the udder'd Cow,
> Or lessen with her Sieve the Barly Mow;
> Marbled with Sage the hard'ning Cheese she press'd,
> And yellow Butter *Marian*'s Skill confess'd;

But *Marian* now devoid of Country Cares,
Nor yellow Butter nor Sage Cheese prepares.
For yearning Love the witless Maid employs,
And *Love*, say Swains, *all busie Heed destroys*.
(lines 11–18)

If we accept that the intention of *The Shepherd's Week* is to burlesque
Philips, then certain parts of this passage make unambiguous sense
– the insistence on the facts and terms of agriculture (we have
already, in 'Monday' (line 14), been invited to smile at the mention
of udders, and at the action of stroking of them); the 'artful
repetitions'[38] that according to Pope are among the chief beauties
of Philips's eclogues; the proverbial saying, italicised the better to
draw attention to its banality; and most of all, perhaps, the fantastic
claim that the parson's maid, who performs these mundane tasks,
should be so delicate (forsooth!) as to be rendered incapable of
performing them by love. It is a mark of the true Arcadian, of course,
that he cannot perform his slight pastoral duties for that very
reason;[39] but the clear corollary of that is that rustics 'as they really
are' are either incapable of loving ('Fit to keepe sheepe, unfit for loves
content', as Spenser describes them[40]), or else love in an animal and
instinctive way which need threaten no interruption to the low tasks
they perform.

If that is the official intention of these lines, however, it is hard not
to agree with almost every critic of *The Shepherd's Week* that here at
least this intention is rather subverted than fulfilled. It is harder to
explain how this happens, but we are likely to feel that if, far from
laughing at Marian's presumption, we find ourselves a little moved
by this account of her feelings, that is something to do with the
insistent factuality of the opening lines of the passage. Obviously they
have no effect on us if the intention is to make us enjoy the
impropriety of discussing cheese-making in an eclogue – our notion
of poetry is too far from those neo-classical assumptions that Gay is
appealing to. We enjoy instead the sensuousness of the image of
milking, the use of the verb 'lessen' to direct attention, artfully, to
an indirect effect of the action of sieving, rather than to the action
itself; the description of the cheese as 'marbled', and the knowledge
of how it is made implied in 'hard'ning' and 'press'd'. The texture
of this language, and the interest in the processes it describes, awaken
a willing interest in us; and we are willing to see a value in the 'skill'
Marian professes, where the reader was expected to register an
amusing indignity and to realise that Gay had no time for that
flirtation with the actual which was to lead, as we have seen, to the
shepherdess's being replaced by the milkmaid in the pastoral art of
the eighteenth century. In this context, and making due reservation

in our response for the probable intention behind them, we enjoy
these images as images of actuality, and are willing to credit Marian's
inability to perform her tasks, just because they, and she, have been
evoked in so concrete a way. Marian's love is not all the funnier
because of her low station in life, but all the more possible to take
seriously, because it makes its way not in the empty leisured world
of Arcadian Pastoral, but in a workaday world in which, we feel, it
has to be all the more sincere, all the less artificial. And more to the
point, the incomprehension of Gay's eighteenth-century readers
suggests that they shared this feeling, and that these poems satisfy
the same demand as would have been satisfied by Gainsborough's
Woburn landscapes, and by the georgic poems which could treat the
everyday subjects of *The Shepherd's Week* with less of the irony which
in that book results from the collision of the formality of the eclogue
and the informality of Gay's rustics.

This sentimental response, however, could be evoked by Gay's
dairymaids, but not by his clowns: the men in *The Shepherd's Week*
remain irredeemably comic and earthy, and while the girls are on
the whole clean, attractive, and sincere, the men cannot help
contaminating the Pastoral, in the spirit of Gay's official intention,
by the frequent use of words which show the absurdity of dignifying
the clowns of the English countryside in a *genre* as formal as
neo-classical eclogue had become. The point is well made at the end
of 'Friday', when two louts sing a dirge to the dead Blouzelinda. The
absurdity of lamenting the death of a mere dairymaid suddenly ceases
to strike us when one of the louts begins to quote Blouzelinda's own
last words, in which she feelingly disposes of her pathetically few and
mean possessions: her spinning-wheel and rake to Susan, her new
straw-hat to Peggy ('for she's a damsel clean'), her leather bottle to
Grubbinol, and so on (lines 123–8). We read the passage not in terms
of a bathetic contrast with the elevated and lyrical effusions of dying
Arcadians, but as a token of Blouzelinda's innocent charity, and
housewifely concern with the details of farm life – a concern which
does her credit, and the more so in contrast with the thoughtless ease
and luxury which those who would merely laugh at this passage must
claim to enjoy. In the last lines of the poem, however, the intention
of the poem is rudely salvaged, when the clowns revert to type:

> Thus wail'd the Louts in melancholy Strain,
> 'Till bonny Susan sped across the Plain;
> They seiz'd the Lass in Apron clean array'd,
> And to the Ale-house forc'd the willing Maid;
> In Ale and Kisses they forgot their Cares,
> And *Susan Blouzelinda's* Loss repairs.
> (lines 159–64)

The Shepherd's Week was immensely popular throughout the early and middle eighteenth century, and set a standard of, in Johnson's phrase, 'reality and truth',[41] in the description of rural life. The countryside of England was henceforth considered to be populated by desirable girls who, though they might be hoped to distribute their favours with some freedom, did so with a bashful sincerity which added to their charm; and by honest clowns, who were incapable of fine feelings but who knew, at least, how to have a good time, and were likely to devote the same rough energy to their work as to their play. It is the passing of a tidier version of this 'bold peasantry' that is lamented by Goldsmith in *The Deserted Village* (1770) – the 'swain' who dances with a dirty face, unconscious that everyone is laughing at him (line 27), the 'coy' barmaid, 'half willing to be prest' (line 251) – though as my argument continues it may seem that Goldsmith's complaint is not so much that this peasantry is passing away, as that it is no longer possible to describe the rural poor in the old comic manner.

That Gainsborough, who detested reading,[42] was nevertheless aware of this comic ideal of rural life is most likely, for Gay more than anyone else made it possible for a version of the peasantry of England to be described at all in the art of the eighteenth century. There is, furthermore, a painting Gainsborough produced at the end of his life, *Young Hobbinol and Ganderetta* (1788),[43] which may take its subject from the poem 'Hobbinol' by William Somervile, apparently in the tradition of Gay, which was published in 1740, though it had originally been drafted some years before *The Shepherd's Week*.[44] It is, in fact, by no means clear that the picture was originally painted to illustrate the poem, or that the title it bears was given by Gainsborough himself; but after his death the painting was engraved and accepted as an apt illustration of 'Hobbinol', which suggests that his public, at least, saw a compatibility between the print and the tradition of comic Pastoral. The poem portrays the Cotswold yeomanry very much in Gay's manner, with the same contrast between a clown who is earthy and burly, and a country maid who as well as being beautiful is sincere and the more desirable for being so. The painting, though, shows Hobbinol and Ganderetta as children, tame and meek, and is part of a sequence of Gainsborough's late paintings of similarly bloodless rustic children – for just as, early in the century, Gay had made it difficult to portray rustics in the image of the Damons and Delias of neo-classical Pastoral – more difficult for poets than for painters, as we saw in the introduction to this book – so it had become more difficult by about 1780 to portray rustics in the style of Gay's Pastoral, though as we shall see in the next essay George Morland sometimes found a way of doing so, at

the expense of losing much of the vigour of the comic tradition (see below, p. 109).

I am suggesting then that we should understand the figures in the landscapes of Gainsborough's Bath period in the light of the tradition of Gay; and a glance at the grandest of Gainsborough's landscape compositions of that period – *The Harvest Wagon*, of 1767[45] – will make the point clear. The wagon appears to be conveying a group of peasants, men and women, to the feast which celebrates the end of the harvest, and which is so important in the mythology of the 'moral economy' of the eighteenth century and before, as numerous pastoral and semi-pastoral poems of the eighteenth century will attest: it is the occasion, according to whom you believe, at which the essential solidarity of the English rural community is confirmed, as landlord, tenant and labourer sit together in a spontaneous celebration whose freedom is uninhibited by any obtrusive sense of social division; or at which that division is aggressively confirmed by the knowledge of everyone present that this is a once-a-year occasion, and that the labourer is being bribed by beer and frumenty to accept

Thomas Gainsborough, *The Harvest Wagon*, 1767

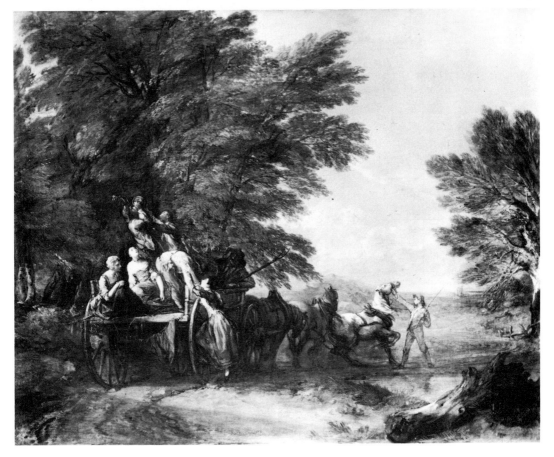

next day the same obligations and the same discipline at the hands of his masters as he has accepted throughout the gruelling weeks of the harvest, and throughout the whole year.[46]

The wagon is receding along a country lane, but has stopped briefly to take on board a country girl who is being lifted into the cart by a helpful labourer. In the wagon itself sit two other country girls, attractive, and attractively dressed for the occasion; and behind them two clowns, on their feet, are struggling over what John Hayes demurely calls a 'water-bottle',[47] but which certainly contains something stronger. The grouping of the figures is generally agreed to be taken from an engraving of Rubens's *Descent from the Cross*, which

Thomas Gainsborough, *The Harvest Wagon*, 1767 (detail)

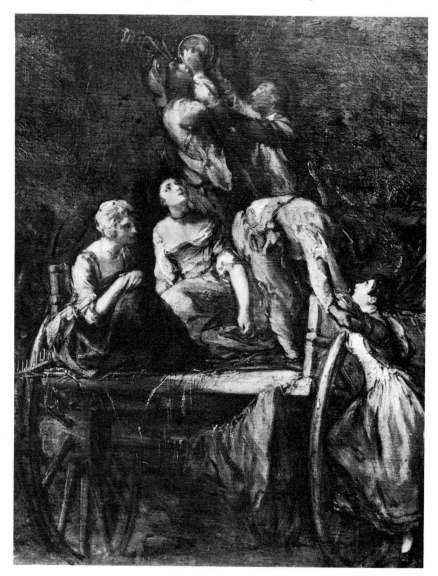

Gainsborough had copied in the early 1760s,[48] and yet comparing
the one with the other we may be struck as much by the contrast
between the two compositions as by their similarity. There is, it is
true, the same vertical arrangement of the figures, but, as its title
implies, in the Rubens the pervasive movement is downward, as the
dead weight of Christ's body is gently lowered by those above him,
and gently supported by those below. In Gainsborough's painting,
the vertical composition points emphatically upward: one of the
struggling clowns strains upwards and backwards, the angle of his
body recapitulated in the rake that is resting on his shoulders, as he
tries to bend away, and so to lift the bottle out of reach of his rival,

Thomas
Gainsborough, after
Rubens, *The Descent
from the Cross*

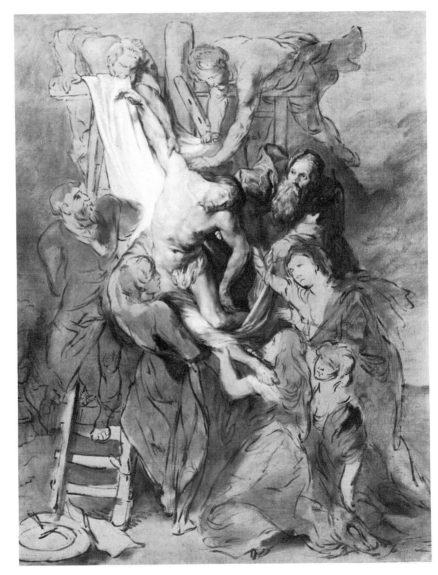

whose arms are extended upwards to insist on his turn. One of the
girls has lifted her head to watch them, and the line of their bodies
is continued by the vertical of her arm, and by that of the right leg
of the third clown who is lifting the third girl into the cart. The
position of this girl, of her arms and her whole body, as she strains
to mount the wagon, reinforces the same upward vertical, and the
sense we get of almost all the figures as involved in an effort upwards
is reinforced by the lead horse, whose raised head has to be restrained
by a further clown, more distant, in the right of the picture. The
dynamic quality, the vitality of the country life as Gay depicted it
in the concrete language of *The Shepherd's Week*, is captured as firmly
by Gainsborough in this painting, as is the contrast between the
rough clowns and the attractive girls which was also a feature of Gay's
burlesque. The men are not at all abashed to appear in front of their
girlfriends in so clownish and comic an aspect, their rough actions
of a piece with the roughness of their dress. The third man, lifting
the girl, expresses in his attitude more concern to get the job done
than consideration for her comfort. The girls, on the other hand,
much neater as I have said than are the men, are still agreeably
natural in their appearance, clothes and hair a little dishevelled, to
indicate that when pressed they may turn out to be as compliant as
they are attractive.[49]

This painting remained unsold while Gainsborough was at Bath,
and on his leaving for London he exchanged it for a horse with the
owner of a firm of carriers.[50] The fact that it did not find a buyer
may indicate that this dynamic and earthy vision of the English
peasantry was already becoming unacceptable by the late 1760s, in
the face of what is clearly by the end of the next decade a demand
for a more serious, more overtly moral, depiction of them. We can
find evidence of this demand for example in the didactic poem
published in 1782 by the Quaker poet John Scott, *On Painting; To
a Young Artist*. Scott begins his discussion of the art of landscape by
affirming, in terms that he acknowledges he has borrowed from
Horace Walpole (see above, p. 7), that the rural landscape of
England is a proper subject for her native painters:

Familiar prospects would thy hand bestow?
Mark what our hayfields and our hop-grounds show;
Where in neat rows the russet cocks are seen,
Or from tall poles depend festoons of green.

But it is the lines on the proper inhabitants of this landscape that are
most striking:

We wish not here for Virgil's classic Swains,
Nor dryad Nymphs light tripping o'er the plains;

Nor yet the grinning Hobbinols of Gay,
Nor cottage Marians, in their torn array:
The rustic life, in every varied place,
Can boast its few of beauty and of grace;
From these select the forms that most may please,
And clothe with simple elegance and ease.[51]

Scott clearly identifies one kind of rustic in English painting as deriving from the comic Pastoral of Gay, but it is a kind as unacceptable to him as the 'classic Swains' of Virgilian Pastoral had become to the painters at the beginning of our tradition. It isn't clear, however, whether Gay's comic rustics are as unreal to Scott as Virgil's are: the coarse humour of his 'Hobbinols', and the unkempt allure of his wenches are inappropriate in the 'familiar' prospects of England, at first apparently because they are unconvincing, but more perhaps because they are unfit for representation. The 'torn array' of the 'cottage Marians' may be suggestive of indecency as well as of a lack of neatness, for Scott, who seems too aware of the official intention of Gay's burlesque to notice that many of his nymphs, and Marian among them, take a careful pride in their appearance, is arguing firmly for 'Decency' in painting, and later in the poem advises the painter to 'shun Naked Form, that scandal of thy art';[52] and here he goes on to suggest that Gay's rustics may be all too evident in the prospects of England, inasmuch as a painter may have to *search* the landscape for models of the 'simple elegance' that he wishes to see portrayed in the painting of rural life. The demand for actuality that Scott is apparently making is poised between being simply that – and so rejecting Gay's comic Pastoral on the grounds that it is unreal – and being in effect a demand to see the rural life portrayed as it ought to be, decent and edifying, even if it is not; and Scott, it should be noted, has a more humane patience with the less disciplined aspects of the life of the rural poor – the alehouse, occasional idleness – than any other poet contemporary with him.[53]

 The reasons for this change are hard to determine, and I shall discuss them later in this essay. It may sometimes seem, indeed, that there is an actually increasing demand for 'reality and truth' in the depiction of rural life, which comes at last to reveal the inadequacy of Gay's comic mode to portray the actuality of the countryside, as writers and artists became more aware of the disjunction between what they observed in the countryside and the means at their disposal to render what they observed – and this is one suggestion we can take from Scott's ambiguous lines on the subject. But this demand is almost always accompanied and undercut by a compensating desire to re-pastoralise what is then seen as the actual squalor of country life into an image of how that squalor may be avoided by the rural

poor, in a life of industry and religion. One could put it another way by saying that the poor are now *blamed* for the thoughtless animal behaviour – drinking and wenching – that the tradition of Gay had happily attributed to them: the poverty of the rural labourer is seen as the squalid consequence of that behaviour, and the poor are then urged to a temperance and industry which is depicted in the art of rural life by images no more actualised, though far less spirited, than Gay's had been or than they are in the paintings of Gainsborough's Bath period.

We can get a sense of how Gainsborough may have been struck by the disjunction between comic Pastoral, and the actuality of village life, from a later landscape of the Bath period, *Village Scene with Peasants on Horseback*, of about 1772;[54] a more dejected portrayal of the village community could hardly be imagined. This picture has none of the soaring vitality of *The Harvest Wagon*: a series of diagonals instead converge on the bottom left of the picture, where the mounted peasants sit with downcast heads on some broken-down horses which seem as dejected as their riders. Behind them, in the centre of the picture and exaggerated in scale in a way that calls

Thomas
Gainsborough,
*Village Scene with
Peasants on Horseback*

attention to their misery, is a group of two seated women, one nursing a baby, and a single standing man, all equally devoid of spirit and vigour – as one later poet of rural life wrote, 'Labour and laughter mingle now no more'.[55] The painting has been compared with the description of Auburn in *The Deserted Village*,[56] but if it does recall Goldsmith's poem, it does so in a way which synchronises the delightful aspect of Auburn's village green, topped by the 'decent church', as it was in Goldsmith's memory, with the sense of the rural community as betrayed, as it is in the poem when the village has been demolished. Goldsmith had shown the jolly village of Gay's *Shepherd's Week* as having been destroyed by the rapacity of the new rich: Gainsborough's picture shows the surviving village too as a place of poverty and despair. It is an image Gainsborough does not repeat so explicitly elsewhere, and one which would have been quite out of place among the edifying pastorals of his London period.

Thomas
Gainsborough,
*Wooded Landscape
with Boy Reclining in a
Cart*

V

The landscapes of the London period – from 1774 to Gainsborough's death in 1788 – are most of them expressive of the new image of the

poor as almost invariably at work, or if not working enjoying the benefits which, it is now to be understood, can only proceed from a sober and industrious life. We find no images now such as the *Repose*,[57] or the drawing of a boy reclining in a cart,[58] both of the Bath period, in which peasant boys are depicted in the undignified postures of unembarrassed repose; for now when the poor relax – as for instance in the *Peasant Smoking at a Cottage Door*[59] of 1788 – it is no longer as a joyful interlude from labour, but with a contentment that arises directly from the sense of labour honestly performed, so that they are careful not to appear too much at their ease.

That Gainsborough's London pastorals must be read in relation

Thomas Gainsborough, *Peasant Smoking at a Cottage Door* (detail)

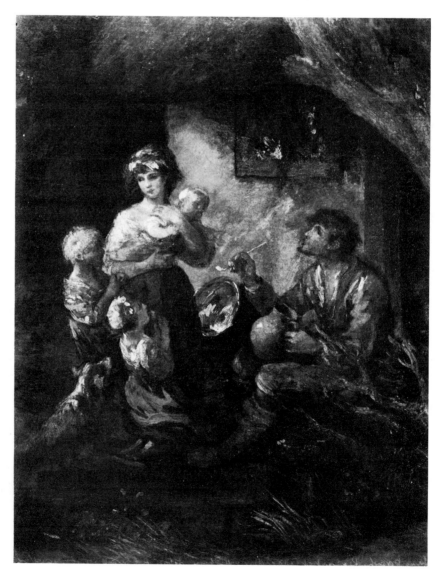

to a specific moral and political ideology, that they are concerned
to promote an image of the 'good' poor for the edification of rich
and poor alike, will become clear in what follows; and Gainsborough's
public could hardly have failed to recognise the meaning of these
pictures, for in their imagery, in the actions they depict and in the
values they seem to endorse, they are strikingly similar to the essays,
tracts, sermons, and treatises on the poor, and often addressed to
them, which became suddenly much more numerous in the 1780s,
as the rich became more aware of the threat the poor represented to
the good order of England. One such tract, which we may take as
representative, was William Paley's *Reasons for Contentment addressed
to the Labouring Part of the British Public* (1792), which was a number
of times reprinted through to 1830, and I shall quote from it where
it may help to illuminate the political content of Gainsborough's
pastorals: thus, as an epigraph to the *Peasant Smoking at a Cottage Door*,
we may take this sentiment from Paley, that he had heard it said

Thomas
Gainsborough, *The
Harvest Wagon*,
1784–5

that if the face of happiness can any where be seen, it is in the
summer evening of a country village; where, after the labours

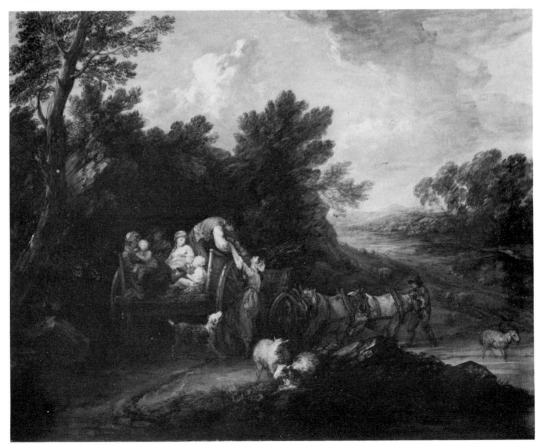

of the day, each man at his door, with his children, amongst his
neighbours, feels his frame and his heart at rest, every thing
about him pleased and pleasing, and a delight and a
complacency in his sensations far beyond what either luxury or
diversion can afford. The rich want this; and they want what
they must never have.[60]

It is the social and political implications of this new, and invariably
domestic idyll, that we shall be examining in the rest of this essay.

Nothing could speak more clearly of this new attitude to rural life
and the new demands made on the poor than a comparison of
Gainsborough's second version of *The Harvest Wagon* (1784–5) with

Thomas
Gainsborough, *The
Harvest Wagon*,
1784–5 (detail)

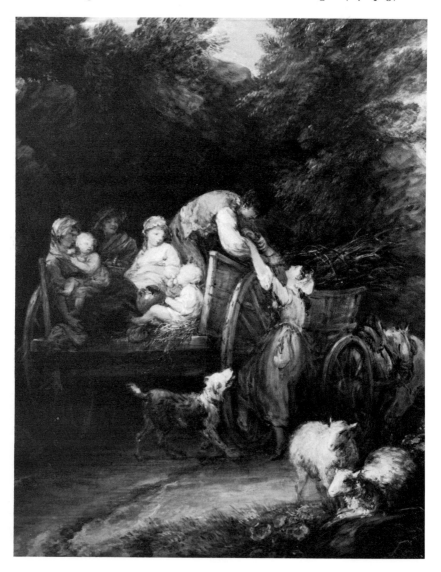

the first.[61] In the later picture, as Hayes points out, the vitality of the figures has been transferred to the landscape,[62] and it is worth asking why it has been felt necessary to take it away from the figures. To begin with, of course, the two clowns fighting over the bottle have been removed, and the clown helping the girl into the wagon now does so with altogether less appearance of effort, altogether more concern for her dignity and comfort. His attitude expresses consideration, not strength. Equally significant, the women in the cart are no longer the neat but slightly dishevelled and unattached wenches of the comic tradition: they are more relaxed, less alert, and they are the mothers of children. The new Pastoral is, as I have said, essentially domestic: it celebrates no longer the imagined vitality of the rural community, but the imagined peace of a properly

Francis Wheatley,
The Harvest Wagon

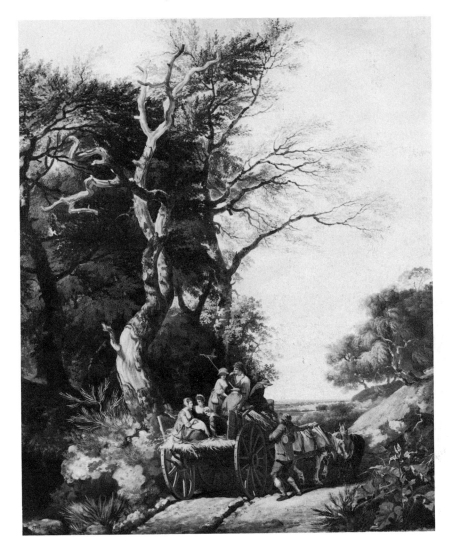

conducted family life; and, understandably more fortunate in this second version than the first, Gainsborough sold it to the Prince of Wales. In a picture of 1774, by Francis Wheatley, also called *The Harvest Wagon*,[63] a frank imitation of Gainsborough's first version, Wheatley retains some of the vertical grouping of Gainsborough's picture, but loses all its dynamic thrust; and the figures have the solemnly 'cheerful' and sober air of Gainsborough's second version.

A more straightforwardly industrious image of the rural poor is the *Cottage Door with Children Playing*, of about 1778, in the Art Museum at Cincinnati; it is one of a series of paintings by Gainsborough, including *The Cottage Door* of 1780 (?),[64] and *The Woodcutter's Return* perhaps of 1782,[65] on the same theme of rustic children and womenfolk awaiting the return at dusk of the family breadwinner. Like a number of Gainsborough's other rural subjects, this has close affinities with a recurrent theme in the eighteenth-century poetry of rural life – most famously perhaps in the lines from Gray's 'Elegy' (1751), on the rude forefathers of Stoke Poges who will not in fact be returning home to an evening welcome:

> For them no more the blazing hearth shall burn,
> Or busy housewife ply her evening care:
> No children run to lisp their sire's return,
> Or climb his knees the envied kiss to share.
> (lines 21–4)

Like the Woburn landscape, *Cottage Door with Children Playing* is a mixture of images of repose and of labour, but they are no longer combined in the *same* images, as they were for example in the woodcutter who found time to court the milkmaid but still kept his bundle of sticks in one hand, his billhook in the other. This picture instead is rigidly divided down the centre, a hard georgic imagery on one side, and a predominantly pastoral one on the other. On the darker left side, the diminished figure of a labourer struggles towards the cottage door bent awkwardly beneath a large bundle of faggots, which he carries on his shoulder; and that this is not his first journey is testified to by a second bundle which he has already set down outside the door, and by the smoke which rises from the cottage chimney. The cottage itself fills the right hand side, and out of the door spills an extended family of no less than twelve dependants, if we count the dog – the rest of them are children and attractive young *ladies* (for they almost seem to be ladies, and are surprisingly well turned-out). Arranged beside them in front of the cottage are a number of household effects – a broom, a brightly shining pan – which hint at a day spent in useful chores, though to depict these ladies actually at work would be to contaminate their delicacy.

We interpret pictures such as these as rural idylls, and this is certainly how Gainsborough and his customers, and certainly how Paley, would have thought of them – as images of the domestic felicity only available to those in humble situations; of a peaceful and a modest retirement, away from the oppressive world of court and city. But this picture emerges from a world of social and economic relations that are anything but idyllic, and it speaks to us about them, as eloquently as it does about fashionable aspirations to a soft and pastoral primitivism. We can make the point by looking harder at that extraordinary contrast between the labourer and his family; the children playing and the well-cared-for household seem happily to combine Pastoral with Georgic, and to hint at a balanced life in which repose is properly only the reward of industry; but still we cannot possibly imagine these fine ladies sweeping or scouring, and we cannot see on the dark side of the landscape an image evocative of any very Happy Britannia. That deformed and struggling labourer blights the landscape, and points to a way of apprehending the relations between rich and poor, consumer and producer, quite

Thomas Gainsborough, *Cottage Door with Children Playing*

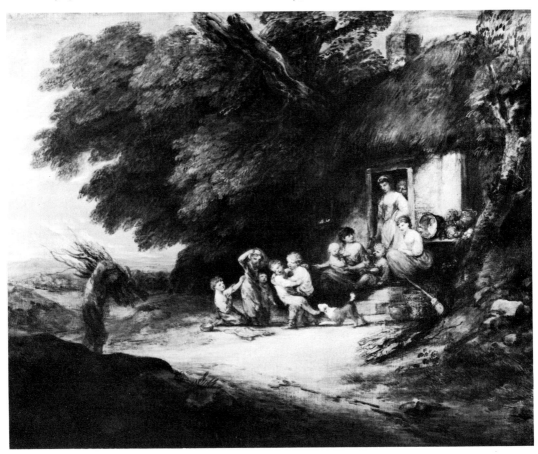

different from that in the Woburn picture. The awkwardness of his posture seems to demand that we read this picture as an image of actuality, not as a pastoral fancy; he has none of the blitheness, the ease of the ploughman at Woburn; his industry seems unending, in that rest will come too late to be enjoyed; his body suggests a pained but uncomplaining patience; he is not a dallying lover, but a dutiful breadwinner; not 'happy' now, just 'cheerful' – which seems to mean, in the language of the period, that he is careful not to be heard to complain. His industry is not now, as it was in the days of Merry England, a patriotic, a social energy, sustaining the power of a just and free kingdom; for the art of the late eighteenth century seldom pretends that English agriculture is able to provide for its labour-force, and hints continually at a crisis of poverty in the villages. This labourer works in what must be a hopeless attempt to support his vast family; and as we count the heads, we know he will need some help.

If we put this image, and others like it by Gainsborough, in the

Thomas Gainsborough, *The Woodcutter's Return*

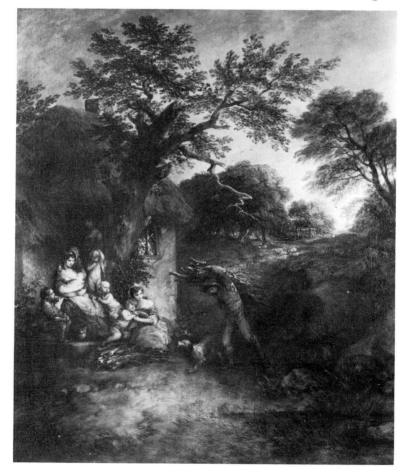

context of E. P. Thompson's account of how working-class consciousness was made in the late eighteenth and early nineteenth centuries, we can see them as attempts actively to resist or to deny the creation of that consciousness. They present the good, the deserving poor as attached to separate little domestic economic groupings which are the sole object of the labourer's attention. 'Now have the poor anything to complain of here?' asks Paley, 'the poor man has his wife and children about him; and what has the rich more?'[66] The good poor do not, as the happy labourers of Happy Britannia did, meet together in social gatherings, in the alehouse and on the green, and waste their time and energy. This change of attitude to the poor in the art of the period is neatly embodied in the lament for the ruined alehouse, in *The Deserted Village*, where 'smiling toil' retired at the end of the day to drink beer and to talk politics (lines 221–52) and in George Crabbe's response to that lament. In *The Parish Register* (1807), Crabbe made a careful attempt to correct the nostalgia and the dangerous sentimentalism of Goldsmith, and in particular adapted Goldsmith's account of the comfortable alehouse at Auburn to his own description of the cottage of the 'industrious Swain' (lines 31ff). Where Goldsmith had written

Imagination fondly stoops to trace
The parlour splendours of that festive place,

Crabbe wrote of the cottage that there taste, 'untaught and unrestrain'd'

...loves to trace
In one gay picture, all the Royal Race;

and indeed the good poor in *The Parish Register* are as fervently royalist as the lazy rustics of *The Deserted Village*, who worked for no master, may have appeared in 1807 to have been republican. Among the prints in the alehouse, 'plac'd for ornament and use', were the 'twelve good rules' of King Charles I – 'urge no healths', 'keep no bad company', 'lay no wagers', and so on[67] – but the walls of the cottage are adorned not with the rules only, but with portraits of King Charles himself, and, more topically, of 'the last Lewis on his throne', the victims of revolutions that Goldsmith's sentimental radicalism – as it now appears to be – could lead us to also. Louis is portrayed along with his wife, and with their son who has now found refuge in England:

where he
Lives and enjoys his freedom with the free;
When Kings and Queens, dethron'd, insulted, tried,
Are all these blessings of the Poor denied.

The other most notable ornaments of Goldsmith's alehouse, the 'broken tea-cups, wisely kept for shew', are absent from the cottage, but their equivalents appear more appropriately in Crabbe's rather less tolerant description of the alehouse in his own 'parish', where

Black pipes and broken jugs the seats defile.
(line 253)

The comfortable furnishings of the cottage of the 'industrious swain' are evidence of his ceaseless devotion to the improvement of the condition of his family; his evenings are spent, not in social idleness, but in the dutiful cultivation of his cottage garden (lines 129–51). But for all the comforts he can afford and the long hours he works, it seems that he cannot survive without public charity:

Thomas Gainsborough, *Mrs Graham as Housemaid*

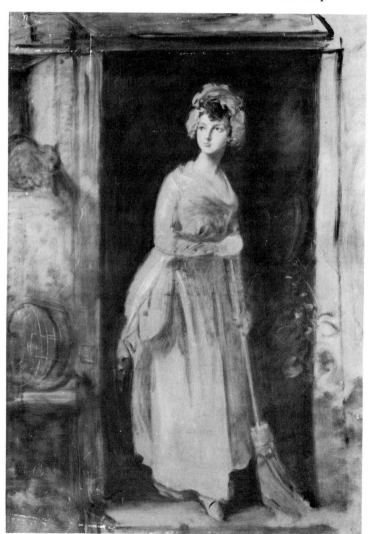

Such are our Peasants, those to whom we yield
Praise with relief, the fathers of the field;
And those who take from our reluctant hands,
What *Burn* advises or the Bench commands.
(lines 269–72)[68]

The word 'relief' there is ambiguous yet precise, at once the charity
we give and the spirit in which we praise those who genuinely deserve
it. Equally dependent on the alms of the rich are the paragons of
humble virtue – 'poor, yet industrious, modest, quiet, neat' – whom
William Cowper describes sympathetically and at length in Book IV
of *The Task* (1785; lines 374–428); and it would certainly have been
recognised in 1778 that Gainsborough's labourer would also have
been unable to support his family by his own earnings, unsupple-
mented by relief or private charity. It may seem a surprise to us,
then, that the ladies in *Cottage Door with Children Playing* are so
immaculately coiffeured and dressed, and that their features have a
delicacy that hardly seems to have known poverty. We will be less
surprised, of course, when we remember that this painting may be
read from right to left, as well as from left to right – it is an idyll,
as well as a prescription for the proper way of life of the humble
countryman, the virtuous simplicity of whose life the rich could envy.

For still more evidently than the milkmaid in the Woburn picture,
these ladies hover between simple neatness and positive elegance;
between an identity as the dutiful womenfolk of a good rustic and
as the shepherdesses of courtly Pastoral. An unfinished picture of this
period by Gainsborough used to be known as *Mrs Graham as
Housemaid*[69] – its title, and the delicacy of its conception together,
make the point that whatever attractions an imagined social descent
had for the rich, they were imagined as available on the easiest terms
– simply to hold a broom was to gain all that the dutiful poor had
to offer, but to lose none of the refinement which only the rich
enjoyed. The most embarrassing example of this type of painting
must certainly have been the *Portrait of a Swiss Lady and Gentleman,
as Swiss Peasants*, which J. S. Masquerier exhibited at the Royal
Academy in 1804, above a tag from *The Deserted Village*:

But a bold peasantry, their country's pride,
When once destroyed, can never be supplied.
(lines 55–6)

The painting is one of numerous attempts, from 1790 onwards, in
painting, in poetry, in criticism, to anaesthetise what seemed at that
time to be the radical energy of Goldsmith's poem, whether (as here)
by stressing the vestiges of the rococo in his portrait of the 'peasantry',

or by pretending that his regret at the destruction of the village is an exclusively personal regret, for his own lost innocence.

The right hand side, then, of Gainsborough's *Cottage Door with Children Playing*, is appealing to the traditional pastoral fantasies of the polite culture, now in the guise of the new, fashionably serious morality we associate with the period of the rise of Methodism and of the Evangelical Movement. The fashion now is to condemn the worthless round of fashionable pleasures, and to try to appropriate the cheerful industriousness and the simple neatness which the rural poor were by various pressures first obliged to exhibit, and then envied for possessing.[70] 'I have no propensity to envy any one', affirms Paley,

> least of all the rich and great; but if I were disposed to this weakness, the subject of my envy would be, a healthy young man, in full possession of his strength and faculties, going forth in a morning to work for his wife and children, or bringing them home his wages at night.[71]

As we read this picture, however, from left to right – from the position of the exhausted labourer, whom no polite connoisseur could identify with, the surprise remains at the ladies' delicacy, and points to a functional but embarrassing paradox at the centre of the late eighteenth-century attempt to define the image of the deserving poor – for it is not too much to say that in this period a primary function of the painting *and* poetry of rural life is to help us distinguish between these who are, and those who are not, the worthy recipients of public and private charity. The paradox is, that these who need the least help, will attract the most: the deserving poor are characterised – and not by Gainsborough only, but by the painter Francis Wheatley, by Crabbe and Cowper, and by the writer of evangelical tracts, Hannah More – the deserving poor are characterised by extreme neatness, and an air of reasonable material, as well as spiritual, well-being; while the undeserving are recognisable from the extreme degradation of their manners, expressions, and dress. What justifies the paradox, of course, is that the good poor work, and take a decent pride in their appearance; while the undeserving, who do not work, feel no shame at the abject appearance they exhibit. As Hannah More points out, it is a 'common mistake, that a beggarly-looking cottage, and filthy-ragged children', raise most compassion 'for it is neatness, housewifery, and a decent appearance, which draws [sic] the kindness of the rich and charitable, while they turn away disgusted from filth and laziness';[72] and Cowper complains angrily of those overseers of the poor who are

> lib'ral of their aid
> To clam'rous importunity in rags,
> But oft-times deaf to suppliants, who would blush
> To wear a tatter'd garb however coarse,
> Whom famine cannot reconcile to filth.
> (*The Task*, IV, lines 413–7)

The successful suppliant, then, will keep up appearances, as do the ladies in this picture – for the rich know perfectly well that those who *look* like beggars are ragged only through idleness, idle only through inclination, and that rags and tatters are a sort of rhetoric adopted only to solicit our concern. The discerning almsgiver uses charity as a reward to the poor for pretending that no charity is needed, that there is no rural crisis, that a hard day's work will still bring the honest workman a competence adequate to all his visible needs.

VI

This paradox points, though, to what remains a puzzle for many students of the literature and painting of the end of the eighteenth century: that both appear, in comparison with the art of the mid-century, to be at once more benevolent, and more repressive, in their image of the poor. The answer to the puzzle seems to lie partly in certain changed attitudes to the conventional imagery of the art of rural life, and partly in a new sense of inevitability about the way wealth is distributed. In the first place, as I noted earlier, one side of the history of the art of rural life in the eighteenth century is of a continued attempt to adapt the conventional image of Pastoral to allow an apparently more realistic portrayal of English life. Obviously enough, this involved a greater and greater insistence on the imagery of work – an imagery that first qualifies, and then entirely replaces, the imagery of an idle pastoral life imagined as being led by courtiers in disguise. But this is not a change made simply in the service of disinterested accuracy; it is not description only, but prescription; the poor must be shown at work, not only because that is what they do, but because that is what they *ought* to do. A part of Crabbe's irritation with *The Deserted Village* was that it retained the ideal of an idle life, but applied it to the poor; for Goldsmith looked back to an imaginary past,

> ...ere England's griefs began,
> When every rood of ground maintained its man;
> For him light labour spread her wholesome store,
> Just gave what life required, but gave no more.
> (lines 57–60)

The poem thus seems to offer a pastoral vision that has been radicalised, and so may easily answer the charge often levelled against it – and based on the assumption that the more actualised an image is, the more humane it will be – that Goldsmith's nostalgia is for a conventional literary ideal, and not for a rural community which could, at any time, have existed. It is perfectly true that, for example, Goldsmith hardly seems to mention the labour his villagers perform except to show them not, actually, performing it – his interest is in the periods 'when toil remitting lent its turn to play' (line 16); and so his images of the inhabitants of Auburn are almost exclusively images of them at rest – seated beneath the hawthorn tree, or dancing on the green. His couplets certainly lack the force of Pope's, or of many of Crabbe's, which derives from the conflict of the sort of antithetical forces which are so notably absent in Auburn; and the verbs that describe his past experiences of the village are languid rather than energetic – 'loiter'd', 'paus'd'. But this concentration on leisure may have been precisely the point, a point confirmed by that feature of the village before its destruction which, in the description which opens the poem, is most conspicuous by its absence – the hall. For the bold peasantry of England, thought Goldsmith, the lightest labour would easily secure the necessaries of life, if as freeholders once again they were obliged neither to pay rent, nor to work for money wages. Goldsmith disengaged the labourer from his 'proper' and 'natural' identity as a labourer, as a man born to toil, and suggested that he could be as free to dispose of his time as other poets agreed only the rich man or the shepherd was free to do. For Paley, it was the poor man's chief blessing, that he 'never goes to bed at night without having his business to rise up to in the morning'; and if the poor could 'choose the objects of their activity', then 'lost in the perplexity of choosing, they would sink into irrecoverable indolence, inaction, and unconcern;'[73] and as far as Crabbe was concerned, though we might well pity the labourer's hard life, it was unwise and even fraudulent to invite him to see himself as anything other than a labourer; we must reconcile him to his lot, not seek to change it.

> Is there a place, save one the Poet sees,
> A land of love, of liberty and ease;
> Where labour wearies not, nor cares suppress
> Th' eternal flow of rustic happiness;
> Where no proud mansion frowns in awful state,
> Or keeps the sunshine from the cottage-gate;
> Where Young and Old, intent on pleasure, throng,
> And half man's life is holiday and song?
> Vain search for scenes like these! no view appears,

By sighs unruffled or unstain'd by tears;
Since vice the world subdued and waters drown'd,
Auburn and *Eden* can no more be found.
(*The Parish Register*, lines 15–26)

By the end of this passage, the generalised 'Poet' of the first line has
been particularised as Goldsmith, and the charge Crabbe brings
against him is not simply that he is nostalgic for a Golden Age that
never existed, but that his nostalgia is touched by a delusive and a
levelling radicalism. Thus 'liberty' in the second line artfully
contaminates the words on either side of it – reducing the 'love'
which is an essential theme of Pastoral to promiscuity, and the 'ease'
of the pastoral shepherd to indiscipline; and it is itself in turn
contaminated by 'love' and 'ease', which convert the radical cry for
liberty into a naive demand for the freedom to sleep late and to sleep
around. In the couplet that follows, by reducing this demand for a
life of ease to an absurd contradiction ('where labour wearies not'),
Crabbe is able to present the demand for equality, too, as equally
absurd, so that it seems that the contrast between the rich and the
poor, the mansion and the cottage, is as natural as that between light
and shade, and as inevitable as the fact that labour wearies, and does
not refresh, the labourer.

It is absurd, too, that the poor should be 'intent on pleasure',
though at this point Crabbe appears no longer to be focussing
exclusively on the aspirations of the poor, as he had been earlier, in
his references to 'labour', '*rustic* happiness', and the overshadowed
cottage; he has now widened the scope of his satire, and speaks more
generally of 'young and old', 'half *man*'s life'. But 'man' here is the
conveniently undifferentiated term we saw it to be in *The Seasons*, and
it allows Crabbe to attack the naive aspirations of the poor while
seeming to attack the longing for eternal, unbroken happiness in all
classes; for he is about to pretend that the curse of Adam, or some
compensating evil, is visited on all men, whatever their degree or
condition, and that the demand for equality was answered as soon
as Eve ate the apple.

There are, however, two submerged references to earlier poems in
the line

Where Young and Old, intent on pleasure, throng,

and if we drag them to the surface they make the true direction of
Crabbe's satire perfectly clear. 'Young and Old' is in this context
an unmistakeable reference to Goldsmith's description of the rustic
sports at Auburn,

> The young contending as the old survey'd,
> (line 20)

and the phrase 'intent on pleasure' is borrowed from Cowper's account of the rich absentees who

> intent
> On pleasure, haunt the capital
> (*The Task*, IV, lines 589–90),

and neglect their responsibilities in the country; and that Crabbe presents here as an impossible dream what Cowper attacks as a lamentable fact makes it clear that the dream is impossible for the poor only. But their condition is not therefore hopeless – at least not for those with the 'will' to accept their lot, and then to improve it; for

> Toil, care, and patience bless th' abstemious few,
> (line 29)[74]

and the 'industrous swain', who is not taken in by the fraudulent pastoralism of Goldsmith, could hope to find in Crabbe's parish, as he could in Lambert's *Hilly Landscape*, a place in the sun, a neat cottage where

> the sun's last ray
> Smiles on the window and prolongs the day.
> (lines 33–4)[75]

There was a similar conflict late in the eighteenth century between the social philosopher Malthus, who, like Crabbe, believed in an intimate connection between toil and virtue, and the radical William Godwin, who believed, as the Goldsmith of *The Deserted Village* seems to have done, that only by leisure were men free to improve their minds and morals; and when in the 1790s Godwin calculated that man need work only half-an-hour a day to secure a basic living[76] he was attacked by Malthus for peddling a spurious pastoralism. The principle of population, asserts Malthus, is

> decisive against the possible existence of a society, all the members of which should live in ease, happiness, and comparative leisure; and feel no anxiety about possessing the means of subsistence for themselves and families...[but]...let us not querulously complain that all climates are not equally genial, that perpetual spring does not reign throughout the year, that all God's creatures do not possess the same advantages, that clouds and tempests sometimes darken the natural world and vice and misery the moral world, and that

all the works of creation are not formed with equal perfection.
Both reason and experience seem to indicate to us that the
infinite variety of nature (and variety cannot exist without
inferior parts, or apparent blemishes) is admirably adapted to
further the highest purpose of the Creation and to produce the
greatest possible quantity of good.[77]

The attack on the dream of ease at the heart of Pastoral, and on the
persistence, in a world 'subdued' by 'vice', of the pastoral myth of
'perpetual spring', the imagery of light or rather of darkness, the
comfortable acceptance of 'variety' in the fortunes of the rich and
poor as 'natural' – these features of Malthus's critique of Godwin all
anticipate the attack on Goldsmith by Crabbe, and are answered by
Godwin in terms that reaffirm his conscious pastoralism: if Malthus
is right,

> then the equalization of property, of which poets have
> dreamed, and which many of the sanguine votaries of human
> improvement have imagined might one day be realized on
> earth, would be of no advantage to any one creature that
> should exist. The golden age would be an age of iron. The
> hopes of the human race would indeed be reduced to nothing.[78]

At the end, then, of the century, the conventional imagery of pastoral
or pastoral–georgic poetry was rejected by most of the writers of the
polite classes, to be appropriated by radical writers, and by the
humble poets of rural complaint, who demanded some of that leisure
for the ploughman and thresher, which the shepherd and the
gentleman–philosopher had long enjoyed.

Before we leave *The Deserted Village*, it is worth discussing a
question which my reading of the poem raises: at what point was the
radical potential of its agrarian egalitarianism recognised? To
answer that question we need first to answer another: at what point,
after the rhetoric of writers and artists whose work seems to confirm
the *status quo* had become more exclusively and more severely georgic,
was the the pastoral vision of society appropriated as a radical
ideology? A number of elements in the poem – the landscape without
the hall, the account of England as formerly a nation of small
proprietors, the description of the alehouse – might all in 1770 have
been found disturbing by its first readers, less as suggesting the
possibility of a redistribution of property in land than as apparently
hostile to the increasing insistence on the discipline of labour. But the
first reviews of the poem suggest that the threat those elements might
have represented was at the time not so much emphasised as diffused
by the idealising, pastoral aspect of the poem. In fact, approving

discussions of an egalitarian distribution of land – confined as they were to works destined for a polite readership – were more acceptable at this time than they later became: Robert Wallace (*A Dissertation on the Numbers of Mankind*, 1753) and William Ogilvie (*The Right of Property in Land*, 1781) both discussed the possibility of such a distribution without attracting hostile attention. When Godwin advocated a similar – infinitely delayed – distribution in *Political Justice* (1793) he attracted more attention, and escaped arrest probably on the ground only that his book was too expensive to be circulated widely; Thomas Spence, at the centre of whose political programme was a redistribution of the rent of land to be achieved by revolutionary means, and whose pamphlets were dangerously cheap, was imprisoned in 1794 and again in 1801. It seems in fact that the polite classes in the eighteenth century had no fear of such notions making much headway among the poor until the 1790s; that to write approvingly of them in the polite literature – where an agrarian egalitarianism appears either as an imagined original, as in Goldsmith's poem, or as a theoretical or remote ideal – was more or less acceptable till then; and that only from about 1790 could *The Deserted Village* be read as a radical poem which pointed (by implication) to the future as well as to the past. And therefore when I refer to what Goldsmith 'said', I am pointing to what he was *understood* to have said, by those, radical or otherwise, who discovered radical implications in his poem twenty and more years after it was written.

VII

Crabbe's attitude to the labourers – that we may pity them, but should not suggest that they are capable of being anything else – is a clear example of that apparent mixture of repression and benevolence in the rural art of this period. It is not just that the rich have the power to be benevolent because they have, simply, power, to exact justice or to show mercy,[79] but that the act of benevolence is itself an act of repression. The point can be grasped by examining one final group of Gainsborough's painting of rural life – his late paintings of the children of the poor. I am thinking of such subjects as the girl feeding pigs, of 1782;[80] the peasant girl gathering sticks, of the same year;[81] the cottage girl with a dog and a pitcher, of 1785;[82] the young woodgatherers, of 1787.[83] The glum and sometimes pixie-like faces of these children were no doubt easily able to move Gainsborough's customers to sigh over the fact that, when they might have been playing, they were hard at work to contribute their mite of labour to the cottage economy. But such sympathy goes only so far; however meek, vulnerable, these children are, they must be working, if they are to earn our sympathy. The bundles of sticks, the

pitcher, are not mere items of local colour, but their passports to our heart. The truly benevolent attitude in the period, expressed everywhere in the writings on the poor, is that their children should, in their own best interests, be so brought up as to be 'inured' – the word occurs over and over again[84] – 'inured' to hard labour; they must experience the pain of overwork so early, that it becomes not a pain at all, but an ever present absence of feeling; and Crabbe is not the only writer to go so far as to recommend forced labour for the children of paupers.[85]

These pictures, then, are touching partly because of the evidence they afford of young children early learning the habits of a pious industry. In the most famous of all Hannah More's tracts, *The*

Thomas
Gainsborough,
*A Peasant Girl
Gathering Faggots*

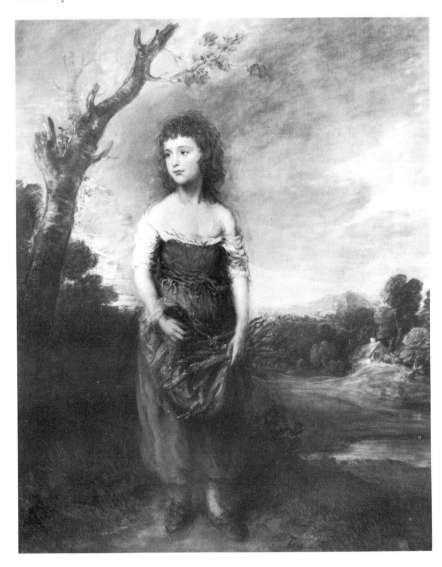

Shepherd of Salisbury Plain, of 1795, just such a young girl as Gainsborough painted spends all day collecting the sparse tufts of wool left by the sheep on the bramble bushes, and she proudly reports her success to her father, a thoroughly industrious shepherd, who happens at that moment to be making a considerable display of his pious poverty to a gentleman traveller. The gentleman is delighted with the little girl's efforts; and the shepherd has already told him that, though in the normal course of things he sends his little sons to work in the fields, he would send them to work even if they got nothing for it, so important does he believe it to be for them to acquire the habit of industry which is, after all, its own reward – and so accustom them to accepting that they are born to a life of endless

Thomas
Gainsborough,
Cottage Children (*The Woodgatherers*)

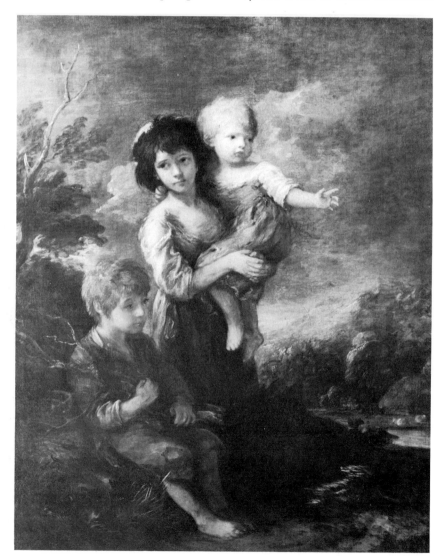

toil. In return for this acceptance that the labourer's lot is ordained by nature, neither the responsibility of the rich nor capable of being changed by protest or social action, the grateful shepherd receives a present of five shillings from the yet more grateful gentleman. The repression here is in the demand that the poor deny they are repressed at all, if they are to awaken our benevolence.

The teachings of church and chapel[86] combined at the end of the century with the rising science of political economy to reassure the rich that whatever responsibility they might feel to relieve the condition of the deserving poor, they were in no way responsible for causing it: 'the laws of commerce', says Burke, 'are the laws of nature, and consequently the laws of God'.[87] Even begging, which the children of even the able-bodied poor are forced into, comes to seem natural on these terms, as it calls forth a benevolence from us that we would be shocked to think unnatural. As Jean Starobinski writes,

> Gainsborough...donne un air de bonheur poétique jusqu'à ses enfants mendiants, comme si l'univers idéal incluait nécessairement l'archétype serein du mendiant.[88]

Gainsborough, Starobinski is arguing, *naturalises* the extreme poverty of the poor – he presents it as a fixture in a changeless world which is the best of all possible worlds. Much the same point is made by William Hazlitt in his brilliant remarks on the poetry of Crabbe, 'a Malthus', as he calls him, 'turned metrical romancer'. Crabbe, he argues, 'professes historical fidelity; but...[he does not] give us the *pros* and *cons* of that versatile gipsey Nature'; 'his song is one sad reality, one unraised, unvaried note of unavailing woe'; 'it gladdens no prospect, it stirs no wish', but offers us only 'incessant matters of fact'; it is 'the *still life* of tragedy', for, finally, 'whatever is, he hitches into rhyme' – a phrase which indicates, by its absolute use of the verb 'to be', the correspondingly absolute, unconditional 'reality' of Crabbe's world, and emphasises the point by echoing Pope's dictum, in the *Essay on Man* (I, 294), that 'whatever is, is right'.[89] The sympathy that Crabbe and the late Gainsborough evoke for the poor is absolutely limited by such considerations as these. Both depict the poor as degraded, as indeed they had become by the process of transforming a paternalist into a capitalist economy; but the sympathy of both men presents itself as a sort of moral compensation for the effects of that process. They become more expansively benevolent in proportion as they represent the poor as more repressed, and congratulate the very classes that were responsible for the repression of the poor for the humane concern they feel at the results of their own actions.

A final glance at the *Cottage Door with Children Playing* will help this point too: as the labourer slowly carries home his bundle of faggots, he appears to be working for no employer or landlord, but for his family only, the sole recipients of the product of his labour. The rich are no longer the absent consumers of that product, but benevolent spectators on the labourer's struggle to survive; incapable of raising his real wages or lowering the real value of his rent, they are anxious only, in their demand that he maximise his productivity, that he will be able to work hard enough and long enough to feed his many dependants.

VIII

The changes we have observed in the imagery of Gainsborough's landscapes and rural *genre* pieces, and which I have described in terms of a progressive appropriation of the material of the Pastoral by the Georgic, is closely related to a change in social and political ideology which we can hardly fail to notice when we compare almost any writings on social or religious morality from the early part and from the end of the eighteenth century. The subject is too large to be discussed here at any length, but in natural theology, for example, we are bound to be struck by a change in the handling of the problem of the apparent imperfections in the Creation, which is absolutely relevant to the theme of this essay. For the Pope of *The Essay on Man*, and to a lesser extent for the Thomson of *The Seasons*, all such imperfections are apparent only, and the task, if it can be so called, of the wise man is to learn to see these imperfections in a wider perspective as partial evils necessary to the production of a universal good, of an actually perfect whole: the truly wise man rightly perceives, for example, that social and economic inequalities are necessary to the divine plan, in the way that we have noted before, that light and shade are necessary to perfect harmony. By the end of the century a small but significant change is evident: rightly to perceive the apparent imperfections in Creation is to grasp that they are part of God's deliberate plan to ensure that we act rightly, or indeed simply that we act: a world, says Paley,

> furnished with advantages on one side, and beset with
> difficulties, wants, and inconveniences on the other, is the
> proper abode of free, rational, and active natures, being the
> fittest to stimulate and exercise their faculties.[90]

Thus poverty, for example, to Paley, or to Malthus, is, rightly understood, nothing else than the stimulus provided by God to our industry and self-improvement.

In 1700, industriousness was not an important virtue; in 1800, it

is the chief, and often seems to be the only virtue. We are right to understand this change broadly in terms of the change from a paternalist to a capitalist economy: industriousness is the prime and self-proclaimed virtue of the capitalist entrepreneur; but we should also notice in this connection that the change of emphasis from wise passiveness to wise activity involves a change, too, in whose virtue and whose wisdom is in question. Virtue is passive in 1700 because it is the virtue of the gentleman that is of most concern, and of the retired gentleman that is most praised; it is active in 1800, because the poor labourer is now at once the model of the industrious, and so of the virtuous life, and the man on whom the wisdom and necessity of continuous industry must be more and more urgently and oppressively enjoined, if the outlay of the entrepreneur is to find its proper reward.

For all their sentimentality, the pictures of working children by Gainsborough represent the final triumph of the Georgic over the Pastoral in his portrayal of the poor. And not only Gainsborough but between 1780 and 1820 Crabbe, Cowper, and as we shall see Constable, too, all oblige us to see the only alternatives in the depiction of the rural poor as the Pastoral and the Georgic; when they drive out the pastoral image, they ask us to agree that they are driving out a merely false vision; when they leave us the Georgic, they expect to agree that they are leaving us with a purely truthful image, for Creation has indeed been left deliberately imperfect, its imperfection has made work necessary to the poor and so natural to them, and nature is truth. The mixed image of Happy Britannia had of course been a false one; it had tried to conceal the divisions in English society as firmly as this later Georgic reveals them. But it's not surprising that by the articulate peasant and rural labourer that mixed image was preferred – so that by 1800 so apparently conventional a poem as *The Deserted Village* could seem to the literate poor an excitingly subversive one, quoted with approval by such radical writers as Thomas Spence and William Cobbett.[91] It offered the image of a past without masters, when nature gave everyone enough to eat in exchange for the least possible labour, and when the best part of life was spent in the alehouse and on the green. The ideology of Happy Britannia, expressed by Gainsborough's Woburn landscapes, and in its different way by *The Deserted Village*, offered a false vision of course, but a valuable one; for it did offer, to a later generation, at least the sense that the present social order was not natural and permanent, but recently developed; and seen in this light, the 'real history' that Raymond Williams has praised Crabbe for introducing into the tradition of rural poetry,[92] as opposed to the nostalgic mythology of Goldsmith, is revealed instead as an attempt

to abolish the sense of history altogether. The reasons for that attempt are clear enough; for only those who think that the past was different from the present are enabled to imagine that the future may be so too.

2 George Morland

The low and ignorant characters with whom Morland associated, formed...a sort of moveable gang, horde, or commonwealth, that, in whatever situation or circumstances, was sure to be *always at home*; and, however various in other respects, never failed to agree in that of belonging to one certain order of the 'guards;' each subsisting 'some how or other,' but all in equal defiance of the *social decencies*.

While their chief sojourned at a house on the Edgeware Road, a genteel personage one day knocked at the door: a fellow who, it seems, went by the name of 'Winking Bob', was ordered to reconnoitre:

'Well *governor*; what do *you* want?'

'Mr. Morland at home?'

'Don't exactly know just yet: what's your name, *cocky*?'

'No matter for my name, I suppose: I want to see him – want to look at his pictures.'

'By G— you'll neither see his pictures, nor him, unless you *tip us* a little bit of your name!'

'Very odd, Sir! Perhaps I want to *buy* a picture.'

'Mayhap you may: all's one for that *there*: but you can't see him, I tell you, without your name.'

'Why then tell him, Sir, if you please, that Lord D—y –'

'Oh, d—n *Lords*,' vociferated Morland out of a garret-window, 'I paint for no *Lords*: shut the door, Bob; and bring up Rattler and the puppy!'

(F. W. Blagdon, *Authentic Memoirs of the late George Morland*)[1]

I

George Morland was the most prolific, and therefore probably the most popular, painter of the life of rural England in the period covered by this book, and indeed in the whole history of English painting. During his short life – he died in 1804 at the age of forty-one – he may have produced as many as 4,000 paintings and drawings,[2] most of them sporting, farmyard, or village scenes, and in the last eight years of his life, when hardest pressed by his creditors, his output was quite remarkable: nearly 800 pictures, and about 1,000 saleable

drawings.[3] His prices were not high, for he was willing to accept almost any price offered to finance his drinking or to pay off his debts,[4] and he sold a large number of his pictures while they were still on the easel,[5] and sometimes to more than one buyer.[6] His loose technique and rich, broad shadows made his paintings as suitable to the method of mezzotint engraving as his rural imagery was congenial to contemporary taste, and he became still more popular by engravings of his work than by his paintings: during his lifetime well over 300 engravings were made of his work,[7] again mainly of his rural subjects, and they continued to be produced in considerable numbers for some years after his death. Yet Morland, if not exactly forgotten now – most writers of the history of English painting concede him a dismissive and condescending paragraph or two – has certainly been buried, in the cellars and stores of our art galleries, and his work has never been as little admired as it is now.

This change in the valuation of Morland's work is perhaps the more remarkable, in that the qualities that now seem to be taken as characteristic of his art are exactly the opposite, as we shall see, of those noticed by his contemporaries. In this century there has been some disagreement, certainly, about Morland's abilities as a painter, but there has been none about the nature of his subject-matter, and he is now seen as entirely sentimental in his version of late eighteenth-century rural life. In the years immediately after his death, the rural paintings he produced were responsible for much nervousness and confusion among his critics, who praised, but were disturbed by, what they saw as his ability to represent the poor without affectation or idealisation; and yet in this century the same images have seemed positively Arcadian to writers as different in their critical persuasions as, for example, Roger Fry, John Berger, and William Gaunt; who seem quite unaware that his originality was once thought to consist in an uncompromising fidelity to nature. The change may be partly the result of the difficulty of coming across sufficient examples of Morland's work to form an adequate judgement of it, and the consequent tendency to take the engravings as a substitute for the paintings; but still, as we shall see, there are pictures easily inspected in the cellars of the Tate which one might have expected to force divisions between the three men.

In his *Reflections on English Painting* (1934) Roger Fry first expressed what has become this remarkable consensus on the nature of Morland's art: a note of surprise that a man who spent so much time in 'country pot-houses' and 'would have nothing to do with the polite world' should still have accepted from that world

the purely fictitious Arcadian figure of the simple peasant – the peasant as he appeared in illustrations to edifying books for the

young, where the good lady delights in distributing alms to the deserving poor. Even his trees, his cottages and his cart horses take on something of the same unreal air of properties in a pastoral scene.[8]

To George Dawe, of Morland's early critics the most troubled by his insistent actuality, Morland's cottages as well as their inhabitants were deficient in taste;[9] so that Morland is chastised by Fry for doing exactly what Dawe would have praised him for doing in 1807 – for inventing a class of simple peasants who did not exist, and passing them off as images of 'the lowest part' of society.

In a brief essay on Morland in *Permanent Red* (1960), John Berger, after noting that his early pictures were mostly 'drawing-room anecdotes or *galanteries*', goes on to point out that around 1790

> Morland changed his genre and began to concentrate on his more famous rustic scenes, set, as it were, Beneath the Spreading Chestnut Tree. These appealed to the current sentimentalization of Rousseau's doctrines, but were in fact as artificial and dressed up as his earlier pictures.[10]

Berger's notion of how Morland did sentimentalise the rural life of late eighteenth-century England is rather different from Fry's – he is attacking not the older pastoral tradition to which Fry sees Morland as attached, but the comic idealisation of Merry England, 'the idea behind the farmyard scenes that Nature was all bacon and ale'.[11] The charge, however, is in essence the same, and the difference reveals only a rather sharper sense of history in Berger than in Fry, which has stopped short however of considering whether the image of Merry England was in every respect as comforting to the buyers of paintings in 1790 as it had been thirty or forty years earlier. And there is a world of difference between that comic image of Merry England and 'the current sentimentalization of Rousseau's doctrines' that Berger connects with it – the latter is far better represented in the late paintings of Gainsborough, with their enclosed, domestic communities; and if criticism of Morland does not begin, as it did in the 1800s, with a clear awareness of the opposition between the social vision of Morland and that of Gainsborough, it can hardly be said to begin at all.

In his remarks on Morland in *English Painting* (1964), William Gaunt is close to Berger, though perhaps closer still to Fry:

> In spite of the rough realities of his career he created an idyll, an Arcadian vision of tranquil cottagers, never, as Sickert remarked, seen at work...of picturesque farmyards and their animals which he painted with masterly skill, of

domestic-looking alehouses about which cluster mild and temperate groups.[12]

We shall discuss in a later section how far this is an adequate description of the painting Gaunt reproduces to illustrate this judgement, *The Alehouse Door*.[13] What is most remarkable here, perhaps, is Gaunt's assumption that there must have been a necessary opposition between the 'rough realities' of Morland's life and what is taken to be his 'idyll of rural life' – an assumption that derives from the belief that in the 1790s Morland's customers would have preferred to see images of men at rest to images of them at work; or that they would have preferred to see them relaxing in alehouses than in front of their own neat cottages. Gaunt's remark about work – so reminiscent of the criticisms of the *Deserted Village* examined in the previous essay – is borrowed, as he acknowledges, from an earlier judgement by Walter Sickert, in comparing Morland with the Barbizon painters, that

> all, or nearly all, of Morland's works are restful or lazy in subject, whereas those of Millet and Bastien Lepage are full of toil or the sense of toil past and inevitably to come.[14]

By the late nineteenth century, it had become axiomatic that whether in literature or the visual arts the actuality of the life of the poor could be represented only by images of them at work, and that to depict the poor at rest was to sentimentalise or to pastoralise them – indeed, Thomas Hardy, for example, seems to have no way of depicting the leisure of the poor except by exploiting the comic–pastoral possibilities in the situation. We have already glanced at this notion in our discussion of Gainsborough, and noticed its origin as a prescriptive, not a descriptive, constraint: it is not so much that the poor always do, but that they always should, work; and its survival into the late nineteenth and twentieth centuries, as a check against sentimentality, has meant that it has also become a barrier between seeing the poor as simply workers with no other identity, and the possibility of seeing them as men with their own choices to make, and a disposition to do other things than the toil they were born to perform.

As we shall see, however, Morland's contemporaries were much disturbed by Morland's images of idleness, which were for them too reminiscent of those habits of dissipation which, if they cannot be shown to have made Morland idle, in the face of his astonishing output, were readily connected with idleness in the rural poor; so that of his more acceptably moralised subjects, one critic remarks that he should have 'taken a moral lesson from...his own works'.[15] There

is then a surprising want of a historical sense in the remarks of both Gaunt and Berger – in the assumption that what looked like an only too acceptable sentimentality in the 1960s must have looked the same in the 1800s, and that what was an acceptable image of rural life in the middle of the eighteenth century must have been equally acceptable fifty years later. This generalised, or flattened, idea of the eighteenth century as an 'age of stability' – of stable social relations and attitudes – is one we can now see rather as the product of an age of stable historiography than as an adequate account of the period it pretended to describe, but it still has sufficient currency to distort and to anaesthetise the content of Morland's paintings.[16]

The current valuation of Morland's art has produced a situation in which it is fairly difficult to approach his work. It explains why it is now so hard to find his paintings: few galleries are willing to exhibit more than one or two examples, chosen invariably for their 'representative' nature, to confirm, that is, what has become a stereotyped idea of the nature of his art. Mezzotints after his paintings, often excellent ones by William Ward or John Raphael Smith, are on the other hand fairly easy to find – the British Museum has a vast collection, and they turn up continually in the shops of print-sellers – but they usually give a very distorted impression of the paintings. There has been no full-length study of Morland's art since 1907 – no such well-illustrated scholarly monographs such as have recently appeared on his near-contemporaries, Hogarth, Gainsborough, Reynolds, Stubbs, Wright of Derby, Constable, even Francis Wheatley; this means that a writer approaching his work has no obvious *point d'appui* such as is provided by the considered judgements of writers who have devoted much time and thought to the study of other painters; and it means too that no attempt has been made to separate genuine works by Morland from the imitations and forgeries that have been passed off as his. The forging of works by 'Morland' was an acknowledged scandal in the first decades of the nineteenth century; and in a notebook entry of 1811 William Blake suggests that two paintings of Morland's that he had engraved for John Raphael Smith were the works of 'a Correct Mind & no Blurrer', and so probably by Peter le Cave, a self-confessed forger of 'Morlands'.[17]

Nor can the work of Morland be approached in terms of any obvious literary or artistic influences, for even more than Gainsborough, he detested reading, and would even snatch newspapers out of the hands of friends who attempted to read them in his presence.[18] He probably did not read a single book after he had left his parents' house at the age of twenty-one or twenty-two; and though while he was living at home he produced a series of illustrations to *The Faerie*

Queene,[19] and later painted subjects for example from Fielding's novels, we are likely to have less the sense with Morland than we do with Gainsborough or Constable that he was preoccupied with issues in the representation of rural life that were also the preoccupation of contemporary writers. He was similarly uninterested in the work of other painters: at his parents' house, he was brought up to study and admire the work of seventeenth-century Dutch masters, and of Gainsborough and Stubbs,[20] and the influence of Gainsborough is everywhere apparent in his landscapes; but in later life he would not look at the work of other men, for fear apparently of compromising his originality,[21] and he once announced that he would not cross the street to look at the finest collection of paintings ever assembled.[22] This does not mean, of course, that it is illegitimate for us to examine Morland's work in the light of the tradition of painting and writing about rural life that we are studying in this book; but we will find ourselves doing so more by way of contrast than of comparison, and always bearing in mind that Morland quite deliberately isolated himself from the contemporary culture of the polite classes for whom he painted; and the fact that he preferred to spend his time with his social inferiors means also that he could not have been much exposed to the assumptions of that culture even in the course of conversation and everyday social contact.

One might add to this list of the difficulties in the way of a reconsideration of Morland the apparently excessive interest in his life, at the expense of his work, that is shared by all who have written about him at any length; and certainly in the last fifty years writers who have produced only a page or two on Morland have tended to insist that because his 'bohemian' style of life hardly enabled him to produce masterpieces, his work is hardly worth extensive discussion. But in fact an awareness of a number of aspects of Morland's life is of great importance in understanding his work, and perhaps only by bearing in mind the social attitudes implicit in his behaviour can we grasp those implicit in his pictures, and come to understand why the judgements made on his work by his contemporaries are so often full of contradictions, and why these judgements remain for all their confusion so exactly the opposite of what has become the twentieth-century received opinion of Morland's work. Numerous biographies have been published, four immediately on Morland's death, and various others around 1900; most of them are easy to find and there is no need here to give any detailed account of his career, but a few points need to be mentioned.

Morland was the son of an unsuccessful but respectable painter, Henry Morland, who was on good terms with some of the leading artists of the period, including Sir Joshua Reynolds,[23] but after leaving home he was for most of the rest of his life probably an

alcoholic, and he seems to have died from the effects of drink, and perhaps also of 'a venereal taint in his blood'.[24] He was involved throughout the 1790s in a continuous struggle to evade the creditors who paid for his extravagant taste in clothes as well as for his drinking: he was repeatedly forced to change and to conceal his address in London,[25] and frequently to escape to the country to avoid making payments he had promised.[26] He was eventually imprisoned for debt, and lived most of his last years within the rules of the King's Bench.[27] For all his extravagance, however, he dressed for most of the years of his fame as a jockey, and was frequently taken for a servant;[28] in his last years he dressed as a hackney coachman.[29] His appearance and behaviour were suspicious enough to cause him to be arrested on a visit to the Isle of Wight, and to be charged with spying for the French,[30] and at another time to be investigated on a charge of forging banknotes.[31]

Morland had a complete aversion to anything resembling polite society; he had a good claim to a baronetcy, but refused to pursue it, not wishing to incur 'the disgrace of a title'.[32] His chosen companions were the very lowest he could find: 'He preferred the hedge alehouse to the town inn', writes one early biographer, 'and was never apparently happier than in the midst of peasants'.[33] Another biographer, noting that Morland's gypsies are 'admirable, since in them vulgarity of character is appropriate', records that he 'often associated with them, and...has lived with them for several days together, adopting their mode of life, and sleeping with them in barns at night'.[34] No doubt, as one writer remarks, he liked the position of pre-eminence his success, generosity, and respectable origins gave him in such company,[35] but Morland himself explained his behaviour differently; he defended the pleasure he took in the company of the fish-porters of Billingsgate with a remark which makes clear his aversion to the politeness of the polite: 'I hear jolly good straight language, and see some first rate fights';[36] and when questioned, for example, on the Isle of Wight as to why he spent so much time in the Cabin, an alehouse frequented by smugglers and wreckers, he replied, 'where could I find such a picture of life as that (exhibiting his sketch-book) unless among the originals of the Cabin?'[37]

Like Gainsborough, he was most reluctant to paint to the orders of his customers[38] – he did not 'choose' to 'accommodate himself' to the 'whims' of 'gentlemen';[39] and as David Thomas has pointed out, Morland was probably the first painter in England to exploit

> a new era in artist-client relationship: that in which the artist produces works in his own studio, at his own expense as regards materials and time, and sells them through an agent or gallery.

The client, therefore, has no say in the subject-matter, scale or colouring of the work, which has already passed from the artist to his agent; and it is important at this stage to notice a second characteristic of Morland's dealings with clients, one hitherto condemned as imprudent. It was his habit to sell through a go-between and thus avoid contact with dealers or buyers and the conditions they might lay down.[40]

The anecdote which is the epigraph to this chapter is a *vignette* of this changing relationship of artist and customer. Lord Derby's manner, and the fact that he has presumed on his rank to call without an appointment, indicate quite clearly how *he* regards Morland; the word '*buy*', italicised by Blagdon, is expected to be an open sesame to Morland's studio, and one which will purchase deference as surely as cash will secure a work from the master's hand; for the 'master' is still a servant to Lord Derby. Winking Bob's reply makes it equally clear that the earl's intention to buy a picture does not procure him the right to enter the studio unannounced – that the

George Morland,
*The Artist in his Studio
with his Man Gibbs*

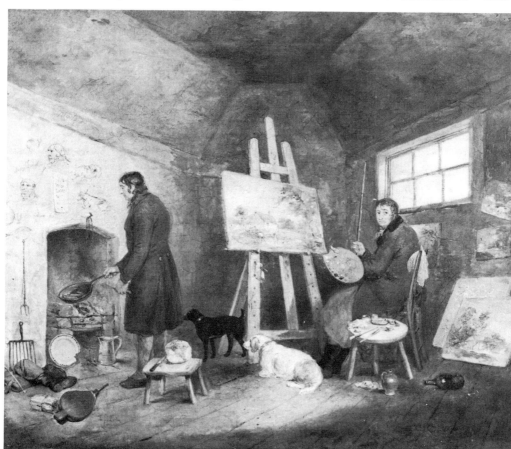

studio is not a shop, and that Morland claims the same freedom to be 'not at home' to casual callers as the earl himself would claim. For Morland, concealed in his garret and protected by his 'guards', is determined to avoid that contact with his polite customers in which he would be forced to pay for their admiration with his own independence.

When he did paint directly for a particular customer, he sometimes seems to have made a point of not completing the picture by the time agreed.[41] He once turned down a commission from the Prince of Wales, for a roomful of pictures,[42] with the same determination to preserve his independence as he had shown when earlier he had refused to enter the studio of the fashionable portrait-painter Romney, at an annual salary of £300.[43] The price Morland finally paid for this independence is made clear by the remarkable self-portrait in the Castle Museum and Art Gallery at Nottingham, *The Artist in his Studio with his Man Gibbs* (c. 1802–3). The studio is an attic in Paddington, bleak and sparsely furnished; some empty gin-bottles lie scattered on the floor; the chimney-breast is decorated with drawings by the artist; on a stool there is a loaf of bread; Gibbs fries sausages on an open fire. Morland himself, seated at his easel in the back of the room, stares directly out of the picture and at us; he looks ill and haunted, but too flabby – 'squalid, bloated, cadaverous', as a contemporary described him at this time of his life[44] – to allow us to romanticise his condition. The *joie-de-vivre* with which he had embraced his independence in the 1790s is entirely gone, and he portrays himself as what he is, a hack broken by poverty and alcohol, painting to pay off his debts. In this final period the quality of his work certainly declined – almost all the pictures I discuss in this essay appear to be from the early or middle 1790s. He exhibited three paintings at the Royal Academy in 1804, the year of his death, but they were accepted for reasons which had nothing to do with their quality:

> West...said he was much surprised at Morland's picture which could only be recd. on account of His former merit. Turner added that it shewed the effects of living within the rules of the King's-bench.[45]

II

A part of the method by which I examined the work of Gainsborough, and which I shall use again in my discussion of Constable, was to compare the imagery of the paintings with that of the contemporary poetry of rural life, and to argue that the arrangement of the images in the former could be understood in such a way as to suggest that they embody a vision of English rural life similar to that more

explicitly developed in the poems. It is an approach that cannot easily be adapted to the study of Morland; as I have said, we are more likely to be struck by the contrast between Morland's imagery and that of his contemporaries, and if I am right in what I have already hinted to be the particular significance of Morland's paintings to the tradition we are tracing out – that it was understood to be at once an uncompromisingly faithful image of the rural poor of the 1790s, and an implicitly radical one – there is no poetry as there is no painting which manages to be both these things at once. The tradition of occasionally radical poetry of rural complaint which stems from *The Deserted Village* works by inviting us to see the poetic ideal of the rural life as, potentially, a social ideal; the actuality of Crabbe's imagery on the other hand attempts to naturalise the condition of the poor, as Hazlitt reveals, and to confirm their fate as men born to toil, while it invites us also to commiserate with those who cheerfully accept that their fate is immutable. The apparent radicalism of Wordsworth's earliest poetry is never less than anxious to present the good poor as domestic and industrious – the recent appearance of the first drafts of what was probably his most uncompromising poem of the 1790s, which remained for the most part unpublished until it appeared in 1842, much revised, as *Guilt and Sorrow*, has done little to dispel this impression;[46] while as we shall see in the final essay of this book, his mature poems – most notably *The Prelude* of 1805 – come close to seeing the social aspects of the life of the poor – as of Man in general – as contingencies which can only screen from us their individuality which is their essence.

On the other hand, the flamboyance of Morland's life, and the popularity of his work, inspired a body of closer and more perceptive criticism by his contemporaries than is available to the student of Gainsborough or Constable, and it is greatly informative about how his work was understood, and in particular about how the social implications of his images were received. An account of these writings can be made to serve something of the same purpose as my accounts of the poetry in the other essays – to facilitate the translation into a more explicit medium of what can only be implied by a pictorial image – and also to support what might otherwise seem, in view of the current estimation of Morland's work, an improbably controversial account of it.

As we have noted earlier, no fewer than four biographies of Morland appeared in the years immediately following his death: by William Collins in 1805, by F. W. Blagdon in 1806, by J. Hassell, also in 1806; and by George Dawe, R.A., in 1807.[47] Apart from Blagdon, whose short but sumptuously illustrated work is of little critical interest, all these writers were well-acquainted with Morland,[48] and

their biographies reveal interesting differences in tone and attitude. Collins is the least censorious of the three, Dawe probably the most, finding much to object to in Morland's life, and making some pertinent criticisms of his work from the point of view of an academic painter; of the three he is also perhaps the most confused in his attitude to Morland's paintings. Hassell is mainly concerned to discuss engravings after Morland, and can often present as criticisms of the prints he discusses, objections, artistic and moral, which he clearly has about the subject-matter and intention of Morland's originals.

But despite the differences between the biographers, there are certain symptoms of disturbance common to all three in the responses that Morland's work excites in them, whether they are openly critical, defensive, or even defiantly justifying Morland's subject-matter to those who might object to it. All three discuss Morland's work very much in the light of what they know about his life; and all are disturbed by the contrary demands they make of Morland, so that they praise him for the unsentimental exactness and objectivity they find in his portrayal of rural life, at the same time as they blame him for the lack of refinement in his image of the rural poor, a lack they attribute to his coarse way of life and his refusal to take the opportunity of mixing with his betters. Morland, writes Dawe,

> has described the manners and habits of the lower class of people in this country, in a style peculiarly his own. No painter so much as himself ever shared in the vulgarities of such society, perhaps, Brouwer expected, who in many points much resembled Morland; nor is it to be wished that a man of equal abilities should again condescend so much.[49]

It is worth considering the attitudes and judgements of Morland's early biographers in some detail, for they have an idea of Morland's aims and achievement quite different from that of twentieth-century critics of his work, and by studying the tone especially in which they discuss certain of the paintings and prints, and by analysing the confusions that appear in their judgements, we can get a clearer sense of the originality of Morland's work, and of what could not be represented in the image of rural life, than if we look at his paintings in the light of the currently received opinions of them.

The images of the poor we find in Morland's paintings are now, as we have seen, generally regarded as placid, sentimental, perhaps Arcadian, and indeed many of them seem to be some of these things. But this is not how his works appeared to his contemporaries. We can detect the threat that many of them represented to the ideal version of the poor, as tame, domesticated, and industrious, that we

find in Gainsborough's late paintings – for so long, and still for Morland's biographers, the most acceptable models of how such subject-matter should be treated – even in the few remarks that Collins, the most admiring of Morland's contemporary critics, makes on his more sensitive subjects. Of the *Return from Market*[50] he writes that it

> looks very like a return to spend the evening at some knowing alehouse in the neighbourhood of St Giles's. The girls in the cart are rather too brazen for rural nymphs, and their driver savours very much of a Tottenham-Court-Road chicken of the same breed.[51]

Here we can sense Collins's delight that Morland has refused the tamely idealised version of rural nymphs that Gainsborough had offered, but we cannot quite sense an approval – it disturbs Collins that these nymphs should have found their way into a painting at all: the picture is good fun as a picture, but dangerous as a moral statement. Elsewhere he throws an interesting doubt on the submerged sexual implications of painting the deserving female poor, as Gainsborough had done, as 'appealing' in both senses of the word: of a version of *The Benevolent Sportsman*, in which a gentleman is seen giving alms to a group of gypsies, squatters, or vagrants, he writes:

> this interesting picture exhibits a sportsman giving charity to a little girl, the mother of whom is rather too handsome for either of her companions in the distance; and we might be apt to doubt the sportsman's motive, if his back was not turned upon all that group.[52]

As it is, we are left simply to doubt the motives of those who enjoy the painting; and if we take this comment along with that on the *Return From Market* we can get a sense of the impossible dilemma that Morland is placed in by his critics, when he paints the poor even in situations which confirm their dependence on the rich. If he idealises them, we miss that sense of objectivity, that freedom from the conventions of English rustic painting that all Morland's contemporary critics so much admire in his work; he was, says Collins, nature's 'faithful copyist'.[53] But if he does ignore these conventions – or if, as in the *Return From Market*, he goes back to an older convention of comic Pastoral which now looks more indelicate than before, and so somehow more true-to-life – we miss the submissive refinement in his image of the rural poor which makes us so desirous of relieving their condition. Collins wants Morland at once to confirm the limits of what is morally acceptable in relation to such subjects, and to ignore those limits, and his confusion is not well concealed by his irony.

Hassell is confused in a not dissimilar way, but can accept more easily that Morland is not obliged to imply in his pictures a moral comment on his subject-matter, and for the most part values him for an objectivity in his image of the outcasts of society which seems to throw the responsibility of moral judgement on us, the observers. Unlike Dawe, he approves of Morland's habit of mixing with the lower classes of society, which he sees quite simply as a part of his search for actuality in his image of them; 'for this best of reasons', he explains,

> it is certain that Morland...had been at some other place than Margate [where Morland spent some time at the beginning of his career], as the rocks bear no resemblance to those in that neighbourhood; these, perhaps, he copied from Hastings, and on the Sussex coast, where it is known he had formed some connexion, which, if not of the most exalted kind, was nevertheless such as answered to the purpose of an artist. Smugglers and fishermen are the principle inhabitants of this coast, and therefore the best, and most appropriate subjects for the scenery.[54]

Of a picture of smugglers that Collins had also admired, he writes with approval of Morland's image of 'that hardy, rough-hewn race, that inhabit the coast, defying the utmost vigilance of government',[55] and as Collins had admired the 'spirit' of Morland's portrayal of them[56] so Hassell admires his 'uncommon boldness'. But this phrase is contained by his clear sense of the artistically appropriate: smugglers suit a rock coast, as *banditti* do a rocky mountain; a bold treatment is suitable to both; and when we grant an artist a licence to paint such subjects as these, it is on the clear understanding that art is art only, and can function as a relief from moral pressures, but not as a challenge to morality.

Hassell often seems less vulnerable than Collins to what appeared around 1800 to be the uncomfortable actuality of Morland's work, because he is more secure in the possession of the moral standards by which his imagery should be judged. He prefaces his remarks on the prints of the poacher[57] and the gamekeeper[58] by lengthy accounts of the dishonesty and improvidence of the one, and of the corruption of the other: the poacher, he begins, 'is an idle, worthless fellow, who takes infinitely more pains to attain a scanty pittance, than half such labour properly directed would do to procure him a comfortable subsistence', and so on; but his criticism of the picture is not that Morland should not portray such a character at all, but that he has not quite caught the true character – that is to say, the moralised stereotype – of the occupation: as represented by Morland, the poacher

is certainly an ill-looking fellow, with a lurcher by his side; yet the man, as represented, is not such a one as appears calculated for this avocation. There wants a costume, or rather a *je ne sçai quoi*, to characterize him.[59]

But Hassell's tolerance does have its limits; and the actuality of Morland's vision must not, for him, be too actual, insistent. If the figure of the poacher does not trouble him, that may be, after all, because it is not painted too convincingly, so that Hassell can easily separate his description of the picture from his judgement of the man. But sometimes his descriptions of Morland's subjects intervene between them and us, for Hassell does not always trust us to make the correct moral judgement on them – as when he refers, as he several times does, to Morland's peasants as 'boors', or 'louts',[60] or in his concern that we know how to respond to Morland's pictures of the poor when they are not at work. We may look with 'sympathetic approbation' on the print of *Rustic Ease*,[61] for it depicts 'the sweets of being reinvigorated by repose after days of fatigue',[62] but we must resist the temptation to 'excuse' the 'indolence' of the *Idle Laundress*[63] on account of the 'native simplicity' of her countenance;[64] and the *Rustic Hovel*,[65] in which 'two lazy country-men' are 'lounging amongst the litter of a stable' is 'a poor subject for a print',[66] no doubt because one of them has a mug of ale in his hand. He cannot easily forgive Morland for painting the poor as idle, as drinking, or as interested in politics: of *Alehouse Politicians*,[67] in which they are all these things, he remarks that it is

> too low a subject to merit the same attention as several other pictures of this artist, who gave himself a latitude upon some occasions, that was very disgusting to an eye of taste.[68]

Hassell reconciles his enthusiasm, which is considerable, for Morland's objectivity, with his usual well-concealed disappointment at the coarseness of his subject-matter, in the same way as Dawe does, as we shall shortly see, and indeed in the same way as Wordsworth, in the Preface to the *Lyrical Ballads*, explains that we might discover the most natural language for poetry by adopting the language of 'low and rustic life', but that language 'purified...from what appear to be its real defects, from all lasting and rational causes of dislike or disgust'.[69] Hassell attempts, that is, to distinguish between an image which is idealised, and one from which whatever is disgusting has been carefully expunged. This enables him to defend Morland aggressively from those who would see his art as unrefined:

> does not Mr Morland delineate, as faithfully as pencil can, all that he intends to describe?...Should he attempt more, would

it not be violating his pencil? He faithfully pourtrays rural scenes – to exceed simplicity would be distorting Nature.[70]

For there is 'no impropriety in gleaning from any quarter' if he 'judiciously winnows away all that is not adapted to the canvass'.[71] That Morland on the whole seems to Hassell to have winnowed away successfully the chaff of rural experience is no doubt largely because he is looking at the prints, and not at the 'canvass' itself: as we shall see, most of the winnowing was done by the engravers, so that Hassell is able to evince less disturbance than Collins and less disapprobation than Dawe, in his remarks on Morland's subjects – it is easier for him to admire the lack of idealisation in the images he discusses, precisely because those images were considerably idealised.

Dawe, who is certainly the most gifted and most articulate of Morland's critics, also finds and to some extent admires an objectivity in Morland's painting, but he is more committed to an idealised version of rural life than either Collins or Hassell. Thus he speaks approvingly of the truth of Morland's 'pencil' and agrees that he

> must be allowed considerable merit for truth and simplicity of character in the objects which he represents, and he is free from the affectation of a refinement which he does not possess: his mind was a mirror, reflecting nature as she presented herself to him; and he never failed to make a faithful transcript of the scenes in which he was most conversant.[72]

But like Hassell, though he acknowledges that 'in the delineation of humble life faithfulness of representation is essential' he insists also that this 'does not preclude selection';[73] and the insistence that faithfulness is not compromised by selection becomes in Dawe's criticism a determined attack on Morland for his 'vulgar' taste in subjects and a general lack of refinement, so that Morland 'not having sufficiently cultivated his taste...was unable to avail himself of the higher beauties of his subjects'.[74] He makes Morland suffer in particular by comparison with Gainsborough, who

> in all his works displayed refined feeling and a elegant mind: he has given to the eye the most interesting representations of rustic innocence; while the taste of Morland was of a lower kind, though he delineated the characters he selected with equal success.[75]

The moral demands that Dawe makes of painting are perhaps nowhere more clear than in this comparison, in which the 'truth' of Morland's art seems to him not a moral virtue at all when seen

beside the refinement of Gainsborough. It is implied throughout the comparison that Gainsborough in painting images of rural innocence was painting something which probably did not exist: his work 'seems most calculated to delight those whose ideas of such employments have been refined by the descriptions of pastoral poetry'.[76] Morland, on the other hand, delineates 'the vulgar and coarse manners of the lowest part of society', whereas he should, like Gainsborough, have exhibited 'the virtues and happiness of rural life',[77] or of a class presumably other than the lowest, yet still made up presumably of the gypsies, woodcutters and milkmaids who fill the canvases of the earlier painter.

Thus Dawe sees none of the integrity of purpose that Hassell finds in Morland: 'fidelity' becomes the mere ability to produce an unmediated image of nature and of society, an easy task compared with the ability to select and refine the actual into the ideal. Morland then is not seen by Dawe as he is by Hassell, as emancipated from the conventions of pastoral painting, but simply as too low to be able to aspire to them. The same sense emerges from his remarks on Morland's fishermen and smugglers: 'the true character of the English fisherman has been better described by Morland than by any other painter'; but Morland does not sufficiently distinguish the fisherman, honest, harmless, industrious, peaceable, domestic – possessing, in effect, all the qualities of Gainsborough's late woodcutter – from 'the smuggler and depredator, who subsists by plunder, in defiance of the laws'.[78] Dawe's point does not seem to be that the distinction he wishes to see made between the fishermen and the smuggler is one that we can actually observe in the society of the English coast, and he was no doubt right, for we know that the line between them was impossibly blurred;[79] so that it seems likely that Morland represents something we can think of as the 'true' character of the contemporary fisherman. He does not represent it in a moral light, however, and pretend that there was indeed the distinction that Dawe would have liked to believe in between the two occupations; and for Dawe truth and morality are opposed terms for the painter of vulgar life, and he values the latter much the more highly.

From this account of Morland's contemporary critics we may begin to understand why his art was admired so highly, and yet censured so severely, in the decades around 1800. In painting 'the lowest part of society' he was bringing within the range of what it was possible to paint a wide selection of the social outcasts whose company he habitually sought out. To a class of customers which was beginning to pride itself on its benevolence, this was indeed a service; and for the most part the increasing interest in the picturesque quality of the subject-matter of painting, which had already tamed

the wildness of mountains, and reclaimed it for the 'eye of taste' by seeing it in terms of newly invented aesthetic categories, had enabled Morland to recuperate what was coarse and ugly in society also, and to make it similarly acceptable. David Wilkie remarked of Morland that

> he seems to have copied nature in everything, and in a manner peculiar to himself. When you look at his pictures you see in them the very same figures that we see here [i.e. in London] every day in the streets, which, from the variety and looseness in their dress, form an appearance that is truly picturesque, and much superior to our peasantry in Scotland.[80]

By extending in this way the range of aesthetic interest in the poor, he was able perhaps to extend the sympathetic range of his admirers, who were certainly up to a point willing to have it thus extended.

A painting such as *The Benevolent Sportsman* (1792), in the Fitz-william Museum, shows clearly the terms on which this could be done: the gypsies in the picture are intolerably rough and ragged; they are not working, and seem to have squatted presumably without the right to do so on what may be private land. But this coarse group

George Morland,
*The Benevolent
Sportsman*

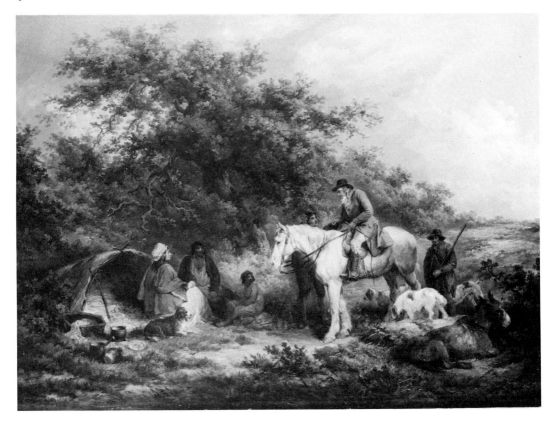

of figures is made fairly acceptable by the figure of the boy receiving alms, who is represented as intensely grateful, and as tugging respectfully at a lock of his hair. The seated figures, who look more puzzled by the sportsman's action than thankful for it – as if they have waited so long for such help that they are no longer able to respond to it as they should – are exhibited in a position of subordination to that secure figure of authority, who bends down, who *condescends*, to relieve them. Benevolence may now by some be allowed to the idle poor as well as to the industrious: an understanding of the laws of a market economy is beginning to make it clear that the able-bodied poor may be unemployed through no fault of their own, so that though there is still a test of desert to be applied, in matters of relief, and we should not give alms on the grounds simply that they are needed, the test is changing, and can be passed even by the idle if on receipt of alms they show themselves properly submissive and obliged, as one, at least, of the gypsies manages to do. Morland's objectivity was thus recognised as of value as far as it allowed the rich to acknowledge that the condition of the poor was desperate, but it could not be allowed to suggest, for example, that the poor were justified in demanding relief as a right, not as a favour, were in any way unbowed before the authority of their benefactors, or questioned the inevitable operation of the economic forces that had made them poor.[81]

But as we shall see, there are paintings by Morland which do present the poor as something other than cowed and forelock-tugging – those of smugglers, wreckers, poachers, obviously, but also some of those which portray the rural labourer. Collins is excited by such images, and Hassell is often unaware of them, but Dawe's reactions show clearly the risk that Morland ran in painting them. This is the point at which the 'truth' of his painting suddenly becomes dangerous – at which the need for selection is invoked; and the quality for which Morland is praised becomes exactly that for which he is blamed. He could only discover the limits of what it was possible to paint by going beyond them; and when he does go beyond them, all that Morland was agreed to have achieved, in freeing the painting of rural life from an idealising convention, is suddenly seen as of no value, and the critics retreat into a contrary and defensive demand for the image of an idealised class of cheerful peasants such as the late Gainsborough had painted.

III

It is high time to look at some examples of Morland's art, and for the convenience of the reader I shall confine my discussion largely to works in the Tate Gallery. It is time, too, to make a concession,

that a large number of Morland's paintings of rural life must seem to anyone, as they would seem to the modern critics whose opinions we have discussed, artificial and idealised, whether in the direction of the comic or the sentimental, and if we come to inspect these without a knowledge of the confusion they caused in those who first wrote about them, we are unlikely to see anything more in them than Fry, Berger or Gaunt have seen. The best recent essay on Morland, by David Thomas, argues that by the appeal especially of prints of his work to a wider and less sophisticated public, he was fixed 'to a phase of cloying sentimentality which regarded a squire's bene-volence or a landlord's *bonhomie* as a remedy for debt, starvation, and bitter cold'.[82] Though I am arguing that Morland is as much an opponent of this paternalist ideology as a propagandist for it, and that we should beware of judging the painter by the prints, there is much truth in this remark for many of the paintings themselves. *Morning, Higglers Preparing for Market* (1791), in the open galleries of the Tate, and exhibited there presumably because it represents so exactly the received idea of Morland's art, is a case in point. The print of this painting[83] by D. Orme is thus described by Hassell:

> The husbandman appears to be tying the knees of his breeches while his wife, with a child by her side, is pouring out for him a glass of liquor. The higgler's man is leading the horse from the stable, and forms a part of the principal group; two pigs wallowing in clean straw, are introduced into the foreground, and are in the artist's best manner.[84]

He introduces this description with the remark about Morland's preference for the company of peasants (for the purposes of research) which is quoted on p. 95 above, and clearly regards the picture, even in the engraved version, as an example of Morland's literal 'fidelity' to nature. We have already noted in the context of Hassell's remarks on other prints after Morland that he is able to praise a number of his works as objective, as without false affectation, precisely because they were not, and that is precisely the case here; so that the fact that Morland's work did become popular for this quality of 'fidelity' will often tell us more about a need in his contemporary admirers, to believe that the life of the rural poor was really, affectation apart, as comfortably domestic as it appears to be in this picture, than it will about any disinterested desire on their part to be presented with an image of the actuality of rural life however sordid that might turn out to be. The point is the same here as it was in relation to the iconography of the milkmaid in the chapter on Gainsborough: the pastoral image is not so much challenged by this 'faithful' image of higglers, as it is inoculated, by a shabbiness mainly about the

buildings that we may regard as picturesque, against the contamination which a more faithful image would bring, and this is a cheap price to pay for the continued reassurance that the poor, though poor, are still cheerful, and still clean, and that even their pigs are too.

The figures in *Higglers Preparing for Market* are a necessarily tamer version, now, of those we encountered in Gainsborough's Bath period. The father of the household is what Hassell would have described as a 'boor', if his coarse features had not been remodelled by the engraver, and were it not for the more refined members of his family gathered around him: his son, or his 'man', has a burly frame but prettily effeminate features, and in the print is tidily dressed and shyly smiling. What must I think be his elder daughter, and not as Hassell says his wife, is prettier still, and manages to look neat in a dress whose coarse cloth will not hang in folds which can be represented as elegant; in the painting she has an expression of concentration as she pours her father a drink; in the print she is more blankly contented. His younger daughter, the best dressed of the four, has turned demurely away from the observer, and stands before her father in an attitude of obedience. Their surroundings, as I have said,

George Morland,
*Morning, Higglers
Preparing for Market*

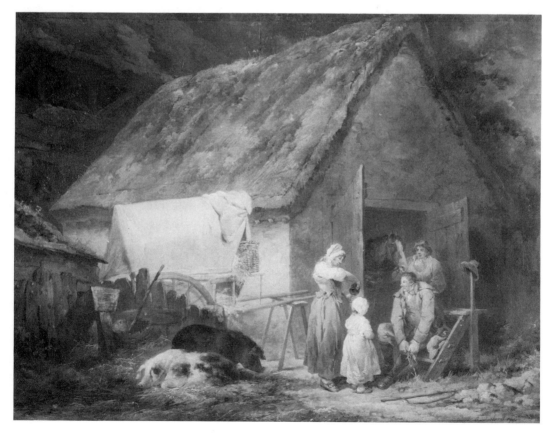

are shabbily picturesque, so that we are invited to notice with approbation how decent the family remains in spite of them. The elder daughter pours out the liquor with an action graceful enough to silence our fears for the sobriety of her father, who watches her without any unseemly eagerness to taste it – a contrast with *The Peasant's Repast*,[85] which disturbs both Hassell and Collins by the malignity, the savagery expressed in the face of the old man who watches his son finish the last of the ale.[86]

This comic and sentimental image of the poor, which the more refined Gainsborough had already abandoned in his second version of *The Harvest Wagon*, is thus still in some way acceptable, but at the price of losing the robustness it had had in Gainsborough's first version of that picture – it is, like the liquor the girl is pouring, refreshing rather than invigorating, and it presents the family of higglers in the domestic context of Gainsborough's last paintings. If the image is somehow more actualised than Gainsborough's, that is something we observe in the farm buildings rather than in the figures, and in so far as Hassell appears to transfer this actuality to them, that is of course precisely because it is so important for him to believe that

D. Orme, after Morland, *Morning, Higglers Preparing for Market*

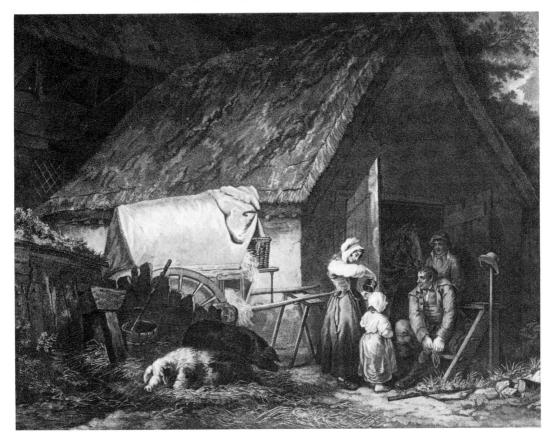

the most faithful possible image of the life of the rural poor will turn out to be nowhere near as squalid as we might have feared.

I am not suggesting that in every case it was Morland's comic or sentimental subjects which earned the praise of being wholly objective, unaffected. A beautiful small landscape at the Tate, *The Gravel Diggers* (undated),[87] has such a remarkable plainness about it – the landscape credibly bare of picturesque incident, the figures seated at their lunch quite without narrative interest – that it tempts me to remove the inverted commas with which I have so far enclosed my references to Morland's 'fidelity' to nature. It is a success possible to Morland because the painting is so definitely a landscape, not a *genre* piece: the figures are at a distance which precludes speculation about their character or feelings, nor are they so positioned in the landscape – two of them are almost hidden by a small hump of rising ground – as to invite us to consider them as the main subject of the picture. It is when the figures in Morland's paintings are closer to us, as they usually are, and their characters are most available for inspection, that he must temper his objectivity with sentimental or comic interest if he is to be praised for the unaffected simplicity of

George Morland,
The Gravel Diggers

his vision; and the dangers of his art occur only when the poor in such pictures seem for one reason or another less than cheerful. It is then that his 'fidelity' to nature, defined as an absence of pastoral affectation, can or should be recognised by us, and would be willingly exchanged by his contemporary critics for a fictitious refinement.

In the reserve collection at the Tate is a small work of 1792, *The Alehouse Door*. A labourer sits on a rough bench fixed to the wall of a lath-and-plaster alehouse, and leans over a crudely made table with a mug of ale clutched in his left hand; in his right he holds a clay pipe. Behind him and over him leans a younger, more handsome labourer, his large hands gripping the table, and the two are looking at each other with some intensity, as if engaged in serious convers-ation. Both are loosely and shabbily dressed, particularly the elder, whose thick woollen jacket hardly fits, whose breeches are unlaced at the knee, and whose broad felt hat conceals his eyes and therefore his expression from us. This is one of the 'mild and temperate groups' which Gaunt described as clustering about 'domestic-looking alehouses'; but John Raphael Smith remarked of this picture that the alehouse 'has been so seldom thought sufficiently *elevated*' a subject for '*pastoral* painters,...that we have seldom seen them attempt its delineation';[88] and it needs only a little knowledge of attitudes to the rural poor in the 1790s to suspect that the image would have seemed far from mild, temperate, and domestic to those who first saw it. 'Two boors at the door of a cottage, one seated, and the other leaning over his companion', is how Hassell briefly describes it; 'there is very little matter in this print'.[89] Uncharacteristically, Hassell has much more to say in favour of the original, which is among 'the choicest of his productions':

> Two peasants are regaling at the door of a cottage, and seem in earnest conversation. The figures are drawn with a force highly characteristic, and exhibit objects to be every day met with in the country. The rude workmanship of the table on which they are resting is truly natural.[90]

The words 'force', however, and 'regaling', hint at the threat which Hassell's passion for Morland's objectivity has enabled him to ignore, and here he does indeed respond to a lack of idealisation in Morland in the face of a painting in which he is clearly aware of a certain danger, but one which he is characteristically able to neutralise, for his prejudices are secure. It seems reasonable to suppose that out of his feelings of partisanship for Morland he has displaced his worries about the painting to the print, and persuaded himself that the dangers latent in the image were revealed rather than concealed by the engraver, R. S. Syer; for the print is quite unusually faithful to

the spirit of Morland's original – the shabby and ill-fitting clothes of the older man, the strength of his body, the intensity of his attitude, have all survived translation; the younger man has been prettified but only slightly, and his huge right hand has not been diminished into a more polite proportion.[91]

The danger is recognised more directly by Collins:

A group of English figures regaling themselves, which, like true sons of liberty, they seem determined on in spite of all opposition.[92]

The picture was painted on the eve of the war with France, and Collins is discussing it while the war continues. It was of course in

George Morland,
The Alehouse Door

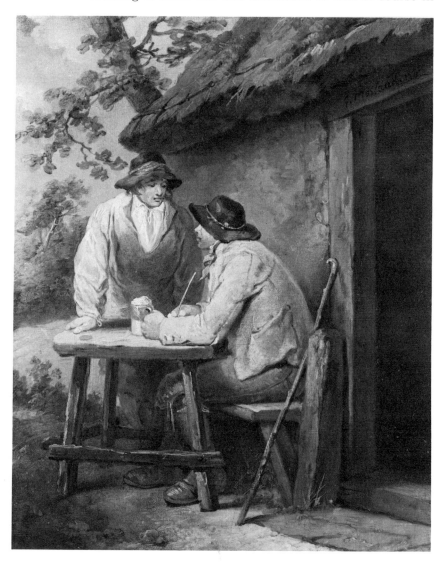

wartime that the 'spirit of independence and liberty' of the English labouring classes, so hesitantly admired in the eighteenth century by Samuel Johnson among others, was expected to reveal its true value: 'their insolence in peace', said Johnson, 'is bravery in war'.[93] For Collins, however, the war has come and the insolence of the poor has remained insolence; and the contrast between his judgement on the picture, and Gaunt's, could hardly be more marked: even the word 'English' has a disturbing political implication. He recognises these labourers as 'free-born Englishmen',[94] men who are represented as actually resisting – they are 'determined' – the demand that they should accept the status of mild, temperate, industrious, submissive labourers. The 'opposition', of course, comes from the observers of

R. S. Syer, after Morland, *The Alehouse Door*

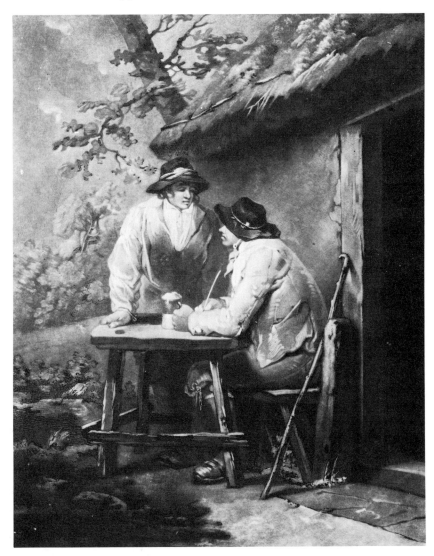

the picture, who prescribe that tame image of the poor which is challenged by these 'true sons of liberty' – with characteristic irony Collins adopts the language of popular radicalism. The jug of ale is a symbol of their indiscipline and their revolt – it is not diluted by any reassuring passivity in their attitudes – and so they are described by both critics as 'regaling', though there is only one pint between them; but the suggestion in that word is surely that their little money would be better spent on the wants of their families than on their own coarse pleasures; and that pint becomes for Morland's critics a signpost on the road that leads from idleness to insurrection.

It is safe to assume, indeed, from the expressions and attitudes of the two men, as well as from Collins's description of them, that they are talking radical politics, for they are not in any sense comic figures, neither obviously enjoying their drink nor engaged in a low-life quarrel, and their earnestness gives them a particular dignity which seems to come from a sense, as Collins reluctantly suggests, of their independence and solidarity. If we compare them with the decent higglers, or with the submissive boy in *The Benevolent Sportsman*, the difference is immediately apparent. The attitudes and expressions of these 'boors' – inscrutable but certainly not submissive – override their picturesque interest: they are not sufficiently ragged to grant us the relief of feeling that they need our alms, and indeed there is no way of forcing an obligation on them by extending a sympathy which they seem so little concerned to solicit. The younger man expresses an air of confident authority, and occupies an elevated place in the composition which properly only the rich could claim; and neither man looks at us, as if concerned about our reaction to him, but each looks at the other as if they share a secret, and in that way demand that we recognise in them a sense of brotherhood – the 'sons' of Liberty – which excludes us and has no need of us. It is a recognition that is forced on us too by the door of the alehouse, which reveals nothing of an interior that is absolutely black and impenetrable. The picture obliges us, in short, to recognise that we cannot know the thoughts and feelings of these men, and so cannot control them.[95]

We can get some idea of the limits of what could be tolerated around 1800 in the image of the agricultural labourer by comparing this picture on the one hand with Wilkie's *Village Politicians* of 1806,[96] and on the other with a fine painting by G. R. Lewis, also in the Tate, a landscape scene near Hereford painted in 1815.[97] The customers at Wilkie's alehouse are grotesquely and condescendingly portrayed, but in what we are clearly invited to recognise as the 'realistic' manner of Teniers or Ostade, so that the painting was much admired for the truth of its representation.[98] We have learned

to be wary of approval on those terms – what was it, we must ask, that its admirers wished to believe was true about the rural poor, and that is apparently confirmed by this image? In this case, the answer is clear; for Wilkie's picture seems immensely eager to reassure us that whatever interest the poor may take in politics, it can be a naive and ignorant interest only, and that these 'politicians' are too stupid to initiate any action which their opinions however radical might prompt them to; and the contrast underlines how determinedly in his painting Morland has refused to characterise his own labourers as comic, and so as posing no serious threat to our belief that those who think must govern those who toil.

Lewis's landscape has recently become very well-known: it is a harvest scene with, in the foreground, a group of five standing figures, two refreshing themselves with small barrels of ale, and two seated figures, one of whom has been painted out but is still clearly visible to the right of the group. Behind them, in the right middle distance, some labourers are loading stooks of corn onto a cart; while further away on the left some reapers are at work. If a spirit of independence and dignity were sufficient to make the image of agricultural labourers a dangerous one, the group of standing figures might seem

David Wilkie, *Village Politicians*

to present as considerable a threat as Morland's labourers do; and yet this painting must certainly have been as acceptable when it was painted as it is now. For these labourers are 'independent' in Barry's sense (see page 18), that they seem able to support themselves without extorting alms from the rich – but are not, as Morland's labourers are, careless of our good opinion.

To begin with, of course, though the labourers are for the moment idle, they will soon be performing again the laborious tasks which their companions are still performing, and their leisure is a part of that georgic balance of rest and labour which we noticed as humanising the situation of the labourer in Gainsborough's Ipswich pictures. They are drinking only to refresh themselves in order to resume their work, and such mild eagerness for a drink as may be portrayed in one of the figures, a dark burly man in profile, is excusable for that reason. They are dressed in clothes newer and neater than Morland's labourers can afford; they stand around in attitudes of some elegance, the two outside figures in academy poses, and everything about them speaks of the manly dignity which could not of course be represented if these men were in the presence of their employer, but which writers on the English peasantry so admire in them when it is properly channelled into taking a pride in one's work, in keeping one's family decent, and so on.

G. R. Lewis,
Hereford, Dynedor, and Malvern Hills...Harvest Scene

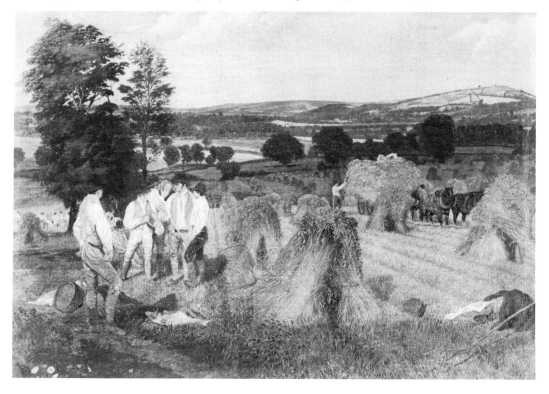

The picture may seem anachronistic, in terms of the history of the art of rural life as it has been outlined so far, and it is certainly quite unlike any other image of the poor in its period. Its appearance in 1815 may perhaps be explained in two ways. Firstly, it is a landscape of Herefordshire, a county in which the georgic ideology of the early and middle eighteenth century has been quite deliberately kept alive by the literate – the evidence for this is too detailed to discuss here, and will be presented in a footnote.[99] But the date of the painting may also invite us to reflect that this is an image of the bold peasantry from which were recruited the victors of Waterloo – or this was how they were imagined to be by those concerned to persuade the poor of England that the fight with revolutionary France was a fight for their own liberties. For these are indeed the 'true sons of liberty' as the phrase might have been used unironically by those with a proper respect for the free institutions of England; and not, as Morland's are, of liberty as it might have been pronounced by the soldiers of Napoleon.[100] The image is pure patriotic Georgic, of a plentiful and a peaceful landscape on the edge of becoming a symbol for the prosperity and stability of the whole society of England. There is a warmth and a value in this image, the labourers standing so confidently in the foreground, that we may appreciate better when we contrast it with the peopled landscapes of Constable; but the picture is entirely directed to confirming the liberty of the poorest of England's subjects, and not to challenging their servitude.

Another picture in the reserve collection at the Tate, *The Door of a Village Inn* (undated) presents a rather different problem from the one we examined in *The Alehouse Door*. A farmer on a white horse has stopped outside a country inn, where he is being handed a mug of ale by the landlady. In the open doorway are two children, one sitting with a bowl of food on her knees, the other standing behind her; on the left a ragged youth is burning off some brushwood. The atmosphere of the painting could not be less idyllic: the boy looks to be almost an idiot, yet nothing is made of the comic possibilities of this; the landlady's expression is blank but worried, and if anything betrays a guarded reserve for her customer, rather than a cheerful respect for his authority, and she will not catch his eye; of the unkempt children, one stares at the horseman with an entirely inscrutable expression, the other turns her eyes downwards and refuses to engage the glances either of us or of the other figures in the painting. The buildings are characteristically shabby, and once again the interior of the inn, which might have been visible through the open doorway, is impenetrably black. This is an image of the poor not as defiant, independent, but as entirely broken in spirit; and yet the *blankness* of the expressions of the mother and children makes it an image entirely unsentimental.

The picture does nothing to 'hide the meanness', or to 'cover the miseries', of the life of the rural poor, as Tickell had advised the pastoral poet to do, in the remark that is the epigraph to my introductory essay; and yet it does not invite our sympathy for them with the moralising sentimentality of the later Gainsborough, and would no doubt have been reproved by Dawe for failing to do so. For the function of Gainsborough's, or Hannah More's, sentimentality is to reassure us that the act of relieving the miseries of the poor is an act of economic exchange: our gift of alms is an *ex gratia* payment, but one given in return for the cheerful obedience of the poor in the past, as it is calculated to purchase more of the same in the future. We will value the absence of such sentimentality from many of Morland's works the more highly as we discover how rarely it is absent from the work of his contemporaries – of Wheatley, or Bigg, or Ibbetson, or James Ward, so often associated with Morland in lists of rural *genre* painters.

For a similarly unsentimental treatment of the poor, we can look perhaps among Morland's contemporaries only to his friend Thomas

George Morland,
*The Door of a Village
Inn*

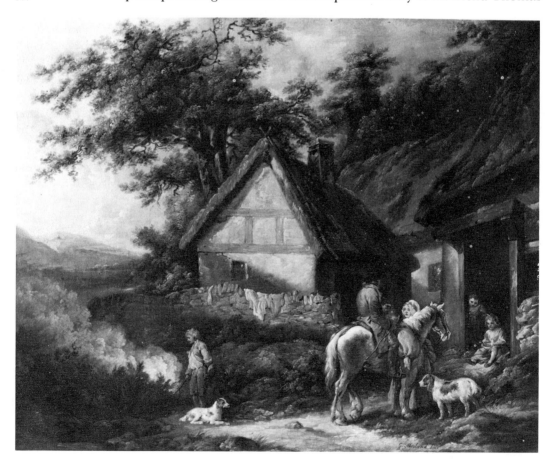

Rowlandson, whose work however seems rather to evade sentimen-
tality than to avoid it. The meaning of many of Rowlandson's rural
subjects is cannily elusive – the bright-eyed good humour of his
rustics seems in the context of his work as a whole to be offered
ironically,[101] but it isn't possible to decide whether the irony is at
the expense of what is imagined to be the actual simplicity of the rural
poor, or of the comic image of them which Rowlandson's public
would accept from a caricaturist, but no longer as willingly from
painters who aimed at more realistic representation. But even if it
is the latter, this irony, like Tickell's, seems more convenient than
challenging, and allows the comic Pastoral to survive on the basis
of a tacit understanding between painter and public that it is not,
or is no longer, an image of the poor 'as they really are' – as if we
know well enough what a 'realistic' image of the poor would be like,
without needing to be confronted with one, and so without having
to confront the emotions of guilt and fear from which only a
sentimental treatment could rescue us. A notable exception, however,
is the small watercolour *Labourers at Rest* (*c.* 1790–5),[102] in the Mellon
collection – a group of three exhausted labourers, and, on the right,
what are probably two travellers; the picture has been known in the
past as *Travellers Resting*.[103] The extreme exhaustion of the two
central figures is conveyed particularly by an attitude which conceals

Thomas
Rowlandson,
Labourers at Rest

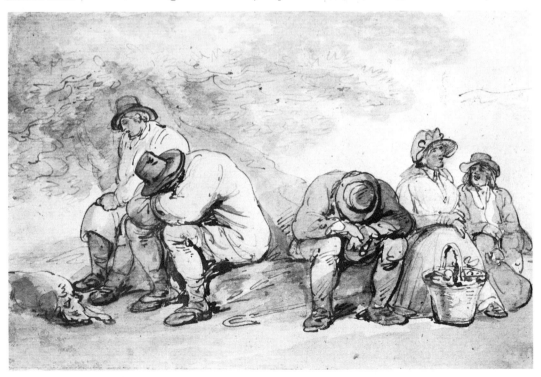

their faces from us, as if they are too tired to solicit our concern; and the same attitude, of course, also protects them from Rowlandson's tendency to ironic caricature, which seems to have been only just restrained in his treatment of the other figures. Perhaps he cannot, then, paint their faces, because to do so would be to risk attenuating the uncomprising blankness, remote alike from the comic and the sentimental, which their pose movingly conveys, but which can be conveyed primarily by facial expressions in *The Door of a Village Inn*.

Morland's painting was engraved in mezzotint by James Ward in 1793, and entitled *Sun-Set; a View in Leicestershire*;[104] Hassell is enthusiastic, indeed lyrical, about it, in the spirit of Paley's envy of the frugal poor (see above, pp. 67–8):

> There is certainly no period when the mind is more tranquillized, than at the decline of a serene summer evening. Nature, satisfied with herself, enjoys those moments that are better felt than described. Labour, relaxing into repose, feels an indifference to hurry and tumult. The farmer, after the fatigue of attending the market, slowly ambles home, and the children of the village enjoy their evening meal. Content and frugality form the wealth of the indigent.[105]

James Ward, after Morland, *Sun-Set; a View in Leicestershire* (detail)

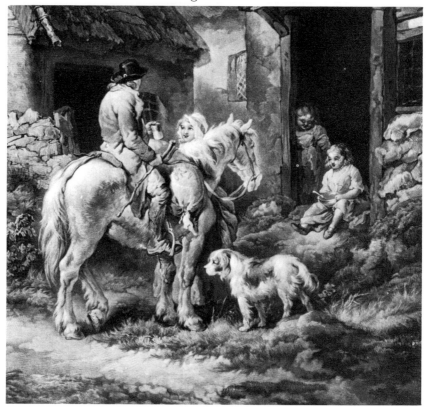

A picture of frugality it may be, though hardly of content; but a
glance at the print makes sense of Hassell's response, and that no
doubt of the buyers of the engravings, to this and many other prints
of Morland's works. The buildings are in better repair, and seem
likely to stand up longer; the boy has become smooth-skinned, pretty,
and holds himself in a less careless posture; the landlady now looks
up at the horseman with a jovial concern to see him properly
refreshed; the first child holds a much larger bowl of soup, and looks
at the farmer with a new benignity – the choker of beads around her
neck has been much enlarged, perhaps to conceal some error of
draughtsmanship, but the effect is to suggest that the family is not
so poor as to be unable to afford a few simple luxuries; and the second
child looks down at her sister with an expression of clammy sweetness.
In short, the poor in Ward's engraving are rather less frugal than
in Morland's painting, and consequently a good deal more contented;
and apart from Syer's version of *The Alehouse Door* I have not found
a single engraving after Morland that I have been able to compare
with his original painting, which does not emasculate his images in
some such way, even when – as in *Higglers Preparing for Market* – he
had done much of the job himself.[106] On the other hand, there is
no such obvious contrast between the originals and the engravings

George Morland,
*The Door of a Village
Inn* (detail)

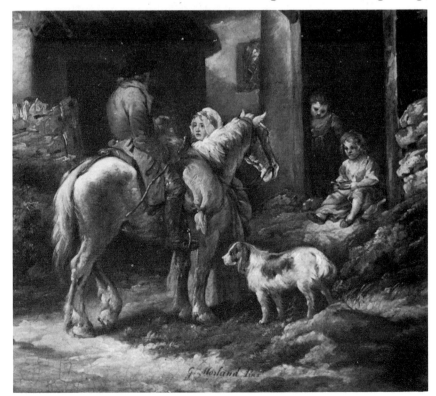

of the work of other painters of rural life contemporary with Morland. Such a judgement must inevitably be based on a brief sample; but in the case of Francis Wheatley, especially, examples of whose paintings are not too difficult to find, and have been generously reproduced in a recent monograph,[107] the engravers had only to copy the paintings as exactly as possible to produce a thoroughly idealised image of the poor.

The engravings of works by Morland that were produced in such numbers were sold at prices ranging from three and sixpence to twenty-one shillings,[108] and so made a version of his art available to a public far lower down on the social pyramid than that which bought his original works. The idealisation of Morland's originals by his engravers thus makes an important qualification of the easy assumption that works of art, as they discover a public among the bourgeoisie and the petty bourgeoisie, become more concerned with images of actuality. Of course, these engravings did offer a more recognisable image of rural life than did engravings after Claude, for example, earlier in the century, in particular the mezzotints of the *Liber Veritatis* that Richard Earlom published in two sumptuous volumes in 1777, and this was no doubt an important part of their appeal. The figures appear in English settings, and are dressed in clothes recognisably, though not insistently, similar to those actually worn by the rural poor. But the condition of these clothes, and especially the smooth complexions and cheerful expressions of those who wear them, are designed to reassure us about the morale and the governability of the poor, not to inform us of their miseries; and the popularity of the engravings does nothing to suggest that this reassurance was unwelcome or unnecessary.

IV

In the context of *The Door of a Village Inn* we may try to consider another frequent criticism of Morland's work, though it is not one about which his critics are unanimous, that his pictures are ill-composed. The point was first made by Dawe,[109] is denied by Fry – 'his composition is often remarkably coherent'[110] – and reaffirmed by Berger, who writes:

> he was incapable of composing. He knew how to balance a
> picture in an automatic way, but the groups of his objects and
> people never cohere. Because there is no tension between them,
> each remains separate. One could take one figure from one
> painting and swap it with a roughly similar shaped figure from
> another, without disturbing either picture at all.[111]

A picture of frugality it may be, though hardly of content; but a
glance at the print makes sense of Hassell's response, and that no
doubt of the buyers of the engravings, to this and many other prints
of Morland's works. The buildings are in better repair, and seem
likely to stand up longer; the boy has become smooth-skinned, pretty,
and holds himself in a less careless posture; the landlady now looks
up at the horseman with a jovial concern to see him properly
refreshed; the first child holds a much larger bowl of soup, and looks
at the farmer with a new benignity – the choker of beads around her
neck has been much enlarged, perhaps to conceal some error of
draughtsmanship, but the effect is to suggest that the family is not
so poor as to be unable to afford a few simple luxuries; and the second
child looks down at her sister with an expression of clammy sweetness.
In short, the poor in Ward's engraving are rather less frugal than
in Morland's painting, and consequently a good deal more contented;
and apart from Syer's version of *The Alehouse Door* I have not found
a single engraving after Morland that I have been able to compare
with his original painting, which does not emasculate his images in
some such way, even when – as in *Higglers Preparing for Market* – he
had done much of the job himself.[106] On the other hand, there is
no such obvious contrast between the originals and the engravings

George Morland,
*The Door of a Village
Inn* (detail)

of the work of other painters of rural life contemporary with Morland. Such a judgement must inevitably be based on a brief sample; but in the case of Francis Wheatley, especially, examples of whose paintings are not too difficult to find, and have been generously reproduced in a recent monograph,[107] the engravers had only to copy the paintings as exactly as possible to produce a thoroughly idealised image of the poor.

The engravings of works by Morland that were produced in such numbers were sold at prices ranging from three and sixpence to twenty-one shillings,[108] and so made a version of his art available to a public far lower down on the social pyramid than that which bought his original works. The idealisation of Morland's originals by his engravers thus makes an important qualification of the easy assumption that works of art, as they discover a public among the bourgeoisie and the petty bourgeoisie, become more concerned with images of actuality. Of course, these engravings did offer a more recognisable image of rural life than did engravings after Claude, for example, earlier in the century, in particular the mezzotints of the *Liber Veritatis* that Richard Earlom published in two sumptuous volumes in 1777, and this was no doubt an important part of their appeal. The figures appear in English settings, and are dressed in clothes recognisably, though not insistently, similar to those actually worn by the rural poor. But the condition of these clothes, and especially the smooth complexions and cheerful expressions of those who wear them, are designed to reassure us about the morale and the governability of the poor, not to inform us of their miseries; and the popularity of the engravings does nothing to suggest that this reassurance was unwelcome or unnecessary.

IV

In the context of *The Door of a Village Inn* we may try to consider another frequent criticism of Morland's work, though it is not one about which his critics are unanimous, that his pictures are ill-composed. The point was first made by Dawe,[109] is denied by Fry – 'his composition is often remarkably coherent'[110] – and reaffirmed by Berger, who writes:

> he was incapable of composing. He knew how to balance a picture in an automatic way, but the groups of his objects and people never cohere. Because there is no tension between them, each remains separate. One could take one figure from one painting and swap it with a roughly similar shaped figure from another, without disturbing either picture at all.[111]

This seems a pertinent and a just remark, but though it has the merit of refusing to make composition a merely technical affair – a matter of automatic balance – and of seeing it as an aspect of a painter's vision of his subject, it still does not go far enough, to consider whether it was an aspect of Morland's vision that he did not compose his groups of figures – for it is these that Berger is mainly concerned with – as Berger would have wished. For there are obviously social assumptions in the notion of composition, about the proper relationship between the figures in a group, whether those relations are easy and relaxed, or, expressive of the tension that Berger looks for, are still contained within the rhythm and harmony of an achieved and shapely form; and as it is unlikely that Morland shared these assumptions, it is unlikely that a number of his paintings lack composition by accident, if they do not lack it by intention.

The point can be made by comparing *The Benevolent Sportsman* with the pictures we are currently examining, for the former is one of Morland's most finished, and engraved was one of his most popular productions, for reasons no doubt much to do with the nature of its arrangement and what that tells us about the paternalist social relations the picture celebrates. The figures are disposed in an easy pyramid, the right side shorter and steeper than the left, and disturbed only by the gun the gamekeeper is holding, as it points upwards and to the right, and by the break in the left-hand-side of the pyramid where it passes over the head of the vagrant child. At the centre and at the top of the composition, of course, is the elevated and authoritative figure of the mounted sportsman; standing either side of him are the next most acceptable figures of the gamekeeper and, on the left, a handsome youth who is drawn from a different and a more refined tradition of rural painting from that to which his parents belong, seated in front of their rough bivouac. If the relations between rich and poor as they appear in Morland's paintings were always as acceptably authoritarian as they appear to be here, or if he was as simply sentimental in his social attitudes as Berger thinks him, then the easy grouping of *The Benevolent Sportsman* suggests that he could happily have composed groups of figures in which none would remain, as Berger puts it, 'separate', and all would confirm the essential unity of English society even in a transaction as full of social tension as the giving of alms.

There is no such comfort offered in *The Door of a Village Inn*: the two figures of horseman and landlady, writes Hassell, 'form a graceful pyramid, without the slightest affectation',[112] and so indeed they do, in the painting of course less obviously than in the print, where the upward movement of the composition is pointed up by the

upturned face of the landlady as she smiles at her customer. Such 'graceful pyramids' are the appropriate form for the delineation of relationships of authority and obedience such as this is. But though Fry remarks of Morland that 'like Gainsborough's, his pictures have no holes in them',[113] we may find one here, for the ostensible subject of the painting, the transaction between the two principal figures, takes place entirely on the right-hand-side of the picture, the centre of which is filled by the gable end of an outhouse, and for a particular reason. Meanwhile on the left, his back turned to the principal group, is the strange figure of the boy burning brushwood, the smoke from which is rising upwards and to the left, and the figure is striking and indeed 'separate' enough for the print of the painting to have been known by the alternative title *Boy Burning Weeds*, as if he were the picture's principal subject.

The composition of the painting as a whole is remarkably well-managed – it is the grouping of the figures which is holed. We can see the structure of the picture in the form of a W, the four lines of which are made up of, from left to right, the smoke from the fire, the two sloping sides of the gable end, and the line from the horse's rump, up to the back and head of the horseman, to the sloping roof

James Ward, after Morland, *Sun-Set; a View in Leicestershire*

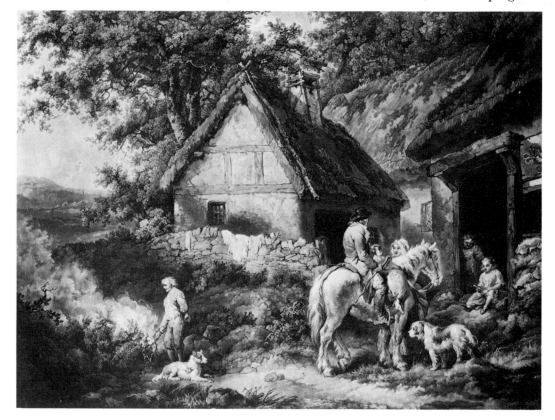

of the thatched porch. The outbuilding at the centre has thus the responsibility of welding into a pictorial relation figures that will not come together in a social relation; the price of what pictorial coherence the painting has is the displacement of the figures from the centre to the edges, where they are turned away from each other, or will not at any rate acknowledge each other's presence; and it is much to Morland's credit that he has found a way of organising the picture without suggesting that it is the image of a society in any way harmonious or unified.

The same point can be made about an excellent drawing in the Fitzwilliam Museum, *Midday Rest at the Bell Inn* (undated), which exhibits exactly that ability to 'balance' in an 'automatic way' that Berger believes Morland substitutes for any more vital principle of composition. The picture is firmly divided in two by a large tree in front of the inn, to the right of which are gathered a number of sportsmen with shotguns – at the time all sportsmen were gentlemen or substantial farmers. One attends to the dogs, another, in a relaxed and confident attitude, watches the landlord as he deferentially pours out a drink; two others are attempting to exercise their *droit de seigneur* with the barmaids – it is a perfect *vignette* of the relations of authority and subservience in the late eighteenth century.

George Morland,
*Midday Rest at the
Bell Inn*

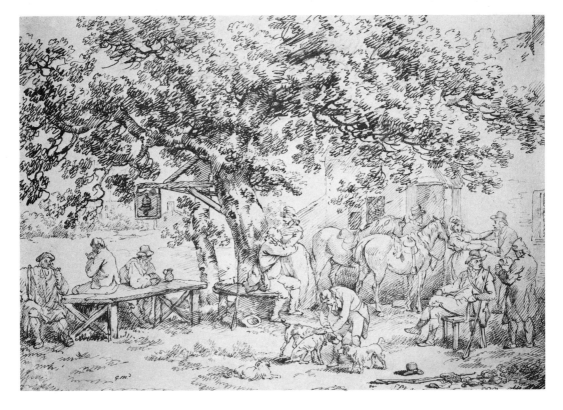

On the left of the picture, at a long wooden table, are three labourers in attitudes of boredom or studied disgust: one smokes and watches the gentlemen without finding anything to amuse him in their behaviour; a second sits with folded arms and stares hard into the table; and between them a third, sitting on the table itself, has turned his back on the jolly scene to the right. They do not speak to each other but seem united, at least in their sense of exclusion. The picture is indeed balanced: the tree which, slightly to the left of the centre, allows the gentlemen appropriately more space than the labourers, holds the composition together beneath its spreading branches as its trunk forces it apart, and the whole picture becomes an almost ironic demonstration of how an image of society may be unified though the society itself is not.

The drawing is strongly reminiscent of a small oil-painting by Morland, of which I have seen only a photograph, *A Tavern Interior with Sportsmen Refreshing*.[114] The current title quite conceals the point of the picture; for there is in fact only one sportsman, who stands in the centre of the composition, his gun in one hand, the other lifting a glass of ale to his lips, as he leans against a rough wooden table,

George Morland,
A Tavern Interior with
Sportsmen Refreshing

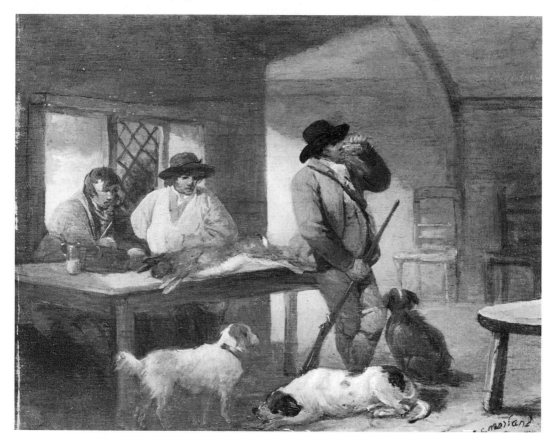

his dogs at his feet. He has turned his back on the other figures on the left, two labourers seated at the table, who drink from an earthenware mug. One of them is clearly related to the figure at the right hand end of the labourers' table in the Fitzwilliam drawing, and both are looking with what seems able to be interpreted as an expression at once of resentment towards the sportsman, and of bitter covetousness towards the sleek hare he has placed on the table in front of them, and which he has of course taken legitimately, but which they would have had to *poach*. The figures, then, are certainly 'separate', all three facing the same way: there is perhaps none of what Berger would recognise as a visual 'tension' between them; but the *social* tension in the situation is palpable.

Also in the reserve collection at the Fitzwilliam there is one of Morland's versions of a *Gypsy Encampment* (undated) in which I can detect no more principle of composition in the picture taken as a whole than I can in the group of figures taken by itself. On the right a farmer or gentleman – a person, at any rate, of some authority in relation to the gypsies – is leaning on a stile and looking at the group

George Morland,
A Gypsy Encampment

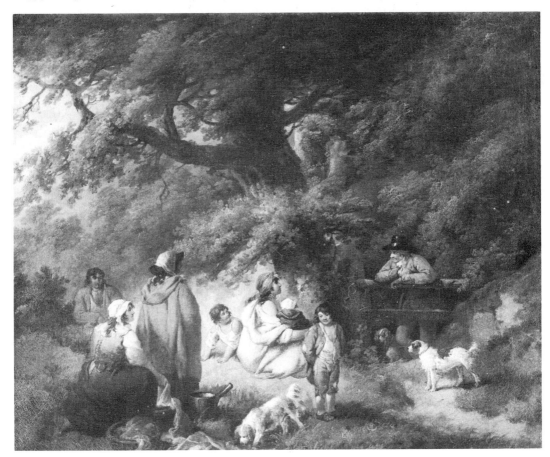

of gypsies in the left and centre foreground. The group seems to be arranged entirely at random, and to be in no obvious structural relation to the farmer: it is a problem that would be less obvious had Morland given the latter the privilege due to authority in such subjects as these, and elevated him above his social inferiors, as he does in *The Benevolent Sportsman*; and in choosing not to do so, he has disturbed our sense at once of the social relations in the picture and of its composition. The farmer stares at the gypsies from their level, with what may be a smile or a grimace: they stare back at him, with a studied lack of response, except for the little boy at the exact centre of the picture, who has turned to watch a dog snuffling among the gypsies' possessions. Unwilling as he seems to have been to depict the only possible relation of farmers and gypsies, of authority and obedience, Morland must of course depict no relation between them at all, and in this picture we can see even more clearly than in *The Door of a Village Inn* an intimate connection between the possibility of composing such subjects as these and what we may presume from all we know of his life and character to have been Morland's attitude to the social relations which must govern the meeting of rich and poor.

V

I must be careful not to overstate the case for Morland: only some of his pictures can sustain our interest as can the pictures we have been examining, and far more of the faults in his massive output are those of a man painting hastily to satisfy the demands of his creditors than of one unable to organise his pictures convincingly because he is unconvinced of the assumptions about society implicit in notions of pictorial organisation; but these two constraints on his achievement are of course related, and had Morland lived the orthodox life of a respected and successful artist he would hardly have been able to disturb and displease his contemporary and modern critics as he does. The bulk of his paintings of rural subjects are indeed sentimental, and he must take as much responsibility for satisfying, on terms his admirers found all too easy to accept, a pretended taste for a fidelity to nature in the image of the rural poor, as he must take credit for exposing the limits of what was acceptable in the painting of them. But his best pictures offer a comment on the attitude of the rich to the poor which might be made almost on behalf of the poor themselves: where his admirers wish to see the image of a unified society, he shows them a divided one; where they wish to see the poor as cheerful and industrious, he shows them as discontented, desperate, contemptuous, or defiantly idle; and there was no other painter of English rural life independent enough, or intimate enough with the

lives of the people he portrayed, to achieve what Morland achieved. His successes are occasional only, but that was inevitably a condition of his succeeding at all: had he delighted his customers less often, he would never have been able to disturb them, and had they laid fewer constraints on his subject-matter he could not have expressed as sharply as he did that desire for social and ideological independence that we seem to have discovered in the paintings discussed in this essay.

3 John Constable

He also suggested the introduction of the figure with white sleves which (he said made the picture').
(*David Lucas's recollection of advice offered to Constable by Benjamin West*)[1]

I

At the time of the opening of the Constable Bi-Centenary Exhibition at the Tate in 1976, art journalists and art historians reviewing it or previewing it seemed to go out of their way to notice and to discuss the figures in Constable's landscapes; but in what they said about them they disagreed with each other so completely that you might have thought one was talking, say, about Boucher, another about Millet. It was the issue of work that seemed to divide them. Thus, in a preview article in the *Observer Colour Magazine*, William Feaver – thinking probably of the six-footers, the canal pictures – wrote:

One after another the scenes pass by, every one midday and drowsy...Bargees lean on their poles. Boys snooze and in almost every foreground the same black and white sheepdog pauses, panting.[2]

The following weekend, in her review in the *Sunday Times*, Marina Vaizey – here with the paintings of the previous decade, from 1810 to 1820 in mind – spoke of

Constable's astonishing power to convey the physical poise of working men and animals at peace in their setting.[3]

The difference between the stress Feaver, and Marina Vaizey, put on work as an element in Constable's landscape may be accounted for by the fact that they have different paintings in mind, but I doubt it; and Anita Brookner would doubt it too – her comment, in *The Times Literary Supplement* a week later, applies to all Constable's work. 'No one', she said, 'saunters through his landscapes; all characters have the appearance of serfs'.[4] There were other opinions too, from

other writers, but these three will do, and the range of opinions could be no wider. Briefly, then, according to Feaver, no one does anything that looks much like work in some, at least, of Constable's landscapes; according to Marina Vaizey, people do work, and in working they are poised, at one with nature; according to Anita Brookner, they do nothing but work, and would no doubt be disciplined by their employers if they dreamed of stopping.

I do not want to adjudicate between these opinions in this essay, so much as try to understand how such a diversity of opinions can have come about, and how each is related to the other; for they have this, at least, in common, that all three writers have said what they have as part of an attempt to understand Constable's pictures in their time, in their social and artistic context. William Feaver is clearly emphasising the aspects of the pastoral tradition that he thinks he sees in Constable. Indeed, Constable himself seems to have thought of his work as Pastoral,[5] though he does not seem to use the term as I do, to mean a vision of rural life whereby the fruits of nature are easily come by, more or less without effort. Marina Vaizey has stressed instead something recognisably Romantic in Constable's work, which attaches him to the world of Wordsworth – the sense we may get from his pictures that the figures are understood in terms of a specifically early nineteenth-century notion of a restorative harmony with nature. Anita Brookner, finally, writes as one who has seen through the repressive mythology of eighteenth-century Pastoralism and nineteenth-century Romanticism alike: these pictures, she is saying, show us the actuality of early nineteenth-century rural life, whether they intend to or not; whatever Constable wants us to believe about the Suffolk he painted, he cannot help showing the life of the labouring class there as one of continual labour, because the continual labour of that class was the foundation of whatever pastoral or Romantic notions Constable had about Suffolk – if those men once stopped working, the vision would fade.

I want to look at some paintings in the light of these different opinions, and I shall concentrate on the period of Constable's work roughly between 1809 and 1821, when his interest in the painting of a social landscape, animated by the figures of men working, seems to have been at its greatest. But first I should anticipate the objection, that I am about to consider the figures in Constable's *landscapes*, in the light of what has emerged in this book as a tradition of rural *genre* painting. We do not ask, of course, whether the *Woodcutter and Milkmaid* is landscape or *genre*, because it is clearly both; and the harmony of the figures and the landscape is achieved without the figures being subordinated to the landscape, or becoming merely objects or bits of colour within it. Indeed, if we look at that

Gainsborough painting with the schemata of Claude in mind, it's hard to say how it is we look at it, whether we look through and past the foreground, to the horizon beyond, or whether we allow the eye to rest in the foreground, before it wanders elsewhere. There were however painters of the middle and late eighteenth century whose figures are of minimal importance in their landscapes, and if not as tiny as Constable's are, still fairly inconspicuous – Richard Wilson would be such a painter. But Constable – and especially in the period of his work I shall be examining – is not simply a landscape-painter as Wilson wished to be, but one clearly concerned to express in his landscapes a social vision – the image of a productive and well-organised landscape, as it relates to the idea of a well-organised society. It's remarkable, then, how little *social* his landscapes are. The nobility and gentry, of course, almost never appear in them[6] – there are no rural portraits of landowners asserting their authority over the landscape behind them. The only figures he paints are those of the labouring poor, and there are not many of them. Sometimes one or two figures may be working in the foreground, with perhaps a couple more of what may be figures further away. No painter offers us a more civilised landscape than Constable, but the existence of the men who have civilised it has for the most part to be inferred from the image of what their effort has achieved. In his published sketch-books we do find a greater concentration on the human: 'notes', as Graham Reynolds describes them, 'of the characteristic actions and work of his fellow-countrymen',[7] ploughing, digging, reaping. But these figures hardly survive translation into paint – and instead are absorbed by the landscapes they cultivate. Or they disappear: the small sketch which became *Boat-building near Flatford Mill* (1815 – the sketch is of the year before[8]) is thronged with figures – at least ten men at work on the barge or near it. In the painting these are reduced to four, and all but two of them have been moved away from the foreground.

In an essay in *New Society*[9] on the Millet exhibition at the Hayward Gallery which ran concurrently with the Constable Exhibition in 1976, John Berger argued that Millet put an end to the possibility of painting a peopled landscape, by sticking his figures, exhausted and degraded as they often are, so embarrassingly near to the picture surface that they seem rather to obscure our view than to be part of it. And we can relate this point to Constable's contrary attempt to present his peopled landscape as an image of the harmony between man and nature, at a time when, as the evidence of Morland, of Crabbe, of Hannah More shows, the rich knew only too well how ragged and how over-worked were the rural poor, even those in regular employment. As far as we can characterise Constable's

political attitudes, he seems to have been, unsurprisingly enough in view of his birth and the position of his family, an old-style rural tory, convinced that the social and economic stability of England depended on a flourishing agriculture. In terms of our tradition, these attitudes are of a piece with eighteenth-century Georgic, except insofar as the interests of agriculture and industry had come to seem over the intervening period in some ways antithetic; so that although, as we have seen, an image of the poor 'as they really are' could on certain terms now be admitted in pictures concerned directly with the problem of the poor, this would have been a considerable embarrassment to Constable, in his attempt to recreate an older, georgic image of the fat and productive land of East Anglia. And so it was necessary for him to reduce his figures until they merge insignificantly with the landscape, to distance them, and even when they are in the foreground to paint them as indistinctly as possible, to evade the question of their actuality. The labourers do not step between us and the landscape – they keep their place, and it is a very small place, a long way away.

There is a real contradiction between this distance in Constable's paintings, and the closeness of the rural community as it is imagined

John Constable,
sketch for
*Boat-building near
Flatford Mill*

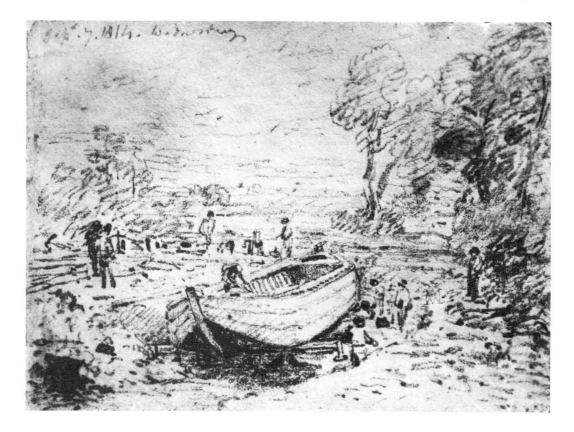

to be in the system of paternalism he longed to see return. In some helpful notes on the manuscript of this essay, T. J. Clark has asked me to say more clearly whether Constable's 'imagined, ideal rural community is characterised by closeness or respectable solitude'. By both, as I have argued; 'but which', he asks, 'predominates?' The question really cannot be answered, in relation to the paintings of the period 1809–21, for such are the constraints on painting the image of the labourers 'as they really are' that closeness can be expressed only by distance – the *ideal* of the close rural community has replaced the *experience* of it. It becomes easier to make the choice after 1820 or so, for Constable by then became more aware of how the stability of his beloved Suffolk was under threat – 'never a night without seeing fires near or at a distance', reports his brother Abram in 1822,[10] and the idea becomes so impossible to maintain that, as we shall see, it virtually disappears from his later pictures.

It's worth pointing out that John and his brother Abram reckoned among the chief advantages of the family's move from East Bergholt to Flatford

John Constable,
*Boat-building near
Flatford Mill*

the riddance of Beggars, very few finding their way down, not being a thorofare, and...callers, or idlers, don't interrupt.[11]

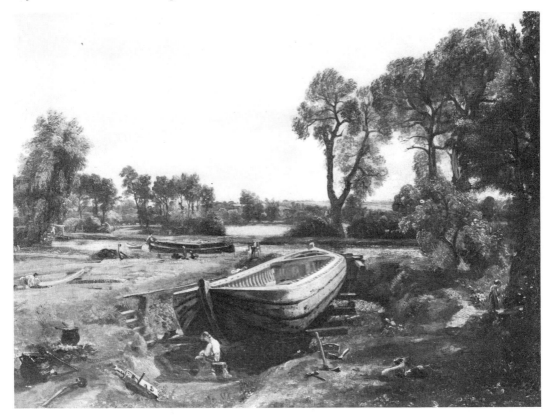

This in 1821 – we are a long way now, after the post-war depression and in a period of continuing peasant riots in East Anglia, from the world of Wordsworth's 'Old Cumberland Beggar' or Morland's *The Benevolent Sportsman*, in which the presence of beggars and so the necessity of charity were the very basis of the social impulse. Indeed, if we compare Constable's work with that of his predecessors discussed in this book, we will notice that the vagrant, as opposed to the industrious poor, hardly ever appear in it, and he nowhere invites that sympathy, dubious or not, for the outcasts of society that Morland elicits. In *Dedham Vale* of 1828[12] a gypsy mother is depicted nursing a baby, and near her is a rough bivouac like that inhabited by the vagrants in *The Benevolent Sportsman*. But, seated in the foreground though she is, we hardly notice her – we look through her with less concern than we do through the figures in Claude's landscapes. Even the redness of her shawl cannot attract our

John Constable,
Dedham Vale, 1828

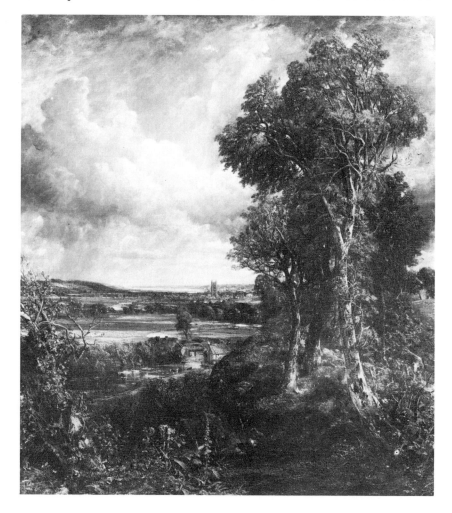

attention, for Constable as far as possible has shaded the red into brown and black, and its texture is absorbed into that of the landscape that envelops and conceals her.

By the mid-1820's, so far from seeing the advantages of the rural life as especially those of a close community, Constable may have come to reckon them instead in terms of the beneficial solitude imposed on labourers in the field, as opposed to the gathering of workers in workshops and factories, where they were liable to seek redress for their complaints in combination. This, at least, is an implication we could draw from the letter in which he writes that the 'mechanic' –

> is only made respectable by being kept in solitude and worked for himself... Remember that I know these people well – having seen so many of them at my father's

– and he goes on to quote Hannah More on the virtues of sociability and the vices of gregariousness.[13] The sentiment is of interest, not only for the authority with which it is delivered – 'I know these people well', says Constable, who 'scarcely ever spoke to, or knew the names of, his father's labourers'.[14] More striking still is that authority embodied in those passives – 'made respectable', 'being kept', and 'worked': the labourer does not work, but is worked, as we 'work' a horse; his industriousness is an entirely passive virtue, reflecting no positive credit on himself, and if he becomes by his labour 'respectable' that is only by the canny management of his employer. We get a good sense here of the sort of harmony Constable now looks for in the well-regulated community – one clearly achieved by obliging the workers to submit to work in solitude, so that the peace of society is bought at the expense of its pleasures.

II

I have described this new image of harmony between labourer and landscape – a harmony only possible if the labourer is distant or otherwise indistinct – as one that Constable arrived at in the attempt to adapt the old georgic vision of England, as a rich and peaceful land where labour is valued and rewarded, to a time in which that vision was clearly threatened by a new fear of the power of the labouring class. But the attitude to the figures in the landscape which is implicit in his paintings can be related, as well, to one we find everywhere in the Romantic literature of rural life, as it was produced by writers with no interest in the economic values of eighteenth-century Georgic, and who, indeed, can be seen as consciously rejecting the georgic vision with its emphasis on wealth and empire, in favour of a concern to describe and protect the virtues fostered in

small, closed communities separate from the mainstream of national life. We may compare, for example, with what I have said about Constable's figures, this moment from Dorothy Wordsworth's tour in the Highlands in 1803:

> Our road was through open fields; the people suspended their work as we passed along, and leaning on their pitchforks or rakes, with their arms at their sides, or hanging down, some in one way, some in another, and no two alike, they formed most beautiful groups, the outlines of their figures being much more distinct than by day, and all that might have been harsh or unlovely softened down.[15]

The twilight masks the 'unlovely' evidence of exhaustion and resentment, and makes it possible for Dorothy, gratefully, to see only what she wishes to see, the figures in outline only. It offers her a beautiful image, and one she knows to be in some way false, instead of the truer picture she would have been forced to acknowledge in the light of day.

Such moments occur throughout *The Prelude*, and perhaps most obviously in Book VIII, where Wordsworth describes the visions of lakeland shepherds which he had experienced as a boy. The passages in question are, apparently, paradoxical, in that Wordsworth is undertaking to describe how as a child he was led beyond an immediate concern for self, family and friends towards a more inclusive love of Man – towards

> Love human to the Creature in himself
> As he appear'd, a stranger in my path,
> Before my eyes a Brother of this world
> (1805 version – lines 77-9)

– and yet this more inclusive social sense is engendered in him by visions always of solitary men, the representatives of men in general by virtue of being seen as symbols of Man in general; and of course it is reasonable to argue that Wordsworth was never able to progress beyond a concern for Man to one for men, and never overcame his horror and suspicion of 'the deformities of crowded life' (line 465) to be able to believe in the virtues of a society which is not a collection of small, separate communities. Thus, in describing one of these visions of shepherds, he writes:

> Or him have I descried in distant sky,
> A solitary object and sublime,
> Above all height! like an aerial Cross,
> As it is stationed on some spiry Rock

Of the Chartreuse, for worship. Thus was Man
Ennobled outwardly before mine eyes,
And thus my heart at first was introduc'd
To an unconscious love and reverence
Of human Nature
(lines 406–14)

The epic and visionary tone of this could not be further from the
domestic landscapes that we shall be studying by Constable; and yet
the same necessary distance is maintained by Wordsworth, as it is by
Constable, and the value and necessity of this distance are precisely
grasped by Wordsworth:

But blessed be the God
Of Nature and of Man that this was so,
That Men did at the first present themselves
Before my untaught eyes thus purified,
Remov'd, and at a distance that was fit.
(lines 436–40)

Only by being kept at a distance are men in Constable's paintings
able to be seen as at one with the landscape, and as emblems of the
contentment and industry which ideally were the basis of England's
agricultural prosperity; and only by being kept at 'a distance that
was fit' can Wordsworth's shepherds be acceptable as representatives
of what is noble and most to be loved in Man. Men as they are, as
Wordsworth clearly says, are too impure, the actuality of their
appearance too much in contrast with the ideal of the human, for
them to invite us to move beyond our merely selfish and familial
concerns to a concern for general humanity; and he makes the same
point still more strongly a few lines later:

first I look'd
At Man through objects that were great and fair,
First commun'd with him by their help. And thus
Was founded a sure safeguard and defence
Against the weight of meanness, selfish cares,
Coarse manners, vulgar passions, that beat in
On all sides from the ordinary world
In which we traffic.
(lines 450–7)

Joseph Farington records in his diary a remark by Wordsworth
on landscape painting which is also relevant to this discussion:

Wordsworth said he thought historical subjects should never be
introduced into landscape but where the landscape was to be

subservient to them. Where the landscape was intended principally to impress the mind, figures other than such as are general, such as may a thousand times appear, and seem accidental, are injurious to the effect which landscape should produce as a scene founded on observation of nature.[16]

This point is not a strikingly original one, and in its defence of the separation of *genres* could have been made by Reynolds as well as by Wordsworth; but the insistence on figures 'such as are general' is close to the attitude implicit in Constable's treatment of his figures: that they should never command a degree of attention that would threaten to turn the landscape into a *genre* painting. As Basil Taylor writes of Constable, if he

> did not depict his country people with much particularity it might be argued that this was not merely a consequence of his style, but proof that he saw them and their life as being an intrinsic part of a whole natural creation.[17]

There have been many attempts to suggest correspondences between Wordsworth and Constable, most of them provocative but almost all of them too ambitious – anxious to see similarities which ignore the different possibilities of language and of paint, the different intellectual interests of the two men, and the differences in their social attitudes.[18] I am not trying here to propose Constable as a Romantic artist, nor am I trying to oppose those who do. My point is merely that in different ways and for different purposes both he and Wordsworth are concerned to see men as in harmony with nature; and that though Constable seems to adhere far more than Wordsworth to an ideal of the rural community whose health is to be measured by its prosperity, and has little interest in the niggardly soil of landscapes we think of as sublime, he experienced the same difficulties in matching men 'as they really are' to his vision of the productive landscape of Suffolk, as Wordsworth did to his of the sublime scenery of the Lakes. These difficulties I have pointed to already in my essays on Gainsborough and on Morland: the increasing insistence on an image of actuality in art, and a consequent unwillingness to continue to represent the poor through the idealising stereotypes of Pastoral.

It is this that explains what may well seem to us a paradox in the art of the early nineteenth century, that it seems to proclaim its concern for the human more insistently than the art of the mid-eighteenth century, and is apparently concerned to depict a social universe in 'the very language of men,'[19] or in images of a landscape that is contemporary not classical, and yet it seems more reluctant

than earlier art to confront the human image with any degree of
directness. Wordsworth's refusal to portray the rural poor of Somerset
and Westmoreland in terms of Pastoral is matched, for example, by
Constable's contemptuous rejection of Boucher's 'pastoral of the
Opera House', in which

> from cottages adorned with festoons of ivy, sparrow pots, &c,
> are seen issuing opera dancers with mops, brooms, milk pails,
> and guitars; children with cocked hats, queues, bag wigs, and
> swords – cats, poultry, and pigs. The scenery is diversified with
> winding streams, broken bridges, and water wheels; hedge
> stakes dancing minuets – and groves bowing and curtsying to
> each other; the whole leaving the mind in a state of
> bewilderment and confusion, from which laughter alone can
> relieve it.[20]

He reminds us, as we were reminded in the essay on Gainsborough,
that

> at this time...the court were in the habit of dispersing into the
> country, and duchesses were to be seen performing the parts of
> shepherdesses, milk maids, and dairy maids, in cottages; and
> also brewing, baking, gardening, and sending the produce to
> market.

The implication in this is clear: Boucher is dismissed to a frivolous
phase in the history of a frivolous nation; the serious painter must
nowadays concentrate on a fidelity to nature, to actuality, that was
beyond the grasp of Boucher, who told Reynolds, as Constable tells
us, that 'he never painted from the life, for that nature put him out'.
 And yet Constable, like the Wordsworth of the *The Prelude*, and
far more than the author of the *Lyrical Ballads*, seems to have been
shocked by the image of men as they are, when their pastoral weeds
have been stripped off; and both men prefer to distance them into
symbols and tokens of humanity, rather than encounter them in a
condition which no degree of charity or self-deception could allow
them to pretend was noble, contented, or anything but degraded.

III

In the oil-sketches Constable made at the start of the period I am
discussing, we feel that he is using paint not so much to imitate the
appearance of a natural scene, as to recreate it in a medium whose
possibilities he has understood for the first time; so that the pleasure
of looking at these sketches lies less in their credibility, or evocative
power, in the degree of their resemblance to an imaginable landscape,
than in harmonies of colour and texture enjoyed almost for their own

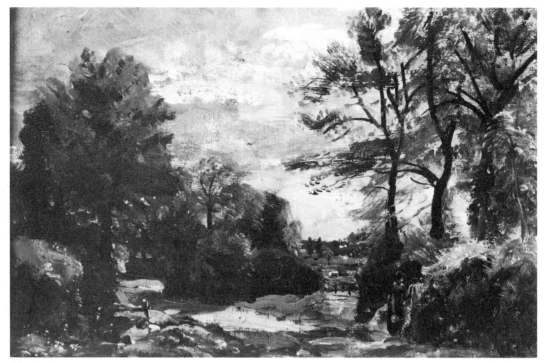

John Constable,
A Country Lane.
(Detail below)

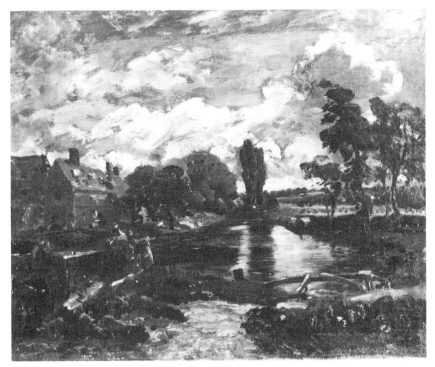

John Constable,
*Flatford Mill from the
Lock* (Detail below)

sake. Objects in the landscape come to exist in terms of their relations with each other, not their relation to an actual original; they are as little iconographical, as much formal, as possible. This new art has consequences for the treatment of human figures in the sketches. At most, the figures come to represent a notional and unrealised 'human element'; but really they are what Constable described, in a remark on Claude, as 'objects of colour' – he especially admired Claude's figures, as 'according so well with the scenes; as objects of colour they seem indispensable'.[21] It's a reasonable remark; the question is, however, how Constable too, who seems to attempt to paint a thoroughly human landscape, could be satisfied with figures as mere objects of colour. For in *A Country Lane*, for example, of uncertain date but probably painted about 1811,[22] that is how we must read the boy on the left, who reappears later in *The Cornfield*,[23] and the young lady on the right. And what can those objects of colour be, in the right distance, but tokens of a human presence in the landscape, which remain, however, tokens we can exchange for no more definite impression of what they are? They form a bright point of focus, at one end of the two alternative paths along which the eye travels to the distance; but what it is there that is somehow and vaguely human, we will not discover, however urgently we scrutinise those patches of red and white.

In that extraordinary series of oil-sketches of *Flatford Mill from the Lock*,[24] which dates from around 1811, there is always a meadow in the right distance, and in some versions of the subject there are haycocks in it. In some versions, too, there are specks of white in the meadow, which represent the light reflected from the haycocks, and sometimes men working with their jackets off. But the more closely you peer at the pictures, the more indefinite the images become. In one version at the Victoria and Albert Museum, some of these ambiguous specks of white are decoded by being topped with smaller specks of black – hats – and one of them is touched with red – a neckerchief? On the opposite bank of the river is a small patch of blue, again the token of a human presence, which may be a woman doing her washing, or the washing itself spread out to dry.

This indeterminacy can be an issue not only in the sketches, which are of especial interest in this connection as indicating how, in his private conceptions, Constable thought of figures as relating to the landscape, but in some of his finished pictures as well. In *Golding Constable's Flower Garden* (1815),[25] for instance, there is a single figure in the distance who seems to have been given the unenviable and rather unlikely task of reaping by himself the whole field of corn[26] – Constable, as we have seen, didn't like too many figures in the landscape at the same time. But though it's clear from the image,

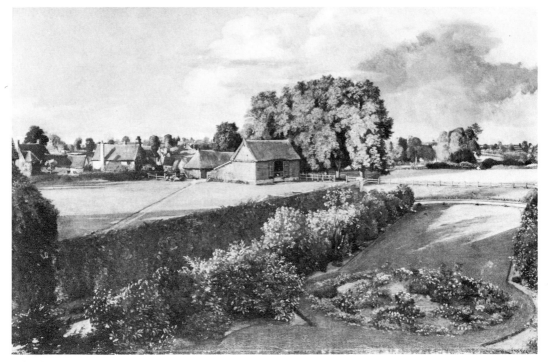

John Constable,
*Golding Constable's
Flower Garden*

John Constable,
*Golding Constable's
Flower Garden*
(detail)

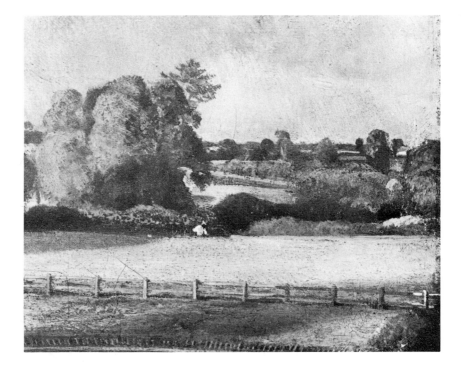

a blob of white and two thin lines, that this is a man, and a man working in his shirtsleeves, no matter how close we get or how much we blow up the image, we will not be able to read it more precisely than that. From a distance, he seems to be a man stooping, seen from his right; from close up, it may be a rather larger torso, seen from behind. Your guess is as good as mine.

Some similarly indeterminate figures appear in the *Haywain*,[27] of 1821, which it will be helpful to compare with a painting by Claude in the National Gallery, his *Coast Scene with Aeneas at Delos*[28] (1672), though I am not suggesting that Constable's picture is influenced by Claude's. If we were to reverse the structure of one of these paintings, as by projecting a slide of one of them back to front, we would observe a remarkable similarity of structure between the two. I want to stress how in the Claude the temples on the right are disposed so as to guide our attention directly to the area of light at the horizon, where the sun has just set or is about to rise; and it is in playing their part in helping us to focus immediately on that area that the objects in the landscape can be seen as unified – not the buildings only, but the trees to the left and in the centre; so that that area of light is the unifying focus of the whole composition. We largely ignore the figures, nowadays at least, until after we have made that initial response, of allowing our eye to be drawn first to the horizon.

Something similar occurs in the Constable painting too, though

John Constable, *The Haywain*

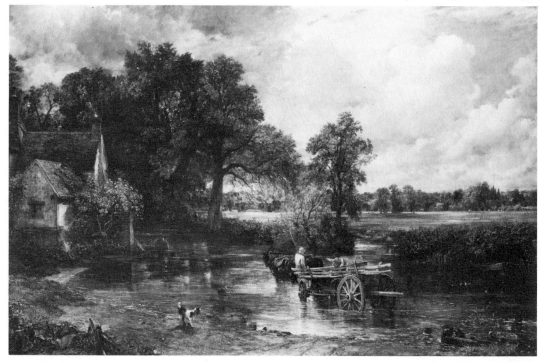

in a less programmatic way. As in the Claude, the objects are arranged so as to facilitate the eye's flight, not to one but two areas of light just below the horizon, this time at the centre and on the right of the composition – one either side, that is, of the tree in the middle distance, which thus complicates the design in a way that the trees at the centre of Claude's painting do not. The composition is complicated further by the fact that the position of the central group does not allow it to be a secondary object of attention, as the figures seem to be in Claude's painting. But still that bright penultimate band is what enables us to grasp how the three-dimensional space of the Stour Valley has been articulated in two dimensions, and to that extent it is on that alluring light that the organisation and the harmony of the landscape depend. What we discover in that band are more tiny figures, little more than blobs of white, apparently hay-making, yet curiously hard to make out, though they are the brightest objects in the gleaming tract of sunlight on the right. And of course it is very much to do with the fact that they are so very little distinguishable – though in some ways hardly less so than the figures in the foreground – the driver with his back to us, the angler half-obscured by the vegetation at the water-side – that they can be presented as in harmony with, and actually as helping to harmonise the scene.

Claude Lorrain, *Coast Scene with Aeneas at Delos*

The landscape is still, an image of stability, of permanence; the

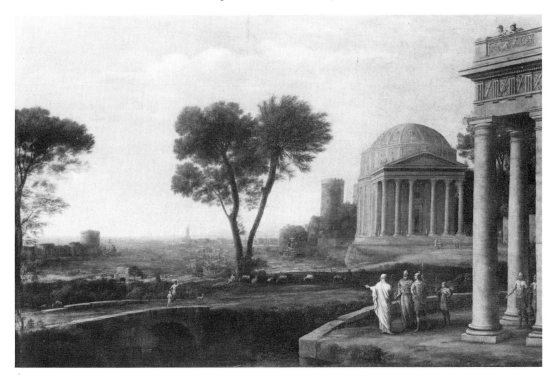

John Constable, *The Haywain* (detail)

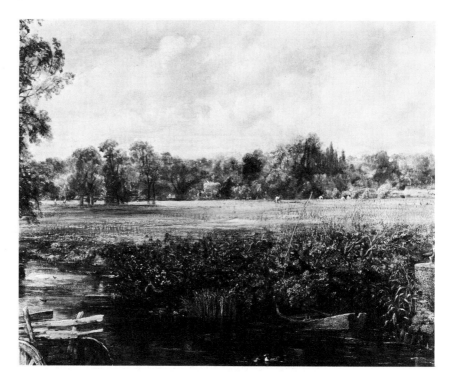

John Constable, *Stour Valley and Dedham Village*

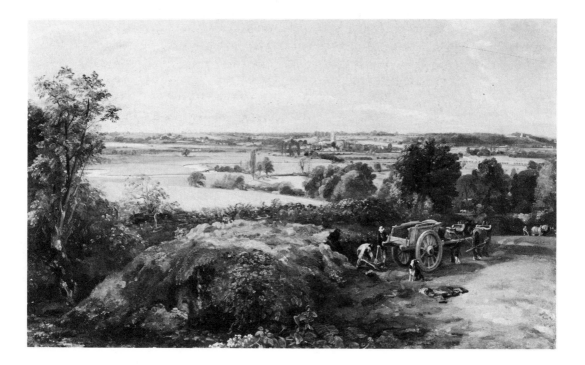

stability of English agriculture seems to partake of the permanence of nature in this image of luxuriant meadowland. And just as the structure of the landscape is in some measure held together by these figures, so also they animate the stillness of the meadow, and support by their activity the stability of an ideally structured economic and social order. We may recall the anecdote of Benjamin West which stands as the epigraph to this essay: the figures 'with white sleves' make the picture as they make the landscape productive and so paintable; but they could not be more unobtrusive, and indeed as I have indicated if they obtruded more, if they became less symbolic, more actualised images of men at work, we would run the risk of focussing on them as men – not as the tokens of a calm, endless, and anonymous industry, which confirm the order of society; and not as objects of colour, confirming the order of the landscape.

IV

There are of course a number of pictures from this period in which the figures are a good deal closer to us – the *Stour Valley and Dedham Village*, for example, of 1814 or 1815,[29] or the *Dedham Vale with Ploughmen*, of about the same date.[30] In the former picture, the figures appear in the foreground, as they might do in a landscape by Claude,

John Constable,
*Stour Valley and
Dedham Village*
(detail)

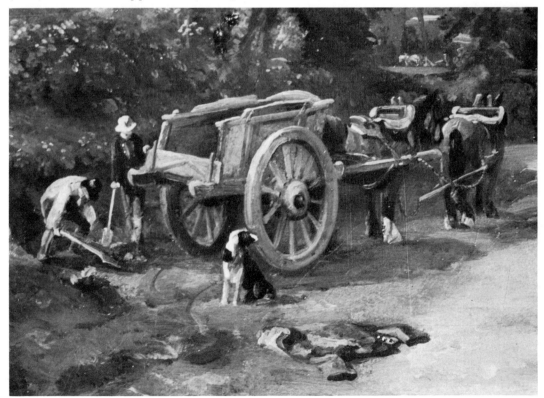

and yet for all their proximity there is a curious, an ambiguous lack of definition about them. The fairly broad, sketchy treatment may suggest they are ragged – but the sense of roughness about their limbs directs our attention as much to the way they are painted, as to what they are. Morland's picturesque is not ambiguous in this way; we know with him that raggedness is being shown as of aesthetic *and* social interest; but with Constable we do not know, as we study these figures, whether we are discovering something about what Constable has seen, or about how he sees it.

John Constable,
*Dedham Vale with
Ploughmen*

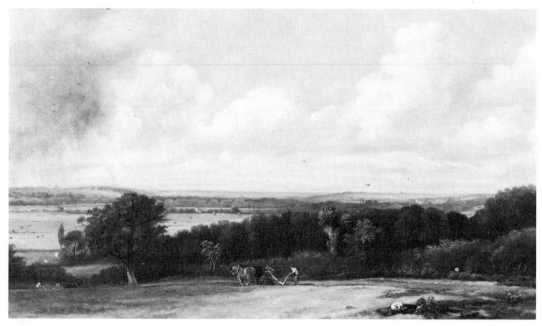

John Constable,
*Dedham Vale with
Ploughmen* (detail)

This landscape too is organised rather as Claude might have organised it, as a system of horizontal planes which mark by their different tones the distance the eye travels in its movement to the horizon, though of course it's part of the extension Constable made of the schemata of Claude that the range of those tones is here much wider, and that the landscape, too, seems wider – there is no sense of the eye being led to a particular and more or less central point of light near the horizon, though the church tower does offer itself as a point to fix on in the distance. The first plane of the landscape – as also in *Dedham Vale with Ploughmen* – is, furthermore, much darker, and much deeper – it extends much further up the picture – than it would do in a Claude; and in the *Stour Valley* it is a piece of fallow land, marked off from the smiling and highly coloured landscape beyond, by a hedge over which the labourers could not see, even if it occurred to them to detach themselves for a moment from their work, and turn to enjoy the landscape – which we, however, as the spectators on this scene, from a high and privileged viewpoint, can see and enjoy. The ploughman in the other picture is equally single-minded, keeping his eye doggedly on the progress of his ploughshare through the earth. And whether in the foreground or background, the figures in both landscapes seem to be characterised by an expressionless and irremissive devotion to their work.

Constable added a tag to the *Dedham Vale with Ploughmen*, a couplet taken from *The Farmer's Boy*, by the 'peasant poet' Robert Bloomfield:

But, unassisted through each toilsome day,
With smiling brow the Plowman cleaves his way.[31]

What is most remarkable about this tag is perhaps its complete inappropriateness to the picture. The ploughman is unassisted, alone – his work is not, as work in the mid-eighteenth century is so often presented as being, pleasantly social, but solitary, and the more 'toilsome' for being so, as well as for the lack of the help a plough-boy could have offered. In spite of being thus alone and unaided, however, Bloomfield's ploughman cleaves his way 'with smiling brow' – with an inexplicable expression of delight – we might have expected instead 'with sweating brow', and indeed, Michael Rosenthal has suggested to me that, in the context of ploughing, 'smiling brow' could be a savagely ironic euphemism for 'furrow'd brow' – a suggestion which brilliantly illuminates the cheerfulness-in-adversity that the rural poor were obliged to feign. The phrase, then, 'smiling brow', in terms of the meaning of the poem as a whole, points in two different directions. It is part of an attempt by Bloomfield to bring the Georgic once again in connection with the Pastoral, and

so to bring back the more humane, as he believes, values of old and merry England; but at the same time it suggests a more guarded, a more characteristically late eighteenth-century notion – the plough-man is smiling to reassure us, that even though he is forced to work all the harder, because his master is saving on labour costs, he is not complaining – he is one of the patient and deserving poor.

Now, this is something it's much easier to write than to paint: whatever the source of the ploughman's cheerfulness, it expresses itself to Bloomfield not as a look but as a feeling – the brow smiles, not the mouth. It is hard to visualise a 'smiling brow', and I do not suppose we try. Constable certainly does not: his ploughman, reproduced from a notebook sketch of 1813,[32] has his back to us, and his expression is not open to our inspection; and I cannot in fact imagine how Constable could possibly have presented us with so frankly implausible an image as an overworked ploughman smiling as he worked. Constable thinks of the tag as appropriate, of course, by the automatic assumption that people who work extremely hard are cheerful for that very reason, hard labour being its own reward; but inevitably the ploughman he offers us must be less a man as a

J. M. W. Turner,
*Ploughing Up Turnips
near Slough*

result of this limitation on him and on Constable. We can get from
him the sense neither that he has something to complain about, nor
even that he is not, in fact, complaining; once again, that necessary
and characteristic indefiniteness in Constable's images of working
men.

We can compare this painting with an almost contemporary
picture by Turner, *Ploughing up Turnips* (1809?).[33] Turner's picture
refuses to subscribe to the regimentedly georgic vision of hard labour
that Constable offers – but it does not seem either that the only
available alternative to that is a vision of rural England in terms of
an idle Pastoral. The men in this picture are in the field to perform
manual labour, which for the moment they are not performing, for
what reason is not clear, though they may be discussing how to mend
a broken plough. They are not therefore seen in terms of a relaxed
and idle Pastoral, but nor can they be characterised by a blind
addiction to work, as in Constable's Georgic. As it were they slip
between the two traditional ways of relating rustic figures to a
landscape, and in doing so appear to us, not as Arcadians, nor as
automata, but as men. They are not in any way mere 'objects of

J. M. W. Turner,
*Ploughing up Turnips
near Slough* (detail)

colour' in the landscape; behind them looms the misty image of Windsor Castle, but nothing in the organisation of the picture encourages us to look through the figures in the foreground, to ignore them at first in favour of that sublime image behind them.[34]

There is the same sense of stereotypes avoided in Turner's *Frosty Morning*, of 1813,[35] which seems to depict a pair of labourers who have been hacking at a pile of frozen turnips and are about to load them onto a cart – further to the left what seems to be a gentleman with a shotgun is standing with his daughter and watching the labourers. All are clearly affected by the cold, and their discomfort gives meaning to the landscape, their attitudes underlining the frostiness of the dawn; but in the same process the frosty landscape gives meaning and identity to the figures, for as the cold makes them loth to work, it detaches them from their imposed identity as workers, and reveals them as men with interests of their own at heart, as well as those of their employers.

The pictures apart from *The Sower* which stay in my mind from the 1976 Millet exhibition already referred to have something of the same power to detach men from their imposed identities, and so to detach the art of rural life from its traditions. The man briefly resting in the vineyard, the man leaning on his hoe, or the man suddenly standing up straight in the flat landscape and pulling on his jacket in the twilight[36] – none of them are presented as working, but as, for

J. M. W. Turner, *A Frosty Morning*

the moment, not doing so. They define themselves not so much as workers, but as men who must work – for whom work is not a natural or a harmonious but a painful activity, which makes unnatural demands on soul and body. When these men suddenly stop working and stand up, we recognise them suddenly as men – just as in the fourth book of *Gulliver's Travels* when the Yahoos raise themselves on their hind legs we recognise them as men; and by implication can recognise their masters, too, the Houyhnhnms, as animals.

There is an early poem by John Clare, 'Dawnings of Genius',[37] also more or less contemporary with the *Dedham Vale with Ploughmen*, which communicates exactly the sense I am trying to communicate about these paintings by Turner and Millet, in that it avoids the georgic and pastoral alternatives and the stereotyped identities they impose. Like Constable, Clare begins by seeing the ploughman in the terms of the severest Georgic, as a thing and not a man, merely as a tool – but this, he insists, is how the rich wish to see him, not how he is. The 'rough rude ploughman' is, then, 'the necessary tool of wealth and pride' (lines 14–15), and Clare was rapped over the knuckles for saying so by his evangelical patron Lord Radstock, who accused him of 'radical and ungrateful sentiments'[38] – lacking, that is, that air of submissiveness that Morland's alehouse labourers also lacked. But Clare goes on to insist on the humanity of his ploughman, and applies to him that characteristically Romantic test of humanity, the capacity for receiving aesthetic pleasure. Constable's labourers never look up or admire the landscape they cultivate; but Clare's ploughman

> Will often stoop inquisitive to trace
> The opening beauties of a daisy's face;
> Oft will he witness, with admiring eyes,
> The brook's sweet dimples o'er the pebbles rise;
> And often, bent as o'er some magic spell,
> He'll pause, and pick his shaped stone and shell...
> Thus pausing wild on all he saunters by,
> He feels enraptur'd though he knows not why,
> And hums and mutters o'er his joys in vain,
> And dwells on something which he can't explain.
> (lines 17–22, 31–4)

The ploughman is 'moil'd and sweating' (line 16) from his labour; but the verbs in the lines quoted are all of temporary relaxation: the ploughman stoops, pauses, dwells, saunters – we remember Anita Brookner's, remark, that no-one saunters in Constable's landscapes, and in the late eighteenth and early nineteenth centuries the word seems to have been used in connection with the poor with the

meaning not simply of strolling idly, passing time, but of taking it easy when you should properly have been working: it is an argument used by Adam Smith in favour of the division of labour, that 'a man commonly saunters a little in turning his hand from one sort of employment to another'.[39] These verbs work as do those at the opening of *The Deserted Village* ('linger', 'loiter', 'pause'); they arrest the sense of unrelenting industry that would characterise the honest ploughman to Radstock or Constable; and Clare's poem, along with a number of others from his earliest period, speaks to us of a developing class-consciousness in the rural poor – the perception of the difference between what they might be, and what others force them to be.

V

Throughout this essay I have been examining the *distance* between Constable the observer of human landscapes and the figures in those landscapes, and have argued that the harmonious relationship of worker and land that Constable seems to depict is only available to him if that distance is maintained. The easy harmony of the woodcutter and the landscape in Gainsborough's picture at Woburn, which Gainsborough could achieve without seeming to diminish the figure at all, was not available to Constable, because the conventions of Pastoral were no longer available. But looking back from the perspective of this essay to the Woburn picture, we can seen the same pressures acting on Gainsborough as acted on Constable, at once to depict and conceal the actuality of rural life, in the image of the ploughman, who, blithe and easy in his attitude as he is, is still perhaps necessarily distant because his identity cannot be pastoralised, so that he cannot be presented in the close-up view which would suggest less a harmony between nature and man than a discord between our ideal of rural life and the meanness of his occupation.

I want to suggest now that in imposing this necessary distance between himself and the figures in his landscapes who appear to be in harmony with them, Constable experiences some of the same problems with the notion of harmony with nature that we discover in much late eighteenth-century and Romantic writing. First of these is, that with the abandonment of the conventions of traditional Pastoral a true harmony with nature seems to be available only to those who work the land or work on it; and from this the writer who describes, or the painter who depicts, is excluded, and reduced to envying a condition that he cannot attain. Second, is that the ideal of a harmonious society as it is admired and depicted in art is almost always now conceived of as somehow remote – whether, as usually in poetry, in the past, or, as in Constable's painting, in the distance.

I have been arguing that the more the figures in Constable's landscapes seem to be a part of them, the more the image of man in harmony with nature is of an automaton, not of a man; the more therefore the identity of those who are merely workers must seem to be a natural, permanent, the only possible identity. But that act of oppression by which the worker is dehumanised, and naturalised, cuts against the oppressor too: the point is well made in Wordsworth's 'Michael' (1800), in the contrast between the tone of the narrator, and his account of Michael himself. The narrator introduces us to the valley in which Michael and his family had lived, as a knowledgeable guide – one who loves the hills and fields but is not *of* them, as are those shepherds who find 'their occupation and abode' (line 26) among them. For Michael,

> these fields, these hills
> ...were his living Being, even more
> Than his own Blood.
> (lines 74–6)

It is a relationship with nature available to him by virtue of his work, which takes him 'up to the mountains' when it drives 'the Traveller to a shelter' (lines 57–8); it is a habit of familiarity formed by that of 'endless industry' (line 97), and one which can be formed only by those who cannot choose not to be abroad in all weathers; and so it is a relationship with nature which must exclude guide, traveller, poet, *observers* of all sorts, who are excluded therefore also from the natural community of the valleys.

This sense of exclusion can be avoided, of course, or rather deferred, as it is so often in the literature of the period we are considering, by imagining the ideal rural community as existing in the past, before the divisions between the idle and the industrious, consumer and producer, those who watch work, and those who do it, had emerged. This is the myth of the lost organic community, always in the past, that Raymond Williams has studied.[40] I can refer to it conveniently here by reminding the reader of the plot of Gray's 'Elegy', which Constable illustrated for an edition produced by John Martin,[41] and which is a particularly early dramatisation of what is a ubiquitous sense of exclusion in the later eighteenth century.

The poet of the 'Elegy', imagining himself to be in a churchyard, is left alone in darkness and solitude by the lowing herd and the weary ploughman; and this abandonment seems to confirm in him a melancholy which is confirmed also by the funereal imagery of the setting. He attempts to find his way back to the world of men, by recreating in his imagination the lost society of merry ploughmen buried beneath the stones. It may occur to us that the dead

ploughmen, described as 'jocund', were no doubt little different from the living ploughman in the first stanza, and it's worth considering why the poet cannot therefore conceive of entering a social relationship with the village community of the present. But it is, of course, a matter of fact, and presented as such, that the poet has no connection with that present community; and if he thinks he could have had with that in the past, this is because he is at liberty to recreate that community on his own terms, just as he wants it to be. He can invent for a start the 'jocund' ploughmen – plural, and members together of the jolly community he thus also invents, when the ploughman offered him by the present is singular, plodding, and weary. He can invent the figure of the dead village poet, with whom he identifies so strongly that it is at times impossible to be sure when the poem refers to its author and when to the unlettered bard of Gray's imagination; and more to the point, he can invent a social function for the bard, as the memorialist of the village, composing verses for the gravestones; and so can invent a possible social relationship, though one available only in this small and defunct community, between poet and public.

That this relationship is imagined as available only to the past is not wholly to its disadvantage, for Gray appears to value at once the ideas of integration and alienation. The possibility that in the past a poet might have discovered a social function in relation to his public underlined in a way that Gray did not find incongenial the impossibility of his finding such a function in the present, and so justifies the poet's sense of himself as alienated from a society which is unworthy of his productions. This is interestingly dramatised at the end of the poem, when as I have said it is hard to separate the author of the poem from the bard he has invented. In particular, the bard who has so secure a place in the community is described as having all the melancholic quirks of character we associate with the alienated poet, as if only by these can he be guaranteed as a true poet. For a poet is identified by the scars he receives in his conflict with society, and so that conflict can be imagined as resolved only on terms which, luckily for the poet and his sense of being a uniquely sensitive, and so inevitably alienated man, are now forever unavailable.

There is a corollary for all this in the remoteness of the figures in Constable's landscapes, who – torso and shirtsleeves, tokens of an ideal rural community, offered as actually existing in Suffolk as the painting is produced – can only be so offered if we are not brought face to face with the actuality of the weary ploughmen; for as long as they are remote, we can invent a happiness in them that matches the smiling landscape. There is a remark of C. R. Leslie's to the point here: that Constable was

peculiarly social and could not feel satisfied with scenery, however grand in itself, that did not abound in human associations. He required villages, churches, farm-houses, and cottages.[42]

Leslie does not add human beings to his list of what humanises a landscape, and it is as if the buildings of the Stour Valley are understood by Constable to be a better representation of the ideal of a natural community than are the members of that community themselves. The ideal, as I have said, must symbolise, and so replace, the experience.

The opposition here between a desired closeness and a necessary distance, everywhere apparent in the earlier pictures, becomes impossible to conceal in the pictures Constable painted at the end of his life – those in which, as Conal Shields and Leslie Parris have written, the objects in the landscape are 'glimpsed *through* [my italics] a maelstrom of paint'.[43] The paint neither imitates now, nor creates – it obscures, or as we say it comes between the painter, and the image he is trying to paint, of a social landscape. There is an analogy here, too, with the problems Wordsworth found, in trying to use the language of poetry, purified certainly of poeticisms, to describe a harmonious relationship of man and nature: that the language, however simple, seems to be an unnatural medium which must exclude the articulate poet from the inarticulate community of nature. One thinks of 'Old Man Travelling' (1798), in which the harmony the old man can hardly be said to 'enjoy' with the natural environment is endangered when he turns out to be able to speak, and is only secured when in later versions of the poem his speech is excised, and he becomes again a walking vegetable, insensitive to pain or emotion – only on those terms can he be a part of nature. The poet, and the 'young' who envy the peace of the old man's condition, are incapable of communication with him: there is a society of the articulate, and a society of nature, and an impassable distance between them.

The true subject of Constable's last pictures – Shields's and Parris's remark is made of the sketch for *Hadleigh Castle* (1829?)[44] – is their scarred and pitted surface, marks of the struggle Constable now has to express his vision of a social nature, which now becomes increasingly subordinated to that self-absorbed struggle for expression. It seems now not so much that the figures are distant from Constable the observer, as that he is hopelessly distant from them. Of *The Valley Farm*, (1835),[45] for example, Shields and Parris write:

[It] is the summation of a lifetime's work and a sinister object it is...the picture bears all the marks of obsession. Constable

describes himself in the studio at night – 'Oiling out, making out, polishing, scraping, &c'. He painted, rubbed down, and painted again, literally torturing the picture surface...Willy Lott's Cottage was to him the emblem of the natural life, of man and nature in concord. But the idyll is fading. That silent couple in the boat going nowhere, cows half sunk in stagnant water, the black beggar at the gate – they are creatures in a bad, bad dream.[46]

Willy Lott's cottage was of course at Flatford Mill, the favoured place of retirement to which beggars never found their way – but now they are at the gate, though hardly glimpsed. The distance between Constable and the social world he depicts has been reversed, so to speak, and instead of pushing the poor away from him, he has retreated to a point from which the idea of 'man and nature in

John Constable, *The Valley Farm*

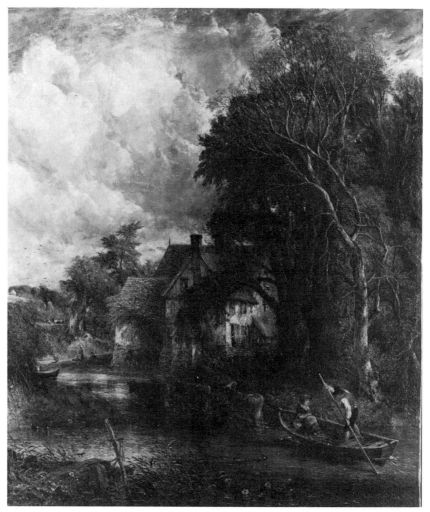

concord', less available now than ever before, is now hardly desirable
– the landscape is not one to enjoy, but to escape from.

It is making a virtue of necessity, if you then insist, as for a while
Wordsworth seems to do, that the path of humanity is not the path
of nature; or if you attempt, as Constable seems to do in his last
lecture on landscape, to change the terms on which harmony with
nature is possible, from those of an instinctive to an intellectual
rapport. 'Man', he said, 'is the sole *intellectual* inhabitant of one vast
natural landscape' (my italics), who 'cannot but sympathize' – it

John Constable, *The
Valley Farm* (detail)

must be understood by an act of intellection – with the phenomena of nature;[47] a remark which may apply to artists and writers of course but can hardly have been intended for the torsos and shirtsleeves of Constable's distant fields. Excluded from the society of the inarticulate, Constable retaliates by excluding them from the society of those with a true appreciation of the universe; he now wishes to 'promote the study' of 'Rural Scenery'.[48] The remark may be taken as a key to an understanding of the paintings of the last fifteen or so years of Constable's life, and as an explanation of why it has not seemed to me to be necessary to discuss that phase of his work at greater length. As he comes to see paintings of landscape as 'experiments' in 'Natural Philosophy',[49] so the emphasis in his work becomes less social, and the figures carry less and less of the *meaning* of the pictures, which is displaced into the clouds, where 'the Student of Nature may daily watch her endless varieties of effect'.[50]

VI

It is time to return to those remarks by William Feaver, Marina Vaizey and Anita Brookner, on the issue of work in Constable's landscapes, to see if we can make sense of the disagreements they revealed. In the pictures we have looked at, we have seen little enough of the *idle* pastoral landscape that Feaver found in the canal pictures – but when we look at the 'bargees' leaning on their poles that he refers to – they may be found, for example, in *Flatford Mill* of 1817,[51] in *The White Horse* of 1819,[52] in the *View on the Stour* of 1822,[53] or in the large sketch for *The Leaping Horse* of 1824–5[54] – we may know better now what he means. The bargees cannot of course be *leaning* on their poles: a laden barge on the Stour is not a punt on the Cam, and the acute angle of their bodies suggests the effort needed to move the barges forward. And yet, distanced, and merged as they are into the whole order of the landscape composition, they hardly communicate very directly the arduousness of their task, and we can say much the same of Marina Vaizey's remark about the 'poise' of working men, for the word takes all the effort out of labour, and replaces it – though as Constable hardly seems to me to do – with an idea of the dignity of labour. 'Poise' has the sense of rest at the point of balance, and enables us to feel that images of the most laborious tasks are images of repose, of idleness even. So indeed they are; but Constable's paintings are images of the repose of their buyers, who observe the labour of the countryside and recognise in it a none-too-paradoxical image of their repose, because of course it is supported and paid for by that labour – the point is the same as that made in the context of Barry's remarks on the 'simple, laborious, honest' hinds who must appear in landscape paintings (see above p. 18).

Constable's paintings, then, combine Pastoral and Georgic in a way by now familiar to us: they attempt to reconcile, and to conceal, the gap between what we do and what our servants do, through the mediating term of nature. This is Basil Taylor on *Boat-building near Flatford Mill*:

> Those elements of the boat-builder's craft he chose to include were sufficient to give the picture reality, but were not so assertive as to make the landscape merely a stage; the human activity and the objects associated with the craft are so unobtrusive they might be a part of nature.[55]

Of *Flatford Mill*, Graham Reynolds says that 'the subject-matter is an amalgam of familiar, homely, workaday actions, viewed under a characteristic summer sky'[56] – where the sky gives the sanction of nature to the workaday actions below; for Constable, writes Reynolds,

> was only at home in a countryside in which the land was used for growing crops or feeding cattle, and in which men were engaged in these activities as their natural daily occupation.[57]

The Pastoral that Feaver sees in Constable's work is of course what Constable would have wished him to respond to, the 'pastoral feel'; the 'Rural Scenery' of England, as Constable says, abounds in 'every description of Pastoral Beauty',[58] though he was not unaware of the inadequacy of the actual inhabitants of England to appear in his pastoral landscapes:

> The figures met with there were perhaps not the most classical – nymphs darting out of a cotton mill in parties – to add to the rippling of the stream – or to quote Shakespeare & be poetical – 'augmenting it with' – not tears.[59]

Taylor, in the revised edition of his study of Constable, has written particularly about the pastoral element in Constable's art,[60] though for him the term is more capacious than it is for me, and he uses it of a harmonious relationship between man and nature which may be articulated through work as well as through repose; and the fact that he does so, instead of recognising the laborious elements in Constable's landscapes as 'Georgic', as other than and opposed to Pastoral, is of course another evidence of how labour in Constable is converted into an image of someone else's leisure.

My argument with Taylor, or Reynolds, or Feaver, or Marina Vaizey, is not of course that they misrepresent what happens to work in Constable's landscapes, but that by being so content with a concept of nature as an unanalysed term of approval, and by missing

the point that the term is always defined by interested parties, they miss or choose to ignore the social and political basis of Constable's 'natural painture'.[61] My point, on the other hand, is not at all that work is an 'unnatural' activity; but that we should look twice at a notion of nature by which it seems 'natural' that some men should work while others do not. 'Constable', remarks Taylor, 'made no comment of any interest, in words or pictures, about the human life of rural England'.[62] As I have tried to show, there is not a peopled landscape by Constable that does not make such a comment, and the political implications of Constable's work are as evident in those who do not observe them as they are in the pictures themselves. To return once more to Marina Vaizey's remark, it is indeed an aspect of Constable's 'power' – and not only of his mastery of oil-paint – that he can convey the 'poise' she so values – the poise, it will be remembered, of 'working *men and animals* at peace in their setting'; a peace, then, in which we hardly need distinguish between the men and the animals, so much are both a part of nature.

We are left, then, with Anita Brookner's remark, that in Constable's landscapes 'all characters have the appearance of serfs'. It would be exactly right, of course, if Constable were Millet, attempting to reveal rather than conceal the pain of agricultural labour; and its inadequacy as a complete account of the figures in the landscape is only that, in piercing the harmonious surface of the painting, to find the hidden politics of the ideal of harmony with nature, Miss Brookner's remark seems to ignore that surface, as if it is only varnish to be cleaned off before we can see Constable in his true colours. It comes close to Raymond Williams's notion of 'real history'[63] – what really happened, in the agrarian history of England, when we have stripped away the nostalgia and mythologising about Merry England or the organic community. But the myths really happened as well, and the human significance of Constable's pictures, in the aspect I have been studying in this essay, is not simply what they cannot help divulging about the rural life in 1810 or 1820, but also what they choose to tell us; not simply, then, that Constable reduces all labourers to serfs, but that in the very same act he presents them as involved in an enviable, and almost a relaxed relationship with the natural world, which allowed his nineteenth-century admirers, as it now allows William Feaver and the others, to ignore the fact that the basis of his social harmony is social division.

NOTES

Introduction

1 The author is probably Thomas Tickell (but see J. F. Congleton, *Theories of Pastoral Poetry in England 1684–1798*, second edition, New York 1968, p. 324).

2 E. P. Thompson, *The Making of the English Working Class*, London 1963; 'Time, Work-Discipline and Industrial Capitalism', *Past and Present*, December 1967, pp. 56–97; 'Patrician Society, Plebeian Culture', *Journal of Social History*, Summer 1974, pp. 382–405; *Whigs and Hunters*, London 1975; Thompson *et al.*, *Albion's Fatal Tree*, London 1975; Thompson, 'Eighteenth-century English Society: Class struggle without class?', *Journal of Social History*, May 1978, pp. 133–65.

3 See especially Harold Perkin, *The Origins of Modern English Society*, London 1969, pp. 17–29.

4 Not the least important evidence for this assertion is the *refusal* of some writers on the problem of poverty to refer to the labouring classes as 'the poor', and yet their inability to avoid doing so. Both William Paley, in his *Reasons for Contentment addressed to the Labouring Part of the British Public* (1792, pp. 217–18 in his *Natural Theology and Tracts*, edition of 1824), and Edmund Burke, in his *Thoughts and Details on Scarcity* (1795, pp. 256–7 in *Works*, vol. iv, 1802), insist that we should not call labourers 'the poor', for they are not poor; but both fall back on an apparently unconscious but repeated use of the phrase a few pages later; see also Samuel Horsley, *A Sermon Preached...May 18, 1786* (1786), pp. 8–11.

5 See E. C. K. Gonner, *Common land and Enclosure*, London 1912, p. 361n., and Thompson, *The Making of the English Working Class*, p. 217.

6 For an account of the difficulties involved in determining whether the 'average' standard of living of the labourer was raised or lowered during this period, as well as in determining who the 'average' labourer might be, see Thompson, *ibid.*, ch. VII.

7 See especially Thompson, *Whigs and Hunters* (*passim*) and Douglas Hay, 'Poaching and the Game Laws on Cannock Chase', in *Albion's Fatal Tree*.

8 Thompson, 'Eighteenth-Century English Society', p. 154.

9 Richardson, *An Account of the Statues, Bas Reliefs, Drawings and Pictures in Italy*, etc., London 1722, p. 186.

10 Walpole, *Anecdotes of Painting in England*, vol. I, London, edition of 1828, p. 121. The passages referred to in this and the previous note are both quoted in Luke Herrmann, *British Landscape Painting of the Eighteenth Century*, London 1973, pp. 19–20.

11 Watt, *The Rise of the Novel*, London 1957; see also John J. Richetti, *Popular Fiction before Richardson*, Oxford 1969.

12 See for example the continual reference to English poets of rural life in essays contributed to the *Annals of Agriculture*, a periodical started by Arthur Young in 1784.

13 Ellis Waterhouse, *Gainsborough*, London 1958, p. 18; the catalogue of Gainsborough's pictures in the same volume gives such evidence as is available of the original purchasers of the pictures; see also John Hayes, 'Gainsborough's Suffolk Patrons', in *The Painter's Eye*, catalogue of the Gainsborough exhibition at Sudbury, Suffolk, 1977.

14 See below, p. 96.

15 For some discussion of this class and its aesthetic interests see John Barrell, *The Idea of Landscape and the Sense of Place*, Cambridge 1972, chapter 2.

16 See G. E. Mingay, *English Landed Society in the Eighteenth Century*, London 1963, chapters VII, VIII.

17 See Deborah Howard, 'Some Eighteenth-century English Followers of Claude,' *Burlington Magazine*, December 1969, p. 727.

18 Prior, *Poems on Several Occasions*, London 1709, p. 46.

19 *Ibid.*, p. 50.

20 *Ibid.*, p. 29.

21 Published in 1732, but written much earlier; see *Poetical Works*, ed. G. C. Faber, Oxford 1926, p. 423.

22 See below, pp. 56–7.

23 'Gratitude, a Pastoral', in *Poems on Several Occasions*, 1736, p. 52.

24 For an informative discussion of *bergerie* in Elizabethan Pastoral, see Helen Cooper, *Pastoral: Medieval to Renaissance*, Ipswich 1977.

25 For a discussion on the management and preservation of large estates, see Mingay, *English Landed Society*, chapters VII, VIII.

26 Warton, 'Reflections on Didactic Poetry', in his *Works of Virgil*, London 1753, vol. I, p. 294.

27 See John Hayes, 'Gainsborough's Early Landscapes', *Apollo*, November 1962, p. 668.

28 *Ibid.*, p. 671.

29 *The Guardian*, no. 22, 6 April 1713; no. 23, 7 April; no. 28, 13 April; no. 30, 15 April; no. 32, 17 April.

30 *Ibid.*, no. 30.

31 *Ibid.*, no. 22.

32 Price, *Essays on the Picturesque*, vol. I, London 1810, p. 339n.

33 See Joseph Farington's *Diary*, ed. Greig, vol. V, London 1925, p. 183; and Gerald Reitlinger, *The Economics of Taste*, I, London 1961, p. 74.

34 Barry, *Works*, London 1809, vol. I, p. 405.

35 Wheatley, *The Industrious Cottager*, engraved 1787; see Mary Webster, *Francis Wheatley*, London 1970, p. 72. Morland's *Industrious Cottager* was engraved by William Blake in 1803.

36 *A Descriptive Catalogue of Thirty-Six Pictures Painted by George Morland...to be engraved by Subscription, by and under the direction of J. R. Smith*, London, no date but *c.* 1793, p. 2.

37 See below, pp. 111–17.

38 See below, pp. 102, 111.

39 1757, Bristol Art Gallery.

40 The phrase which has become the title of this book is taken from an unsigned review of Crabbe's *The Village* in *The Gentleman's Magazine*, December 1783, LIII, pp. 1041–2, and reprinted in *Crabbe: The Critical Heritage*, ed. Arthur Pollard, London and Boston 1972, p. 44. The reviewer remarks that Crabbe represents 'only the dark side of the landscape, the poverty and misery attendant on the peasant'.

41 *The Parish Register*, 1807, lines 19–20; see below, pp. 78–80.

42 See Webster, *Francis Wheatley*, p. 43, for a discussion of these pictures.

43 *Reapers* and *Haymakers* (1783), Upton House, Banbury, The National Trust (Bearsted Collection); *Reapers* (1784) and *Haymakers* (1785), London, The Tate Gallery; *Reapers* (1794) and *Haymakers* (1795), Port Sunlight, Lady Lever Art Gallery.

44 Paulson, *Emblem and Expression*, London 1975, p. 173.

45 Tate Gallery, Press Release of 25 July 1977.

46 *The Financial Times*, 6 September 1977.

47 *The Guardian*, 8 August 1977.

48 Taylor, *Stubbs*, second edition, London 1975, p. 40.

49 The volume of Blake's illustrations to Gray's poems is in the Mellon Collection; a facsimile, *William Blake's Water-Colour Illustrations to the Works of Thomas Gray*, ed. Sir Geoffrey Keynes, was published in 1972 (Chicago); the reaper appears in design no. 109.

50 Mellon Collection.

51 This is a (very free) translation of *Les Moissoneurs*, by C. S. Favart.

52 Duck, *op. cit.*, pp. 22–5; Chatterton, *Poems* (1777), pp. 12–18.

53 Thomson, *The Seasons*, 'Summer', lines 352–70; 'Autumn', lines 151–76.

54 *Complete Works*, ed. P. P. Howe, vol. XVIII, London and Toronto 1933, p. 86.

55 1660–4; reproduced in Sir Anthony Blunt, *Nicolas Poussin*, London and New York 1967, pl. 243.

56 Sir Joshua Reynolds, *Discourses on Art*, ed. Robert R. Wark, San Marino, California, for example pp. 59, 70.

57 London, The Tate Gallery.

58 Some articulate criticism of the assumptions of the tradition I am discussing is to be found in the writings of theorists of the picturesque, notably those of William Gilpin and Archibald Alison. In his *Observations relative to Picturesque Beauty* (London 1786, vol. II, p. 44), Gilpin writes:

In a moral view, the industrious mechanic is a more pleasing object, than the loitering peasant. But in a picturesque light, it is otherwise. The arts of industry are rejected; and even idleness, if I may speak, adds dignity to a character. Thus the lazy cowherd resting on his pole; or the peasant lolling on the rock, may be allowed, in the grandest scenes; while the laborious mechanic, with his implements of labour, would be repulsed.

Gilpin is concerned to promote an idea of art by which it is elevated above practical concerns and the prescriptions of practical morality; for him the 'grandest scenes' are precisely those which resist man's abilities to render them serviceable to his merely material needs, and he sees the 'lolling peasant' and the 'lazy cowherd' as images of man rendered impotent by intractable landscapes. For further examples of such hostility to the practical in Gilpin and Alison, see my *Idea of Landscape and the Sense of Place*, p. 79. I have little to do with this hostility here, however, other than to notice it, for Gilpin was hardly influential on the painters of his time, except perhaps on a few watercolourists, who expressed their disaffection from the tradition I am examining more thoroughly, but less controversially, by painting landscapes emptied of people, not peopled with idle labourers.

1 Thomas Gainsborough

1 *The Letters of Thomas Gainsborough*, ed. Mary Woodall, revised edition, London 1963, p. 99.

2 Dryden's version of Virgil's *Georgics* was published in his *Works of Virgil* (1697); eighteenth-century georgic poems, and poems which, not strictly Georgic in form or content, are clearly related to the georgic tradition, include John Philips's *Cyder* (1708), Pope's *Windsor Forest* (1713), Gay's *Rural Sports* (1713, revised 1720) and *Trivia* (1716), Thomson's *The Seasons*, (first complete edition 1730), Somervile's *The Chace* (1735), Smart's *The Hop-Garden* (1752); Dodsley's *Public Virtue, a Poem, in Three Books*, of which only Book I, 'Agriculture', was published (1753), Dyer's *The Fleece* (1757), and Grainger's *The Sugar-Cane* (1764).

3 *The Seasons*, 'Summer', line 534.

4 1713 version, from which all quotations are taken, lines 517–18.

5 The phrase is Wordsworth's; 'To the Spade of a Friend', line 8.

6 Thomson, *Liberty*, 1738 edition, lines 1181–5.

7 Bernard de Mandeville, *The Fable of the Bees, or Private Vices, Public Benefits*, London 1714.

8 Hume, 'Of Commerce', in *Essays Moral, Political and Literary*, Oxford 1963, p. 271.

9 *Ibid.*, p. 272.

10 Douglas Hay, 'Property, Authority, and the Criminal Law', in E. P. Thompson *et al.*, *Albion's Fatal Tree*, London 1975.

11 See John Hayes, *Gainsborough* (hereafter 'Hayes'), London 1975, pp. 30–1.

12 'A Discourse on Pastoral Poetry', in *The Poems of Alexander Pope* (Twickenham edition), vol. I, ed. E. Audra and Aubrey Williams, London and New Haven 1961, p. 25.

13 James Barry to Dr Sleigh, 1765, in *The Works of James Barry*, London 1809, vol. I, p. 20; quoted in Elizabeth Einberg's introduction to the catalogue of the George Lambert exhibition held at Kenwood, London 1970, p. 10.

14 'An Essay on the Georgics', in Dryden's *Works of Virgil* (see above, note 2), pages unnumbered.

15 London, Tate Gallery.

16 Einberg, p. 14.

17 Mellon Collection.

18 Einberg, p. 14.

19 With Thos Agnew and Sons, 10 June 1926–26 August 1946. Collection unknown. What may be a preparatory sketch for this painting, from a private collection, is illustrated in Luke Herrmann, *British Landscape Painting of the Eighteenth Century*, London 1973, pl. 2c.

20 Note that these figures may not have been painted by Lambert: W. T. Whitley, *Artists and Their Friends in England 1700–99*; London and Boston 1928, p. 219, quotes an initialled newspaper article of 1766 to the effect that 'Mr Lambert never painted the figures in his own landscapes'. See also note 49 below.

21 Einberg, p. 14.

22 Herrmann, *British Landscape Painting*, p. 21.

23 So called in the edition of 1720; the first version (1713) was titled *Rural Sports. A Poem*.

24 For a discussion of georgic poetry in these terms, see Richard Feingold, *Nature and Society*, London and New Jersey 1978, pp. 17ff.

25 Hume, 'Of Refinement in the Arts', in *Essays*, &c., p. 276.

26 Sismondi, *De la Richesse Commerciale*, quoted in *Marx and Engels on Malthus*, ed. Ronald L. Meek, London 1953, p. 105.

27 We can almost see her doing so, however, in *Farm Buildings with Figures, and Milkmaid milking Cows*, *c.* 1755, the Mellon Collection; reproduced in Hayes, pl. 29.

28 See Helen Cooper, *Pastoral: Mediaeval into Renaissance*, Ipswich 1977, pp. 58–9. In early eighteenth-century pastoral poetry, the return of the milkmaid may be related to the interest in the folksy pastorals of Thomas D'Urfey – see for example D'Urfey's 'A Ballad of Andrew and Maudlin', in *The Penguin Book of Pastoral Verse*, eds. John Barrell and John Bull, London 1974, pp. 246–7, where '*Joan* of the Dairy' appears in disarmingly earthy circumstances; 'Maudlin' is of course the name of the milkmaid in *The Compleat Angler*. See also William D. Ellis, Jnr., 'Thomas D'Urfey, the Pope-Philips Quarrel, and *The Shepherd's Week*', *PMLA* LXXIV (1959), pp. 203–12.

29 *A New Collection of Poems Relating to State Affairs*, London 1705, p. 149.

30 Toledo, Ohio, Museum of Art; Hayes, pl. 73.

31 Kenwood, Iveagh Bequest; Ellis Waterhouse, *Gainsborough* (hereafter 'Waterhouse'), London 1958, pl. 114.

32 Not later than 1773, Englefield Green, Royal Holloway College.

33 *Poems*, vol. I, p. 25.

34 *The Guardian*, no. 40, 27 April 1713; for full discussions of what was at issue in the Pope-Philips quarrel, see J. F. Congleton, *Theories of Pastoral Poetry in England 1684–1798*, second edition, New York 1968, and Adina Forsgren, *John Gay, Poet 'Of a Lower Order'*, Stockholm 1964.

35 See Pope, *Works*, ed. Elwin and Courthorpe, London 1871–89, vol. I, p. 234.

36 *Lives of the English Poets*, ed. George Birkbeck Hill, Oxford 1905, vol. II, p. 269.

37 See Congleton, *Theories of Pastoral Poetry*, p. 136.

38 *The Guardian*, no. 40.

39 The convention begins with the tenth *Idyll* of Theocritus.

40 *The Faerie Queene*, VI, x, 37.

41 *Lives*, p. 269.

42 See William Jackson, *The Four Ages*, etc., London 1798, p. 183.

43 1788, Los Angeles, Mrs Mildred Browning Greene; Hayes, pl. 140. The question of whether or not the painting was intended by Gainsborough himself as an illustration to 'Hobbinol' has been studied by Duncan Bull, in some as yet unpublished research. I am most grateful to him for making this research available to me.

44 The manuscript of the first version of the poem, 'The Wicker Chair', written according to Somervile when John Philips's *Cyder* (1708) was 'just publish'd', was printed in F. Waldron's *The Shakespeare Miscellany*, London 1802.

45 Birmingham, Barber Institute of Fine Arts.

46 For a hint of what may have been an attitude common among the rural poor to the harvest feast, see Stephen Duck's *The Thresher's Labour*, in *Poems on Several Occasions*, London 1736, pp. 26–7.

47 Hayes, p. 213.

48 Private collection, *ibid.*, p. 211.

49 Earlier comic representations of the peasantry of England may be seen in John Wootton's *Distant View of Henley-on-Thames*, *c.* 1742, Windsor, The Royal Collection, reproduced in Herrmann, *British Landscape Painting*, pl. 6; in his(?) *Haymaking Scene in the Severn Valley*, Mellon Collection, and in William Hogarth's and George Lambert's, *Landscape with Farmworkers*, date unknown, Mellon Collection, Herrmann, pl. 8.

50 Hayes, p. 213.

51 *Poems*, in the *British Poets*, vol. lxx (Chiswick 1822), p. 164.

52 *Ibid.*, p. 180.

53 See for example the 'Life', *ibid*; also pp. 32, 183; also note his approval of *The Deserted Village* in *Critical Essays*, London 1785.

54 Private collection.

55 Samuel Pratt, *Cottage Pictures; or, the Poor*, in *Sympathy and Other Poems*, London 1807, p. 187.

56 See *The Painter's Eye*, catalogue of the Gainsborough exhibition at Sudbury, Suffolk, 1977, pages unnumbered, p. 8.

57 Late 1760s (?), Kansas City, William Rockhill Nelson Gallery; Waterhouse, pl. 112.

58 Late 1760s, London, British Museum.

59 Los Angeles, University of California.

60 Paley, *Reasons for Contentment*, etc., in *Natural Theology and Tracts*, edition of 1824, London, pp. 220–1.

61 Toronto, Art Gallery.

62 Hayes, p. 224.

63 Castle Museum and Art Galley, Nottingham.

64 San Marino, Henry E. Huntington Art Gallery; Hayes, pl. 116.

65 Belvoir Castle, Duke of Rutland; Waterhouse dates the picture 1782 (p. 119), Hayes 'about 1773' (p. 217).

66 Paley, *Reasons for Contentment*, p. 221.

67 For the full list, see Crabbe, *Life and Poems*, London 1847, vol. II, p. 144n.

68 Richard Burn's *Justice of the Peace and Parish Officer*, first published in 1755.

69 London, Tate Gallery. See Waterhouse, *Painting in Britain 1530–1790*, Harmondsworth 1953, p. 189.

70 See for example Cowper, *The Task*, IV, *passim*.

71 Paley, *Reasons for Contentment*, p. 221; for similar expressions of envy for the condition of the life enjoyed by the poor, see James Yorke, *A Sermon Preached in the Cathedral Church of Lincoln* (Lincoln 1777), p. 11; and Richard Watson, *A Sermon Preached...April 1785* (London 1793), pp. 8–9.

72 *Black Giles the Poacher*, edition of 1830, London, p. 3.

73 Paley, *Reasons for Contentment*, p. 218.

74 W. K. Thomas ('Crabbe's View of the Poor', *Revue de l'Université d'Ottawa*, 36,1966) suggests that this line may be adapted from a remark of Burke's in *Thoughts and Details on Scarcity*, in *Works*, vol. IV, London 1802, p. 257: 'Patience', says Burke, 'labour, sobriety, frugality, and religion' should be recommended to those he declined to call 'the labouring *poor*'; 'all the rest is downright *fraud*'. As Thomas points out, each of the virtues in this list has its equivalent in Crabbe's line: 'patience' appears in both; 'labour' may be Crabbe's 'toil'; 'abstemious' may represent Burke's 'sobriety'; 'care', his 'frugality'; and 'bless', his 'religion'.

75 I have based my discussion of Crabbe exclusively on *The Parish Register*, because the introduction to that poem was deliberately designed as an attack on *The Deserted Village*; but it could as easily have been based on what is generally regarded as his most humane poem, the first part of *The Village* (1783). In that poem Crabbe's overtly empirical approach to rural life works finally to *naturalise* the miseries of the poor as it does in *The Parish Register*; he is unwilling to see any causal connection between poverty and crime; and the charge of concealing the miseries of the poor by a convenient screen of pastoral convention, apparently addressed to the reader in general ('you'), finally turns out to be levelled only against a wealthy and capricious valetudinarian, whom no actual reader could be embarrassed into identifying with. It is worth pointing out that *The Village*, when

it appeared, elicited few of the (mild) complaints which greeted the publication of *The Deserted Village*, but secured instead for Crabbe the protection of some extremely influential members of the polite classes.

76 Godwin, *Enquiry Concerning Political Justice*, ed. Isaac Kramnick, Harmondsworth 1976, pp. 746–7.

77 Malthus, *An Essay on the Principle of Population* (1798), ed. Anthony Flew, Harmondsworth 1970, pp. 72, 211–12.

78 *Of Population*, London 1820, p. 599.

79 See especially Douglas Hay's essay, 'Property, Authority and the Criminal Law, in *Albion's Fatal Tree*.

80 *The Girl with Pigs*, Castle Howard, George Howard; Hayes, pl. 146.

81 *Peasant Girl Gathering Sticks*, with Thos. Agnew, 1978.

82 *The Cottage Girl with Dog and Pitcher*, Russborough, Sir Alfred Beit, Bt.; Hayes, pl. 147.

83 *Cottage Children* (*The Woodgatherers*), New York, Metropolitan Museum.

84 See for example Cowper, *Hope* (1782), line 7; Thomas Ruggles, *The History of the Poor*, vol. II, London 1794, p. 144.

85 See *The Parish Register*, lines 194–203.

86 For an account of the attitudes of the Established Church to the problem of poverty, see R. A. Soloway, *Prelates and People, Ecclesiastical Social Thought in England 1783–1852*, London and Toronto 1969, Chs. I–III; for the more ambivalent attitudes of the Methodist leaders, see *The Making of the English Working Class*, ch. XI.

87 Burke, *Thoughts and Details*, p. 278.

88 Starobinski, *L'Invention de la Liberté 1700–89*, Geneva 1964, p. 163.

89 Hazlitt's comments on Crabbe will be found in his *Lectures on the English Poets* (1818) and *The Spirit of the Age* (1825); all the phrases quoted are taken from one or the other of these.

90 Paley, *Natural Theology*, London 1802, p. 538.

91 See Spence, *Pig's Meat; or, Lessons for the Swinish Multitude*, London, second edition 1795(?), pp. 33–6; for Cobbett's use of *The Deserted Village*, see James Sambrook, *William Cobbett*, London and Boston 1973, pp. 45, 67, 69, 192.

92 'Literature and Rural Society', *The Listener*, 16th November 1967.

2 George Morland

1 F. W. Blagdon, *Authentic Memoirs of the late George Morland* (hereafter 'Blagdon'), London 1806, p. 8n.

2 But for a more cautious estimate, see Sir Walter Gilbey, Bt., and E. D. Cuming, *George Morland*, London 1907, p. 221.

3 George Dawe, *The Life of George Morland* (hereafter 'Dawe'), London 1807, p. 164; see also William Collins, *Memoirs of A Painter* (hereafter 'Collins'), London 1805, p. 118.

4 Collins, p. 71; Dawe, pp. 66, 68, 120; Blagdon, p. 8.

5 Collins, p. 39.

6 Dawe, p. 97; Blagdon, p. 9; *Monthly Magazine*, December 1st 1804, pp. 417–18.

7 The fullest lists of engravings after Morland are to be found in Gilbey and Cuming, *George Morland*, pp. 246–84.

8 Fry, *Reflections on English Painting*, pp. 80–1.

9 Dawe, p. 194.

10 Berger, *Permanent Red*, pp. 177–8.

11 *Ibid.*, p. 178.

12 Gaunt, *English Painting*, p. 96.

13 See below, p. 111.

14 Sickert's comments are thus paraphrased in G. C. Williamson, *George Morland*, London 1904, p. 88.

15 J. Hassell, *Memoirs of the late George Morland* (hereafter 'Hassell'), London 1806, p. 131.

16 To this brief consideration of recent critical accounts of Morland, I should add a mention of David Thomas's essay (see below, note 24), and of Joseph Burke's discussion of him, in *English Art 1714–1800*, Oxford 1976, pp. 390–1, a well-informed and sensible piece which does not merely repeat what I have called the received opinion of his work; it does not, however, raise issues of immediate relevance to this essay.

17 William Blake, *Complete Writings*, London 1966, p. 553; see also Allan Cunningham, *The Lives of the Most Eminent British Painters*, revised and edited by Mrs Charles Heaton, London 1879, vol. I, p. 10 and n.

18 Dawe, p. 28.

19 *Ibid.*, p. 13.

20 Dawe, p. 79; Hassell, p. 105.

21 Dawe, pp. 177–8.

22 *Ibid.*, p. 177.

23 *Ibid.*, p. 25; Hassell, p. 7.

24 Most biographers of Morland agree that his sexual morality, at least, was exemplary; the evidence for Morland's possible venereal infection comes from Joseph Farington's *Diary*, ed. J. Greig, vol. I, London 1922, p. 215; see David Thomas's catalogue for the Arts Council Exhibition, *George Morland*, London 1954, p. 11.

25 See for example Collins, pp. 74, 82, 88–94, 102, 122; Dawe, pp. 91–3, 147, 149.

26 Collins, pp. 78–9, 105; Dawe, pp. 108, 117.

27 Collins, p. 115; Dawe, p. 163.

28 Dawe, p. 146; but Blagdon, who did not know Morland, says he liked to dress as a fox-hunter (p. 13).

29 Dawe, p. 172.

30 Collins, pp. 107–11; Dawe, pp. 160–1.

31 Collins, pp. 98–102; Dawe, pp. 153–4.

32 Collins, p. 54; Dawe, p. 29.

33 Hassell, pp. 127–8.

34 Dawe, p. 199.

35 Hassell, p. 103.

36 Quoted in G. C. Williamson, *George Morland*, London 1904, p. 53.

37 Cunningham, *The Lives of the Most Eminent British Painters*, London 1830, vol. II, p. 222; the direct speech may be Cunninghams's invention – see *Monthly Magazine*, 1 December 1804, p. 417.

38 *The Letters of Thomas Gainsborough*, ed. Woodall, revised edition, London 1963, pp. 87–91; Collins, pp. 53–4; *Monthly Magazine*, December 1st, 1804, p. 420.

39 Dawe; quoted by Gilbey and Cuming, *George Morland*, p. 89.

40 Thomas, *George Morland*, pp. 5–6.

41 Dawe, p. 97.

42 *Ibid.*, p. 151.

43 *Ibid.*, p. 97.

44 Quoted in C. Reginald Grundy, *James Ward, R.A.*, London 1909, p. xxxiv.

45 Farington, *Diary*, vol. II, London 1923, p. 221.

46 Wordsworth, *The Salisbury Plain Poems*, ed. Stephen Gill, Hassocks 1975.

47 See above, notes 1, 3, 15.

48 Collins, p. 128; Dawe, p. ii; Hassell, pp. 26–7.

49 Dawe, p. 176.

50 It has not always been possible to discover the dates and present owners of works referred to by Morland's biographers. *Return from Market* was engraved in mezzotint, and published, by John Raphael Smith, London 1793.

51 Collins, p. 234. One can see what Collins means – there is a hard-bitten, tarty style about the girls, which goes oddly with the pastoral title. This comment by Collins, and his and Hassell's remarks on Morland's *Smugglers* (see above, p. 101) all appear to derive from *A Descriptive Catalogue of Thirty-Six Pictures Painted by George Morland...to be engraved by subscription, by and under the direction of J. R. Smith*, London, no date but *c.* 1793, pp. 11, 23.

52 Collins, p. 236; from his description of the picture, it would seem that this is not the same version of the subject as that now in the Fitzwilliam Museum, Cambridge, and discussed below, pp. 105 and 123.

53 Collins, p. 201.

54 Hassell, p. 79.

55 *Ibid.*, p. 181.

56 Collins, p. 232.

57 Engraved in mezzotint by S. W. Reynolds, published by W. Jeffryes and Co., London 1800.

58 *Innocence Alarm'd*, engraved in mezzotint by J. R. Smith, jnr, published by H. Macklin, London 1803.

59 Hassell, p. 118.

60 *Ibid.*, pp. 63, 73, 114, 163.

61 Engraved in mezzotint, and published, by John Young, London, no date.

62 Hassell, p. 131.

63 Engraved (line) by William Blake, published by J. R. Smith, London 1803.

64 Hassell, p. 78.

65 Engraved (mezzotint) by E. Bell, published by E. Orme, London 1804.

66 Hassell, p. 129.

67 Engraved (mezzotint) by William Ward, published by Jas. and Wm. Ward, London 1801.

68 Hassell, p. 154.

69 Wordsworth and Coleridge, *Lyrical Ballads*, ed. W. J. B. Owen, second edition, revised, London 1971, p. 156.

70 Hassell, p. 58.

71 *Ibid.*, p. 79.

72 Dawe, p. 179.

73 *Ibid.*, p. 203.

74 *Ibid.*, p. 178.

75 *Ibid.*, p. 183.

76 *Ibid.*

77 *Ibid.*, p. 184

78 *Ibid.*, pp. 197–8.

79 See Cal Winslow, 'Sussex Smugglers', in *Albion's Fatal Tree*, London 1975, pp. 149ff.

80 Quoted in William Bayne, *Sir David Wilkie*, R.A., London and New York 1903, p. 40.

81 There are two contemporary prints of this painting: a mezzotint, engraved and published by J. Grozer, London 1795, and a small line engraving by W. Nicholls (no date, publisher, or place). Both are, of course, thoroughly idealised versions of the paintings – the gypsy child is less dishevelled, the mother prettier, the boy *smiles* his gratitude, and so on; but the failure of emotion in the father, so impressive a feature of the painting, is preserved in both prints.

82 Thomas, *George Morland*, p. 8.

83 Engraved (stipple), and published, by D. Orme, London 1796.

84 Hassell, p. 128.

85 Stipple engraving by C. Josi, published by J. R. Smith, London 1797.

86 Hassell, p. 47; Collins, p. 232.

87 This picture is discussed by Fry, *Reflections on English Painting*, pp. 81–2; he does not say much, but seems to regard it as Morland's best.

88 If it is indeed Smith who is the author of the catalogue of the Morland Gallery (see above, note 51). This quotation is from p. 13.

89 Hassell, p. 73.

90 *Ibid.*, p. 186.

91 *The Alehouse Door*, published by J. R. Smith, London 1801. Syer also engraved the *Alehouse Kitchen* (same publication details), an apparently unidealised version of a painting I have not seen. Hassell approves of the latter print (pp. 73–4), but largely it would seem because it happened to be when he and Morland were out walking together that Morland saw and sketched the subject. Apart from Syer's work, the grimmest, and therefore perhaps the most faithful, engraving of one of Morland's grimmer subjects that I have come across is W. Barnard's mezzotint of *The Cottage Fireside* (published by Thomas Palser, London 1811), in which a shepherd or labourer and his wife sit before the fire in an oppressively small room, their child beside them, all with expressions uncompromisingly blank and hopeless; yet because of that blankness, and because they do not try to catch our eye, and so to make a direct appeal to our emotions, the picture remains entirely unsentimental. Once again, I have not been able to locate the original painting.

92 Collins, p. 232.

93 Johnson, *The Idler*, London 1767, vol. ii, p. 330.

94 See Thompson, *The Making of the English Working Class*, ch. iv.

95 *The Alehouse Door* may be compared with *The Tap Room* (1795), the present whereabouts of which I have been unable to discover, and I rely for this description on a photograph in Morland Box 3 in the Witt Library, London. Two peasants sit and one stands at a table in a tavern interior, apparently waiting for their ale to warm by the fire; the figure on the left is clearly reminiscent of the seated figure in *The Alehouse Door*, and all of them share the seriousness, removed entirely from sentimentality or caricature, of the figures in the earlier picture.

96 1806; collection of the Earl of Mansfield.

97 *Hereford, Dynedor, and Malvern Hills...Harvest Scene*; for a discussion of the date, see Leslie Parris, *Landscape in Britain, c.* 1750–1850, catalogue of Tate Gallery exhibition, London 1973, p. 104.

98 This is even Hazlitt's opinion, who in a long comparison of Wilkie and Hogarth (*Works*, ed. P. P. Howe, vol. vi, London and Toronto 1931, p. 139), insists that the former is not a comic painter at all, as Hogarth is, but offers us a reality entirely unmediated.

99 Herefordshire, or Siluria (as the country between the Wye and the Severn, but more specifically Herefordshire itself, were poetically known) had generally been thought of as the home of English Georgic since John Philips had celebrated the county in his *Cyder* (1708); see for example William Diaper's semi-georgic *Dryades* (1713), lines 64–73. The georgic virtues of the Man of Ross (see Pope's *Epistle to Bathurst*, 1733–44, lines 249–98) further established the connection between Siluria and the simple, unobtrusive industry that is the essence of Georgic. In John Dyer's *The Fleece* (1757), Herefordshire is presented as a pastoral–georgic haven in a newly industrialised Britain. Later writers on Herefordshire confirm this character, at once georgic and idyllic, of the county: see for example John Duncumb, *Collection towards the History and Antiquities of the County of Hereford*, vol. i, Hereford 1804, pp. 158, 171, 180; and the same author's *General View of the Agriculture of the County of Hereford*, London 1805, pp. 10, 12, 122. In both these works Duncumb quotes from the poets mentioned above.

 John Clark, author of the first Board of Agriculture report for Herefordshire, as well as of the first Radnor and Brecknock reports, has much the same notion of the relation between Herefordshire and the rest of the kingdom that Dyer has:

> manufactures and agriculture contribute to the mutual strength and support of each other; hence the whole machine is kept in perpetual motion, whilst, in this county, it derives its whole vigour from no other resources than the mere production of its own native soil. Health, peace, and plenty smile in the countenance of its very peasantry: whilst the whole of its wool is annually sent to less favoured districts, where the manufacturing it into cloth, furnish [sic] employments to their inhabitants, who thereby partake of a portion of that superabundance of comfort with which nature has blessed this favourite district.
> (*A General View of...Hereford*, London 1794, p. 32)

This could almost be a commentary on *The Fleece*; and it comes as a surprise therefore to read, in Clark's other reports, that the very separation of the agriculture of the other counties along the Welsh Border from the industries of the north, is the cause of the depressed state of their agricultural economy. 'When that immense quantity of wool', writes Clark in his report on Radnor (London 1794), 'which this county and Breconshire annually produce, is considered, it is surprising that some person, or company, from England, has not made the attempt to establish a woollen manufactory in some part of South Wales, since many thousand pounds would be saved by manufacturing the wool here' (p. 33). In his report on Brecknock (London 1794), he writes:

> The extensive mountains in which this district abounds, are covered with innumerable flocks of sheep, the manufactory of whose fleeces into woollen cloths, would furnish employment for more than double the number of present inhabitants. Yet, wonderful as it must seem, the wool is almost wholly purchased by dealers in that article, as soon as it is separated from the sheep, who send it, some one, some two hundred miles to be

manufactured; there it furnishes the necessaries – the comforts of life, to thousands of our more deserving – more industrious fellow subjects; while the natives of the mountains where the wool grew, are either idle, or manufacturing the refuse of it into stockings...To complete our humiliation, part of the wool thus manufactured into cloth, is sent back for our consumption, the said 200 miles again, where we thus pay ten shillings for that quantity of wool for which we received about one, and looking around us contemplate the wretched state of our own poor, let us wrap the fine garment around us with what *comfort* and *pride we can.* (pp. 46–7)

It is possible of course that the same circumstances which contributed to the health and prosperity of the peasants of Herefordshire could have been a cause of poverty in the other two counties – if in Herefordshire alone the production of raw wool was so efficient that to redeploy any of the pastoral population into local manufacturing industry would have left the farmers short of labour, and also (somehow) depressed wage-levels. Such figures as we have, however, suggest that in the 1790s the poor were relatively as numerous and their condition as desperate in Herefordshire as in the two counties over the border (*Reports from Committees*, 1882, vol. v, pp. 540–3), so that if the establishment of woollen manufactures would have been a profitable and a benevolent action in one county it would have been so in all three. That Clark offers quite opposed accounts of the health of the three counties, in the light of much the same evidence from all of them, may be a testimony to the power of the georgic image of a unified and properous Herefordshire that Philips and Dyer purvey. It is also no doubt a result of a not wholly unintentional confusion between the agricultural wealth of a region – for Herefordshire was by far the most productive of the three counties – with the happiness of its labouring poor, that is so essential a feature of English Georgic as we studied it in the previous essay. The 'Silurian', or Leominster sheep, were unusually profitable; but the labourers of Herefordshire were not, for that reason, unusually well-off.

100 But see above, p. 21.

101 See for example, *Harvesters Setting Out, Ploughing, A Dead Horse on a Knacker's Cart*, all reproduced in John Baskett and Dudley Snelgrove, *The Drawings of Thomas Rowlandson in the Paul Mellon Collection*, London 1977.

102 Assigned to this period of Rowlandson's work by John Reily, *Rowlandson Drawings in the Mellon Collection*, New Haven 1978, p. 39.

103 See Baskett and Snelgrove, *The Drawings of Thomas Rowlandson*, p. 28.

104 Engraved (mezzotint) by James Ward, no publisher given, 1793.

105 Hassell, p. 85.

106 It is hard to know what Morland's attitude may have been to those who engraved his work. According to Dawe (p. 109), he never censured them, however indifferent their productions, and his trade with the publishers was lucrative enough to silence any disquiet he might have felt, for they might sell as many as 500 copies of a single print (Dawe, p. 79). On one occasion, however, Morland bought some copper-plates, with the intention of engraving his own works – whether for artistic or for economic reasons is not clear; but he never got down to the job, though he did succeed in alarming his publishers into giving him a better price for the permission to engrave his works (Dawe, p. 134).

107 Webster, *Francis Wheatley*, London 1970, p. 72.

108 Hassell, pp. 166–77.

109 Dawe, pp. 196, 211–13.

110 Fry, *Reflections on English Painting*, p. 81.

111 Berger, *Permanent Red*, pp. 178–9.

112 Hassell, p. 49.

113 Fry, *Reflections on English Painting*, p. 81.

114 Undated; Faustus Gallery, London.

3 John Constable

1 Annotation by Lucas of C. R. Leslie's *Memoirs of the Life of John Constable*, London 1843, p. 7; printed in *John Constable: Further Documents and Correspondence*, ed. Leslie Parris, Conal Shields and Ian Fleming–Williams, London and Ipswich 1975, p. 54.

2 *Observer Colour Magazine*, 15 February 1976.

3 *Sunday Times*, 22 February 1976.

4 *The Times Literary Supplement*, 27 February 1976.

5 See for example *John Constable's Correspondence* (hereafter '*JCC*'), ed. R. B. Beckett, vol. VI, Ipswich 1968, p. 171; *John Constable's Discourses* ('*JCD*'), ed. Beckett, Ipswich 1970, p. 9.

6 Note, however, the girl in the donkey-cart in *Wivenhoe Park* (exhibited 1817), Washington D.C., National Gallery of Art; reproduced in Basil Taylor, *Constable: Paintings, Drawings and Watercolours* (hereafter '*Constable*'), second edition, London 1975, pl. 51.

7 *John Constable's Sketch-Books of 1813 and 1814*, ed. Graham Reynolds, introductory volume, p. 9.

8 The painting is in the Victoria and Albert Museum, London; the sketch appears in the 1814 sketch-book (see previous note), p. 57.

9 Berger, 'Millet and the Third World', *New Society*, 29 January 1976.

10 Constable to Fisher, 13 April 1822, *JCC*, vol. VI, p. 88.

11 Abram to John Constable, 28 January 1821 and 2 August 1824, *JCC*, vol. I, London 1962, pp. 190, 216; in the second letter Abram responds to John's agreement with the remark quoted.

12 Edinburgh, National Gallery of Scotland.

13 Constable to his wife, 22 October 1825, *JCC*, vol. II, Ipswich 1964, p. 403.

14 According to Michael Kitson, *Sunday Times*, 22 February 1976. I have not discovered his source.

15 *The Journals of Dorothy Wordsworth*, ed. de Selincourt, London 1941, vol. I, p. 323.

16 Quoted in *JCC*, vol. V, Ipswich 1967, p. 75.

17 *Constable*, p. 48.

18 See especially R. F. Storch, 'Wordsworth and Constable', *Studies in Romanticism*, 5 (1966), pp. 121–38; Morse Peckham, 'Wordsworth and Constable', in *The Triumph of Romanticism*, Columbia, S.C., 1970; Karl Kroeber, *Romantic Landscape Vision: Constable and Wordsworth*, University of Wisconsin Press 1975 – which also offers a useful list of works comparing the painter and the poet (p. 9n).

19 The phrase is Wordsworth's, of course; see *Lyrical Ballads*, ed. W. J. Owen, second edition (revised), London 1971, p. 161.

20 This remark and the two following are taken from *JCD*, p. 59; see also *JCC*, vol. II, p. 32.

21 *JCD*, p. 54.

22 London, Tate Gallery; see *Constable*, p. 198, for a brief discussion of the date.

23 1826, London, National Gallery; *Constable*, pls. 73, 119.

24 There is a version in the Royal Academy of Arts, London, another in the Victoria and Albert Museum, London, and two in private collections. The catalogue of the Constable Bi-Centenary Exhibition at the Tate Gallery (hereafter '*Catalogue*'), by Parris, Fleming-Williams and Shields, London 1976, notes a further version (p. 74), has small monochrome reproductions of three of the paintings (pp. 73, 75), and reproduces one of them again in colour (opposite p. 49).

25 Ipswich, Christchurch Mansion.

26 Though Ian Fleming-Williams has suggested to me in conversation that he may be clearing weeds from the margin of the field.

27 London, National Gallery.

28 London, National Gallery.

29 Boston, Museum of Fine Arts; for a discussion of the date of this picture, see *Catalogue*, p. 93.

30 Mellon Collection; there is another version of this work – see *Catalogue*, pp. 87–8.

31 Bloomfield, *The Farmer's Boy*, London 1800, 'Spring', lines 71–2.

32 Reynolds, *Sketch-books*, 1813 vol., p. 71.

33 London, Tate Gallery.

34 I owe the last point in this paragraph to Conal Shields, who made it to me in conversation.

35 London, Tate Gallery.

36 *Le Vigneron* (pastel and black crayon) 1869–70, Rijksmuseum H. W. Mesdag, The Hague; *L'Homme à la Houe*, 1860–2, private collection, U.S.A.; *La Fin de Journée* (pastel and black crayon) 1867–9, Memorial Art Gallery of the University of Rochester.

37 *The Poems of John Clare*, ed. J. W. Tibble, London 1935, pp. 69–70.

38 See *The Letters of John Clare*, ed. J. W. and Anne Tibble, London 1951, p. 49n.

39 Smith, *The Wealth of Nations*, ed. Andrew Skinner, Harmondsworth 1974, p. 113.

40 See *The Country and the City*, London 1973, *passim*.

41 London 1834; re-issued 1839 with an added *vignette* after Constable.

42 Leslie, *Memoirs of the Life of John Constable*, London, edition of 1949, p. 37.

43 Shields and Parris, *John Constable 1776–1837*, second edition, London 1973, p. 17.

44 London, Tate Gallery; *Constable*, pl. 122.

45 London, Tate Gallery.

46 Shields and Parris, *John Constable 1776–1837*, p. 17.

47 *JCD*, pp. 72–3.

48 Introduction to *English Landscape*, reprinted in *JCD*, p. 9.

49 John Constable: *Further Documents and Correspondence*, p. 20.

50 Introduction to *English Landscape*, *JCD*, p. 9.

51 London, Tate Gallery; *Constable*, pl. 58.

52 New York, The Frick Collection; *Constable*, pls. 52, 53.

53 San Marino, California, Henry E. Huntington Library and Art Gallery; *Constable*, pl. 80.

54 London, Victoria and Albert Museum; *Constable*, pl. 97.

55 *Constable*, p. 28.

56 Reynolds, *Constable: The Natural Painter*, London, edition of 1976, p. 59.

57 *Ibid.*, p. 22.

58 See note 5 above, for this and the previous quotation.

59 Constable to Fisher, 16 December 1823, *JCC*, vol. VI, p. 146.

60 *Constable*, pp. 47–9.

61 Constable to Dunthorne, 22 May 1802, *JCC*, vol. II, p. 32.

62 *Constable*, p. 30.

63 See for example 'Literature and Rural Society', *The Listener*, 16 November 1967.

INDEX